SEVENTEENTH CENTURY MARINE PAINTERS
OF THE NETHERLANDS

SEVENTEENTH CENTURY
MARINE
PAINTERS
OF THE NETHERLANDS

BY

COLONEL RUPERT PRESTON

C.B.E.

F. LEWIS, PUBLISHERS, LTD

PUBLISHERS BY APPOINTMENT TO THE LATE QUEEN MARY

The Tithe House, Leigh-on-Sea, England

PRINTED AND MADE IN ENGLAND

©
Copyright by
F. LEWIS, PUBLISHERS, LIMITED
THE TITHE HOUSE, LEIGH-ON-SEA, ENGLAND

First published 1974
Reprinted 1980
ISBN 0 85317 025 8

PRINTED IN GREAT BRITAIN BY
CLARKE, DOBLE & BRENDON LTD., PLYMOUTH AND LONDON

Contents

Author's Note

I should like to record my indebtedness to Mrs. Sheila Horlick for her research, especially towards compiling the notes on Dutch history, ships and their flags in the seventeenth century; Mr. Roger Took, for his assistance and research; Mr. Michael Robinson, late Keeper of Pictures, and the staff of the Maritime Museum, Greenwich, and the many other museums and persons too numerous to mention by name, whose assistance has been so invaluable.
1974 RUPERT PRESTON

Introduction

Great interest is now being taken in Marine Paintings, but little has been written about the 17th Century Marine artists of the Netherlands. In 1937, my late father Admiral Sir Lionel Preston wrote 'Sea and river painters of the Netherlands'. This book is now practically unobtainable and much unpublished research has been done since 1937.

This has been put together to form this new book. In it, those artists who made the greatest contribution to 17th Century Netherlands Marine Painting have been listed in alphabetical order so that it can become an essential reference book for all those devotees of early marine painting through its simple and easily usable format, in addition to its unique contents.

Each artist is introduced by a short biographical account. There are then some specimen signatures to act as a guide – and emphatically no more than that – to identification; it cannot be overstressed how rash it is to rely too strongly on signatures.

Ultimately, attribution can only be satisfactorily determined by the individual – and it remains a matter of individual opinion – after close analysis of the painting's stylistic qualities. To this end, each artist is represented by a photograph of his works, selected primarily because of their availability to the specialist at first hand in museums and public collections. Nothing can equal the value of knowledge acquired by direct reference to the pictures themselves.

The recognition of characteristic details can then be compared with further clues, which may combine and lead to a successful attribution. The subject itself may be useful if it is of a particular historical occasion; the flags are invariably a help; furthermore, the development and variety of ship construction may give additional information. The use of canvas or panel and the size of the same may also be typical of a particular artist and therefore always worthy of note.

To help answer some of these questions, there are included three appendices on the history, ship construction and flags of the period, so that it is hoped that by referring to the documentary and visual information contained in this book, enjoyment and knowledge of the 17th Century marine painters of the Netherlands may be increased.

Index

ARNOLDUS (AERNOUT) VAN ANTHONISSEN

Born Leiden *c* 1630, died Zierikzee 1703.

Arnoldus van Anthonissen was the son of Hendrik van Anthonissen (1606-1657) and so was related by marriage to Jan Porcellis (1585-1632).

He was Chairman of the Lucas Guild in Leiden in 1662 and besides painting a little in Amsterdam, he was in Zierikzee in 1677 and Middelburg in 1683.

His paintings are few and he did not appear to sign them until after the death of his father in 1657.

His estuary scenes are calm and peaceful in the manner of Simon de Vlieger (1600-1653) and Jan van Goyen (1596-1656). His open sea paintings show rough seas with sharp pointed waves, dark shadows falling across them in the style of de Vlieger, some retaining the grey green tones of Hendrik Anthonissen.

His signature can be confused with his father's and with Aert van Antum (1580-1620), but there is little similarity with the work of the latter painter who betrays his Flemish origins.

Signatures:

A.A., A.V.A., Aernout Anthonissen.

Signed Examples:

DUBLIN National Gallery.

No. 152. *Estuary scene with shipping.*

Signed: Aernout Anthonissen.

Canvas: 25½ x 37½ in. 65 x 95 cm.

EMDEN Ostfriesches Landesmuseum.

No. 900. *Men-of-war and small craft in a choppy sea.*

Signed: A.A.

Panel: 12 x 24 in. 31 x 63 cm.

LEIDEN Stedelijk Museum de Lakenhal (see figure 1).

Sea Battle in the Sound, Denmark 1658.

Signed: A.A.

Canvas: 25½ x 37½ in. 67 x 95 cm.

Shipping in a choppy sea off a coast.

Signed: A.A.

Canvas: 30 x 51 in. 76 x 130 cm.

HENDRIK VAN ANTHONISSEN

Born Amsterdam 29th May 1605, died Amsterdam 12th November 1656.

A Dutch marine painter who worked chiefly in Amsterdam. He was the pupil of his brother-in-law, Jan Porcellis (1585-1632) and the father of Arnoldus Van Anthonissen (1630-1703).

He lived at Leiden in 1632, moved to Leiderdorp in 1635, Amsterdam in 1636 and finally Rotterdam in 1645, where he was still active in 1652.

In his early days he painted in the style of Jan Porcellis, but later was influenced by Simon de Vlieger (1600-1653) and Jan van Goyen (1596-1656).

Henrik van Anthonissen often painted large pictures with turbulent seas of grey-green and silvery tone. The ships and backgrounds were usually good, but the skies were a weak feature. Some of his paintings included the forts of Goa. He has not the finery of the Porcellis school. Anthonissen usually signed his work, but the various signatures often gave rise to confusion with those of his son, Arnoldus, and also with Aert Van Antum, though there is little similarity with the work of the latter.

Signatures:

H. V. ANT., VAN ANTO., H.V.A., VANT H., VANTON, H. V. AN., H. V. ANTHVN., H. V. ANTHONISSEN.

Signed Examples:

AMSTERDAM Rijksmuseum.

No. 366AI. *Surprise of three Portuguese galleons.*

Signed: H. V. Anthonissen 1653.

Canvas: 59 x 108 in. 152 x 273 cm.

AMSTERDAM Scheepvaart Museum (see figure 2).

Episode in the Battle of the Downs 1639.

Signed: H.V.A.

Panel: 17½ x 41 in. 45 x 104 cm.

GREENWICH National Maritime Museum.

No. 27-242. *Shipping in a gale.*

Signed: H. V. AN.

Panel: 11 x 13 in. 28 x 33 cm.

LENINGRAD State Hermitage Museum.

No. 2869. *Coastal View with a ship in a squall.*

Signed: H. V. ANT 1647.

Canvas: 13 x 17 in. 32.5 x 43 cm.

SCHWERIN Staatliches Museum.

No. 127. *The beach at Scheveningen.*

Signed: H. V. A.NTON.

Panel: 12½ x 17¾ in. 32 x 45 cm.

AERT VAN ANTUM

Born Antwerp 1580, died Amsterdam 7th September 1620.

Aert Van Antum was an early Flemish-Dutch artist who painted chiefly in Amsterdam. He was possibly a pupil of Hendrik Vroom (1566-1640) whom he is thought to have copied at times.

Antum, Vroom, Andries Van Eertvelt (1590-1652) and Claes Wou (1592-1665), were the outstanding early seascape painters, with high horizon and little sky.

Van Antum's subjects were sea battles, ships in rough seas and shipwrecks. His work is attractive and brightly coloured with green waves and ships often broadside profile with brown sails and mainsail only. Vessels are accurate but do not float correctly. Sea rather unreal with whales and waterspouts. Figures on decks of ships slightly exaggerated.

1604 is the first dated work, and only a few others are dated until 1618, two years before his death (1620).

Signatures:

A.A., AVANTUM, AERT ANTUM, note the similarity of the signature with Arnoldus and Hendrik Van Anthonissen.

Signed Examples:

AMSTERDAM Rijksmuseum.

No. 368. *English and Dutch ships fighting the Armada off Dover in 1588.*

Signed: AERT ANTUM 1608.

Panel: 16 x 32½ in. 41 x 82.5 cm.

(Very like a painting by H. Vroom).

No. 369. *The Ship 'Eendracht'.*

Signed: AERT ANTUM 1618.

Panel: 16 x 32 in. 41 x 82 cm.

GREENWICH National Maritime Museum.

No. 62-18. *A French ship and Barbary pirates.*

Signed: A.

Panel: 6½ x 12½ in. 16.5 x 32 cm.

No. 32-27. *Heemskerk's defeat of the Spaniards at Gibraltar 1607.*

Signed: AERT ANTUM 1608 or 1619.

Canvas: 72 x 116 in. 183 x 295 cm.

National Maritime Museum.

No. 38-1654. *Shipping at Amsterdam* (see figure 3).

Canvas: 22 x 35 in. 56 x 90 cm.

PRAGUE National Gallery.

Stormy seas.

Signed: A. V. ANTUM.

Panel: 30 x 43 in. 73.8 x 110 cm.

EMDEN No. 740A. *Battle of Armada 1588.*

Copper. 8½ in. 22 cm. diameter. Signed and dated 1604.

LUDOLPH BACKHUYZEN, or BACKHUIZEN, or BACKHUISEM

Born Emden 1631. Died Amsterdam 1708.

Ludolph Backhuyzen was one of the most important seascape painters. On leaving school Backhuyzen first worked under his father as a clerk in the Government offices at Emden and later in the counting house of an Emden merchant. In 1649 he emigrated to Amsterdam working as a calligrapher and writing master. Later he turned to making pen drawings and grisailles of shipping. In 1657 and 1660 he is called a draughtsman and in 1664 an artist. His earliest drawing is dated 1650 and his first oil painting 1658.

Backhuyzen was a pupil of Allaert Van Everdingen (1621-1675) and Hendrik Dubbels (?1620-1676). The influence of Dubbels is seen in some of his paintings.

After the departure of the William van de Veldes to England in 1672 Backhuyzen became the leading marine painter in Amsterdam. He is less elegant in his composition, heavier in colour and atmosphere and less careful in execution than Willem van de Velde the Younger, but some of his pictures belong to the best works of seascape painting.

His pictures are inclined to be dark, usually large and painted on canvas. They were frequently composed with a turbulent sea with dark waves in the foreground and nearly always dark clouds with some blue sky. Backhuyzen's ships are inclined to be heavy and he leaves his ships in the background incomplete in detail, which gives the impression of their being seen through a slight mist. Ludolph Backhuyzen is known to have painted over two hundred pictures many of which are not signed and also executed a few grisailles.

Signatures:

Usually L.B. or L. Backhuizen but there are many other variations, such as L. Back., L. Bach., L. Bakhuis., L. Bakhuizen, L. Bakh., L. Backh.

Signed Examples:

AMSTERDAM Rijksmuseum.

No. 410. *Embarkation of Marines in 1671.*
Signed: L. Bakh.
Canvas: 36 x 55 in. 91.5 x 140 cm.

No. 411. *The River 'Y'.*
Signed: L. Backh.
Canvas: 32 x 26 in. 81 x 67 cm.

No. 412. *Rough Sea.*
Signed: L. Backh. and dated 1692.
Canvas: 21 x 27 in. 53.5 x 69 cm.

No. 413. *Shipping off the Zuyder Zee.*
Signed and dated 1695.
Canvas: 14½ x 18 in. 37 x 46 cm.

No. 415. *The River 'Y' before Amsterdam.*
Signed: L.B.
Canvas: 24 x 29¾ in. 61 x 75 cm.

No. 416. *The River 'Y' before Amsterdam.*
Signed: L. Backh.
Canvas: 26¾ x 32 in. 67.5 x 81 cm.

No. 417.AI. *Man of War King William under full sail off Rotterdam.*
Signed: L. Bakh. dated 1689.
Canvas: 51 x 98½ in. 130 x 190 cm.

No. 417 A.8. *Rough Water.*
Signed: L.B.
Canvas: 12½ x 15 in. 31.5 x 39 cm.

No. 417 A.9. *Man beaching boat in calm sea.*
Signed: L.B.
Canvas: 12½ x 15 in. 31.5 x 39 cm.

AMSTERDAM Scheepvaart Museum (see figure 4).

The Hollandia with Admiral De Ruyter, 1665.
Signed: L. Backhuyzen 1666-67.
Canvas: 44½ x 67 in. 113 x 171 cm.

View of Shipping Roads.
Signed: Lud Backhuyzen.
Panel: 23 x 32½ in. 59 x 83 cm.
BONN Rheinisches Landesmuseum.
 No. 53-13. *Stormy Sea.*
 Signed: L.B. 1650.
 Panel: 16 x 18 in. 40.7 x 47.7 cm.
BREMEN Kunsthalle.
 No. 13. *Man-of-War and smaller craft.*
 Signed: L.B.
 Panel: 14 x 19 in. 35 x 48 cm.
COPENHAGEN Royal Museum of Fine Arts.
 No. 15. *Small Vessels in Morning Calm.*
 Signed: L.B.
 Canvas on Panel: 16½ x 24 in. 42 x 61 cm.
 No. 16. *Evening with Amsterdam in Background.*
 Signed.
 Canvas on Panel: 16½ x 25 in. 42 x 62 cm.
 No. 17. *Vessel going alongside jetty in harbour.*
 Signed.
 Canvas: 16 x 16½ in. 41 x 42 cm.
 No. 20. *The Battle of Lowestoft 1665.*
 Signed: L.B.
 Canvas: 55 x 92 in. 141.5 x 234.5 cm.
DUBLIN National Gallery.
 No. 173. *Dutch East India Fleet leaving port.*
 Signed: L. Bakh. 1702.
 Canvas: 51½ x 45½ in. 131 x 116 cm.
 No. 1673. *Coastal Scene with Shipwreck.*
 Signed: L.B.
 Canvas: 19 x 29 in. 49 x 74 cm.
EDINBURGH National Gallery.
 No. 2. *A squall, with a lugger running to port.*
 Signed: L.B.
 Canvas: 17¼ x 23 in. 44 x 58.5 cm.
HAGUE Mauritshuis.
 No. 6. *Arrival of Prince Willem III at Oranjepolder.*
 Signed: L. Bakhuis. 1692.
 Canvas: 21 x 26.5 in. 53.5 x 67.5 cm.
LICHTENSTEIN Fuerstliche Sammlung.
 No. 550. *Choppy Sea off Amsterdam.*
 Signed: L.B.
 Canvas: 27 x 35½ in. 69 x 90 cm.
 No. 558. *Two Warships.*
 Signed: L.B.
 Canvas: 27 x 35½ in. 69 x 90 cm.
 No. 597. *Choppy Seas.*
 Signed: L.B. 1677
 Canvas: 28½ x 43 in. 73 x 109 cm.
LILLE Museum.
 No. 957. *Dutch man-of-war at anchor and fishing vessels.*
 Signed: L.B.
 Canvas: 24¾ x 31½ in. 63 x 80 cm.

4

LONDON Dulwich College.

No. 327. *Small boats in a storm leaving a beach.*

Signed : Ludolph Back. 1696

Canvas : 24½ x 30¾ in. 62 x 85 cm.

LONDON National Gallery.

No. 204. *Dutch men-of-war and other vessels in a breeze off Enkhuizen.*

Signed : L. Bakhuizen and L.B. Dated 1683.

Canvas : 39¾ x 53¾ in. 101 x 137 cm.

No. 818. *A beach scene with fishermen.*

Signed : LB.

Panel : 13 x 19⅛ in. 34.2 x 48.5 cm.

No. 1050. *Dutch men-of-war entering Mediterranean port.*

Signed : L. Backhzen. Dated 1681.

Canvas : 46½ x 64⅛ in. 118 x 164 cm.

LONDON Wallace Collection.

No. 244. *Calm shore scene.*

Signed : L. BAKH (Twice).

Canvas : 20¼ x 27 in. 51 x 74 cm.

GREENWICH National Maritime Museum.

No. 31-25. *Battle of Vigo Bay, October 12th 1702.*

Signed : L. Bakh.

Canvas : 19 x 27 in. 48.5 x 68.5 cm.

No. 52-7. *Dutch ships wrecked on a rocky coast.*

Signed : L.B.

Canvas : 33 x 44 in. 84 x 112 cm.

No. 34-39. *Action of the third Dutch war.*

Signed : L. Bakhuizen, 1685.

Canvas : 26½ x 31½ in. 67.5 x 80 cm.

No. 47-86. *Dutch yacht before the wind in a harbour.*

Signed : L.B.

33 x 40 in. 84 x 102 cm.

No. 37-1726. *Dutch merchant and small vessels off the coast.*

Signed : L.B. Dated 1665.

Canvas : 42 x 66 in. 107 x 191 cm.

No. 43-67A. *A small ship passing under the bows of a Dutch man-of-war, a flagship coming in to anchor.*

Signed : L.B 1676

Canvas : 40 x 54 in. 102 x 138 cm.

No. 43-107. *Dutch flagship with a yacht under her stern.*

Signed : LBAKH.

Canvas : 22 x 30 in. 56 x 76 cm.

No. 40-288. *Ships repairing at Amsterdam.*

Signed : LB 1699

Canvas : 30½ x 44 in. 77.5 x 112 cm.

No. 48-724. *Dutch shipping in a harbour.*

Signed : L. Bakh.

Panel, Grisaille : 19 x 25 in. 48.5 x 63.5 cm.

MUNICH Alte Pinakothek.

No. 1041. *Amsterdam Harbour.*

Signed : LB 1697

Canvas : 43½ x 57½ in. 111 x 146 cm.

PARIS Louvre.

No. 2304A. *The sea by the Helder.*

Signed : L. Bakhuizen.

Canvas : 26¾ x 35½ in. 68 x 90 cm.

No. 988. *View of Amsterdam on the Y.*
Signed : Ludolf/Back/Sen/1666/and underneath : An/dc/Spiegel and under that : Amsterdam
Canvas : 50½ x 88 in. 128 x 222 cm.
ROTTERDAM Prins Hendrik Museum.
No. 1046. *Dutch squadron of seven ships.*
Signed : L.B. 1682.
Canvas : 58 x 74 in. 147 x 188 cm.
ROTTERDAM Boymans-van-Beuningen Museum.
No. 1018. *A ship saluting.*
Signed : LB
Canvas : 21 x 27 in. 54 x 68 cm.
No. 1019. *A storm off a Dutch coast.*
Signed : L.B. 1682
Canvas : 58 x 74 in. 148 x 188 cm.
VIENNA Kunsthistorisches Museum.
The harbour at Amsterdam.
Signed and dated 1674.
Canvas : 67 x 82 in. 170 x 210 cm.

GERRIT VAN BATTEM

Born Rotterdam 1636, died Rotterdam 1684.

Gerrit Van Battem was a painter of various subjects. He worked chiefly in Rotterdam. His seascapes depict both calm and turbulent seas and show a wide variety of styles, which is probably due to the fact that Van Battem was influenced by Jacob Ruisdael (1630-1681), Willem Van De Velde the Younger (1633-1707) and Ludolph Backhuyzen (1631-1708).

In each picture the style of one or the other is visible. Battem has the movement of Ruisdael with a little of the mood of Backhuyzen, yet his painting of vessels in calm water is reminiscent of Willem Van De Velde the Younger.

Gerrit Van Battem's pictures are however rare and not enough is known of his work to be dogmatic about his style, though his paintings are small. He is understood to have painted the figures in some other artists' pictures.

Signatures :
 GVB., G. V. BATTEM., BATTEM.
Signed Examples :
BRUSSELS Musee Royaux des Beaux-Arts.
 No. 774. *Shipwreck in a storm.*
 Signed : G. V. BATTEM.
 Panel : 13 x 17 in. 34 x 43 cm.
GREENWICH National Maritime Museum (see figure 5).
 No. 62-64. *Shipping near a jetty.*
 Signed : G.V.B.
 Panel : 10½ x 12 in. 27 x 31 cm.
 No. 62-64. *Shipping off a town.*
 Signed : G.V.B.
 Panel : 10½ x 12 in. 27 x 31 cm.

JAN KAREL DONATUS BEECQ

Born Amsterdam 1638, died Amsterdam 1722.

Little is known of Jan Beecq's life. He is said to have painted in Paris under the patronage of the Duke of Vendome and was a member of the Paris Academy. In 1714 he was in Amsterdam and as several of his pictures show English men-of-war, Beecq may have been in England at some time.

Although chiefly a 17th Century painter, Jan Beecq paints with a mood reminiscent of the 18th Century

English school of marine painters. Though the ships, flags and skies are convincing, his seas are inclined to be too silvery to be realistic.

The work of Jan Beecq is often confused with that of Isaac Sailmaker.

Signatures:

J. van Beecq., J. V. Beecq.

Signed Examples:

COPENHAGEN Royal Museum of Fine Arts.

No. 40. *English warships in a calm sea.*

Signed: J. van Beecq, 1677.

Canvas: 31 x 52 in. 79 x 132 cm.

No. 41. *English warships in a breeze.*

Signed: J. van Beecq.

Canvas: 22½ x 35½ in. 57 x 90 cm.

MALTA Museum.

English ship.

Signed: J. van Beecq, 1679.

Canvas: 35 x 21 in. 90 x 54 cm.

PARIS Musee de la Marine.

A set of three:

(1) *French ships off a Turkish port.*

(2) *French ships.*

(3) *French attack on a Barbary pirate.*

All signed: J. V. Beecq 1684.

GREENWICH National Maritime Museum.

No. 36-92. *English three-decker before the wind.*

Signed: J. van Beecq, 1679.

Canvas: 22½ x 35½ in. 57 x 90 cm.

No. 61-155. *Shipping in a calm* (see figure 7).

Fully signed and dated 1677.

Canvas: 40 x 34 in. 101 x 86 cm.

CORNELIS BEELT

Born Rotterdam 1640, died Haarlem 1702.

A Haarlem Landscape painter with enough versatility to paint any type of picture with conviction. He enjoyed producing seascapes and in particular shore scenes in the style of Egbert van de Poel. He was elected Master of the Haarlem Guild in 1661.

Primarily interested in fishing fleets, he is well known for his work at the Rijksmuseum (No. 447) which shows the fleet at sea. More of his shore scenes depict the return of the fleet in the evening and the catch being eagerly examined and marketed by the fishing folk among whom wander elegant ladies and horsemen.

It is the figures in Beelt's painting which command attention. They are full of variety, colour and life, often grouped together in animated discussion. His waves are rather unreal.

The beach of Scheveningen features very frequently in these shore scenes.

Signature:

K. beelt.

Signed Examples:

AMSTERDAM Rijksmuseum.

No. 447. *The herring Fleet* (see figure 6).

Signed: K. beelt.

Canvas: 44½ x 80½ in. 113.5 x 204.5 cm.

ANTWERP Koninklijk Museum.

No. 924. *Coast at Scheveningen.*

Signed: K. beelt 1655.

Panel: 34 x 43½ in. 57 x 82 cm.

THE BEERSTRATEN FAMILY
JAN ABRAHAM BEERSTRATEN Baptized Amsterdam 1622, died Amsterdam 1666.
ABRAHAM BEERSTRATEN Born Amsterdam 1639, died 1666(?).
JOHANNES BEERSTRATEN Born 1653(?).

This Amsterdam family of painters depicted seascapes, Dutch and Mediterranean harbour views, a few sea battles and winter scenes.

Both Jan (father) and Abraham (son) had a natural talent for the architectural and enjoyed mixing real and imaginary buildings in their pictures. Ships are well drawn and technically accurate.

Jan is reputed to have worked from sketches by Johannes Lingelbach (1622-1674) who journeyed frequently abroad; it is believed no Beerstraten moved far out of Amsterdam.

Frayed flags are a recognisable characteristic of Beerstraten paintings. There is little to distinguish between the styles of the various paintings signed by the Beerstratens, though there may have been a tendency for Abraham to use a more grey and slightly colder palette than Jan.

Signatures, mostly different, show how difficulties have arisen for years over attributions, especially as all Beerstratens have varied the spelling of their surname.

There are few works signed by Abraham, however, it can be presumed that the paintings signed A or A. van with the name in full are by him.

Johannes was taken to an orphanage on 2nd October 1666. He had been taught to draw by his father. He later ran away from the orphanage and nothing more is known about his history.

Dated works by Jan are from 1653 to 1666 and it is believed that most of the seascapes are by him.

Signatures:
 The name in full with different spelling. Also the monogram I.B., J.B., A.B., A.J.B.

Signed Examples:

AMSTERDAM Rijksmuseum.
 No. 455. *The Battle of Ter Heyde* (see figure 8).
 Signed: I. Beerstraten 1659 (called Jan Abrahamsz).
 Canvas: 109 x 141 in. 176 x 281.5 cm.

COPENHAGEN Royal Museum of Fine Arts.
 No. 44. *Ships among the rocks* (probably in the Mediterranean).
 Signed: J. Beerstraat (called Jan Abrahamsz).
 Canvas: 30 x 36 in. 76 x 91 cm.

DRESDEN Gemaldegalerie.
 No. 1622. *Ships in a bay with rocks.*
 Signed: Beerstraaten (called Jan Abrahamsz).
 Panel: 27½ x 36 in. 70 x 92 cm.

GREENWICH National Maritime Museum.
 No. 40-227. *A Dutch flagship and a flute running into a Mediterranean harbour.*
 Signed: I. Beerstraten (called Jan Abrahamsz).
 Panel: 24 x 33 in. 61 x 84 cm.
 No. 36-61. *Dutch ships in a southern harbour.*
 Signed: Johan Beerstraaten 1660 (called Jan Abrahamsz).
 Canvas: 30 x 41 in. 76.5 x 105 cm.

GRONINGEN Groninger Museum.
 No. B266A. *Men-of-war.*
 Signed: J.B. 1666
 Panel: 16 x 19 in. 37.7 x 49 cm.

HAMBURG Hamburger Kunsthalle.
 No. 9. *The tower of Hoorn.*
 Signed.
 Canvas: 30 x 25 in. 76 x 64 in.

PARIS Musee du Louvre.
 No. 2310. *Harbour of Genoa.*
 Signed: Johannes Beerstraaten.
 Canvas: 37 x 51 in. 94 x 129 cm.

PRAGUE National Gallery.
No. 0/10-102. *Ships off a Mediterranean coast.*
Signed: Beerstraten (called J. Beerstraaten).
Canvas: 39 x 54½ in. 100 x 138.5 cm.
ROTTERDAM Boymans-van Beuningen Museum.
No. 1034. *A seaport at the foot of mountains.*
Signed: I. Beerstraten 1654 (called J. A. Beerstraaten).
Canvas: 23¼ x 32¼ in. 59 x 82 cm.
STOCKHOLM National Museum.
No. 1044. *View of the port of Venice.*
Signed: J. Beerstraaten 1660.
Canvas: 15¼ x 20¾ in. 39 x 53 cm.

JACOB BELLEVOIS

Born Rotterdam 1621, died Rotterdam 19th September 1671.

A Dutch seascape painter whose work is original in style, but slightly reminiscent of Simon de Vlieger (1600-1653).

Jacob Bellevois lived chiefly in Rotterdam, but was in Gouda and Hamburg, after which he returned to Rotterdam, dying there in 1671.

Bellevois usually painted choppy or rough seas and used an overall brownish grey. The sails are a rather dirty brown, not the usual colour of 17th Century canvas and although his shadows are inclined to be heavy, he is a good colourist and he gets movement into his ships (see figure 9).

Most of Bellevois' pictures are fairly large and it is often possible to distinguish his work by the serrating of the upper edges of the ships' flags. Often the blue of the Dutch flag shows as dark green. The later paintings of Bellevois are signed, usually on a flag, but the earlier works which were not signed have often been attributed to Simon de Vlieger. There are six known paintings of a shipwreck off a rocky coast, which are all similar to each other.

Signatures:

J. Bellevois, JB (J.B. joined together).

Signed Examples:

AMSTERDAM Rijksmuseum.
No. 462. *Rough seas.*
Signed: J. Bellevois.
Panel: 36¾ x 59 in. 93.5 x 149.5 cm.
BRUNSWICK Gemaldegalerie.
No. 396. *Ships wrecked in a storm off a rocky coast.*
Signed: J. Bellevois.
Canvas: 41¼ x 58¼ in. 105 x 148 cm.
GREENWICH National Maritime Museum.
No. 61-71. *Shipwreck and small vessel off a rocky coast.*
Signed: J. Bellevois.
Canvas: 31½ x 48 in. 80 x 122 cm.
HAGUE Mauritshuis.
Ships in an estuary with a town in the distance.
Signed: J. Bellevois.
Canvas: 41½ x 48¼ in. 106 x 122.5 cm.
HAMBURG Kunsthalle.
No. 367. *Choppy seas.*
Signed: J. Bellevois
Panel: 29 x 42 in. 73.7 x 106.5 cm.
LICHTENSTEIN Fuerstliche Sammlung.
No. 824. *Rough seas.*
Panel: 18 x 24¾ in. 48 x 63 cm. Signed: Bellevois.

ABRAHAM VAN BEYEREN

Born Hague 1620/1, died Overschie 1690.

The well known still life painter who produced a few fine seascapes, especially of the River Maas under the influence of a strong wind. His seascapes are in the manner of Van Goyen (1596-1656) and the style of A. van Everdingen (1621-1675) with a touch of the skill of Jacob van Ruisdael (1625-1682) and reminiscent of the early paintings of Simon de Vlieger. Abraham van Beyeren became a Member of the Hague Guild in 1645. He lived in Leyden in 1638, Delft in 1657, Amsterdam in 1672 and Alkmaar in 1674, but chiefly in the Hague. No seascapes appear to have been painted by van Beyeren before his fortieth year. He is regarded as the Impressionist of the Marine School and his seascapes are predominantly grey with fishing boats rolling in a lively sea and an overcast sky with a town or coast in the background. His waves are inclined to be pointed. His seascape pictures are rare.

Signatures:

Monogram composed of A.V. and B., or A.B., or A. Beyeren.

Signed Examples:

BUDAPEST Museum of Fine Arts.

No. 252. *Fishing boats in choppy sea.*

Signed: A.B.

Canvas: $27\frac{1}{2}$ x 44 in. 69.8 x 112 cm.

LENINGRAD State Hermitage Museum.

No. 5201. *Fishermen with their catch on shore.*

Signed: A. Beyeren.

Canvas: $46\frac{3}{4}$ x 66 in. 119 x 167 cm.

PHILADELPHIA John G. Johnson Collection.

No. 637. *Vessels in a choppy sea.*

Signed: A.B.

Canvas: $32\frac{1}{2}$ x 44 in. 82.5 x 112 cm.

ROTTERDAM Boymans-Van Beuningen Museum.

No. 1049. *Ships in the Maas in a choppy sea* (see figure 10).

Signed: A.V.B.

Canvas: 29 x 39 in. 73.5 x 99 cm.

JAN THEUNISZ BLANKERHOOF

Born Alkmaar 1628, died Amsterdam 1669.

Jan Blankerhoof was apprenticed to Cesar van Everdingen (1617-1678), a painter of historic events and portraits. He was a member of the Alkmaar Guild in 1649 and visited Rome and Greece several times.

It is regrettable that there are so few signed examples of his work as the quality of his pictures is excellent, although there are undoubtedly several pictures painted by him and attributed to others, especially to Backhuyzen and Beerstraten, but the colouring should distinguish him.

Several times in 1665 to 1666, Blankerhoof was at sea taking part in actions, in order to make pictures on the orders of the Dutch Admiralty, and for this he was nick-named Jan Maat (matelot-sailor).

Blankerhoof's paintings are executed in grey tone, using little colour and his works usually show a coastline or town in the background, giving some witness of the travels in Italy and Greece. The seas are usually rough and another characteristic is to show ships' flags turned upwards and frayed in the wind.

Signatures:

J. Blankerhoof or monogram J.B., I.B. or I.B.H.

Signed Examples:

BRUSSELS Musee des Beaux-Arts.

Ships in a stormy sea (see figure 11).

Signed: J. Bl..khoof.

Canvas: 36 x 52 in. 91 x 132 cm.

HAMBURG Kunsthalle.

Ships off a coast in choppy water.

Signed: J.B.

Canvas: $12\frac{3}{4}$ x $15\frac{1}{4}$ in. 32.6 x 38.8 cm.

HOORN Town Hall.
Battle of Bossu.
Signed: J. Blankerhoof.
Canvas: 90 x 53 in. 229 x 271 cm.

GASPAR BOS or CASPAR or JASPAR VAN DEN BOS
Born Hoorn 1634, died Hoorn after 1656.
The son of a shipbuilder in Hoorn who followed his father in the same trade. Bos was an exponent of grisaille painting, an enthusiastic but self-taught artist who, if he had lived longer, might well have achieved wider fame.
Signatures:
 C. or J. van den Bos.
Signed Examples:
AMSTERDAM Scheepvaart Museum.
 A view of Hoorn 1654 (see figure 12).
 Signed: J. Van den Bos.
 Grisaille on panel: 12½ x 20 in. 32 x 50 cm.
ROTTERDAM Prins Hendrik Museum.
 No. 1435. *Ships passing close to land.*
 Signed: C. Van den Bos.
 Grisaille on panel: 12 x 18 in. 30.6 x 45.8 cm.

CORNELIS BOUMEESTER
Born Rotterdam 1670, died Rotterdam 1733.
Cornelis Boumeester was a rare grisaille painter who also painted tiles.
Little is known about him, but he most likely visited Italy at some time. An interesting feature of Boumeester's painting, is his sea of pyramid-shaped waves and the crescent shape of some of his flags.
Signatures:
 C. BOVMEESTER, BVMSTR., C/BOUMEES/TER., or C.B.M.
Signed Examples:
GREENWICH National Maritime Museum.
 No. 45-43/6. *Dutch ships in a gale off a rocky coast.*
 Signed: C.B.M.
 Grisaille on panel: 14½ x 20 in. 37.5 x 51.5 cm.
 No. 32-56. *Several Dutch ships arriving at Naples.* (see figure 13).
 Signed: C/BOVMEES/TER
 Grisaille on panel: 24 x 33 in. 61 x 84 cm.
 No. 30-18. *Dutch ships at anchor.*
 Signed: C.B.M.
 Grisaille on panel: 17½ x 22½ in. 45 x 57.5 cm.
 No. 30-17. *English ships in a strong breeze.*
 Signed: C.B.M.
 Grisaille on panel: 17½ x 22½ in. 45 x 57.5 cm.

PIETER BOUT
Born Brussels 1658, died Brussels 1719.
A Flemish landscape and genre painter of considerable skill, whose landscapes were often beach scenes. A familiar beach scene depicts a number of fishing folk on the sand displaying their catches. These figures are attractively and well drawn in bright colours and the attention one automatically pays to his figure groups causes one little to notice his backgrounds. These are in fact well painted and in perfect harmony with the bright and lively foreground where groups are in conversation or at work (see figure 14).
In Brussels for periods throughout his life and an apprentice of that Guild in 1671. Bout also worked in Paris for a few years and may have travelled to Italy. He is known to have painted the figures in some works of Adrian Frans.

Signatures:
P. bout., P.B. There is another artist Pieter de Bloot (1601 Rotterdam 1658) who signed P.D.B.
Signed Examples:
AMIENS Musee des Beaux-Arts.
Harbour Scene.
Signed: P.B.
Panel: 12½ x 19¼ in. 32 x 49 cm.
FRANKFURT Stadelsches Kunstinstitut.
No. 296. *Beach of Scheveningen with the return of a fishing fleet.*
Signed: P. bout Af 1677.
Canvas: 19¾ x 26¾ in. 50 x 67.7 cm.
KARLSRUHE Badische Kunsthalle.
No. 203. *Selling fish on the shore.*
Signed: P. bout f A1683.
Canvas: 8¼ x 9¾ in. 21 x 25 cm.

LEONARD BRAMER
Born Delft 1596, died Delft 1674.
Leonard Bramer was primarily a portrait and history painter who painted a few seascapes. He usually depicted seascapes in a storm or being wrecked on a rocky coast in a flamboyant but rather crude style. He may have been influenced by the Italian painter Agostino Buonamico (Tarsi) 1565-1644.
Bramer's ships are carelessly painted and inaccurate and his seas quite unconvincing. He spent a great amount of his time in Italy and most of his pictures are there now in private hands.
Signatures:
L.B.
Signed Examples:
HAMBURG Kunsthalle.
No. 725. *Shipwreck on a rocky coast* (see figure 15).
Canvas: 39½ x 53 in. 100 x 134.5 cm.
Signed bottom right: LB.

JAN VAN DE CAPPELLE, CAPELLE, or CAPEL
Born Amsterdam 1624, died Amsterdam 1679.
Jan van de Cappelle was one of the greatest Dutch marine painters. He was a wealthy dyer, a citizen of standing and an art collector who painted as a hobby.
Cappelle is said to have been self-taught, but was a friend of Simon de Vlieger (1600-1653) and de Vlieger's influence can be seen in his painting. His art collection contained many marine paintings by de Vlieger and Jan Porcellis (1585-1632), and he was a friend of Rembrandt, Frans Hals and Eeckhout, who all painted his portrait.
The number of paintings by Cappelle is very small and therefore very valuable. He invariably painted calm water, chiefly in estuaries and most of his pictures show small ships dispersed over a smooth mirror surface of water. Often he has a yacht in the left or right corner. His early pictures are of a light silvery grey tone, later, of golden tones mingled with grey, but there was very great variety of colour. Cappelle was a master of painting reflections. He ignored historical events and battles and painted with originality and imagination, although using much that is in the paintings of Simon de Vlieger (1600-1653), Willem van de Velde the Younger (1633-1707) and Hendrik Dubbels (1620-1676). In fact seascapes by Dubbels are often attributed to Cappelle. Apart from his marine works, he executed a number of winter landscapes and possibly a few etchings. His paintings are dated between 1645 and 1665, early works chiefly on panel and later on canvas.
Signatures:
J. V. Cappelle, J. V. Capelle, J. V. Capel, J. V. Capell, J.V.C.
Signed Examples:
AMSTERDAM Rijksmuseum.
No. 681. *State barge saluted by the Home Fleet* (see figure 16).

Signed : J. V. Capel. 1650.
Panel : 25 x 36½ in. 63.5 x 93 cm.
BRUSSELS Musee des Beaux-Arts.
 No. 88. *A Calm Sea.*
 Signed : J. V. Capelle.
 Canvas on Panel : 25 x 31 in. 63.5 x 79.5 cm.
CHICAGO Arts Institute (Ryerson Collection).
 No. 1624/25-79. *A calm sea near the shore.*
 Signed : J. V. Capelle 1651.
 Canvas : 22 x 27¾ in. 56 x 70.5 cm.
COLOGNE Walraf-Richartz Museum.
 No. 2535. *Ships in a calm sea offshore.*
 Signed : J. V. Capelle.
 Panel : 18½ x 22½ in. 47 x 59.5 cm.
GREENWICH National Maritime Museum.
 No. 6267. *Two vessels by the shore at daybreak.*
 Signed : J. V. Capelle 1651.
 Panel : 21 x 19½ in. 53.5 x 49.5 cm.
LONDON National Gallery.
 No. 865. *A small vessel in a calm and another ashore.*
 Signed : J. V. Cappelle.
 Canvas : 13¾ x 45 in. 18.5 x 114.5 cm.
 No. 965. *Yacht firing a salute and other vessels.*
 Signed : J. V. Capelle 1650.
 Panel : 33½ x 45 in. 85.5 x 114.5 cm.
 No. 966. *Yacht firing a salute in a river.*
 Signed : J. V. Cappelle 1665.
 Canvas : 36½ x 51½ in. 93 x 131 cm.
 No. 967. *River scene with vessels.*
 Signed : J. V. Cappelle.
 Canvas : 48 x 60¾ in. 122 x 154 cm.
 No. 4456. *Dutch vessel becalmed in a river.*
 Signed : J. V. Cappele.
 Panel : 44 x 60½ in. 112 x 153 cm.
 No. 151. *View of Overschie.*
ROTTERDAM Boymans-Van Beuningen Museum.
 No. St.5. *Calm sea.*
 Signed : J. V. Capelle.
 Panel : 43¾ x 45 in. 111 x 114 cm.
STOCKHOLM National Museum.
 No. 265. *A jetty scene.*
 Signed : J. V. Capell 1649.
 Panel : 21½ x 27½ in. 55 x 70 cm.

LORENZO A. CASTRO

Little is known about this painter other than that he may be the L. A. Castro who was Master of the Lucas Guild at Antwerp 1664-5 and therefore a Netherlands artist. In a catalogue of pictures compiled prior to 1686, thirteen seapieces by Castro are mentioned, six of which are now at the Dulwich College Gallery, London. There are a further two paintings, signed and dated 1672 and 1675.

His paintings are characterised by being full of colour, movement and interest. Some of his works have a close resemblance to those of Abraham Storck (1644-1712).

His paintings portray battles, galleys in the Mediterranean, flying Barbary coast flags and harbour scenes. Like Abraham Storck and Jacob Bellevois he paints 'V' shaped or crescent shaped ripples in his flags.

He was not a great painter but should be definitely recorded as a 17th Century marine artist.

Signatures:
 CASTRO, L. CASTRO, L. A. CASTRO, LORENZO A. CASTRO.
Signed Examples:
GREENWICH National Maritime Museum.
 No. 33-40. *A Mediterranean harbour scene.*
 Signed: L. A. Castro
 Canvas: 41½ x 51 in. 105 x 130.5 cm.
LONDON Dulwich College Gallery.
 No. 361. *British and Dutch Warships.*
 Signed: L..... Castro Fecit.
 Canvas: 70 x 37½ in. 178.5 x 94.5 cm.
 No. 428. *Battle between Barbary coast ships and a British ship* (see figure 17).
 Signed: L Castro Fecit
 Canvas: 42 x 36½ in. 107 x 92 cm.
 No. 436. *British warships in a Mediterranean port.*
 Signed: L. Castro
 Canvas: 25 x 30 in. 64 x 76.5 cm.
 No. 437. *Dutch ships off Holland.*
 Signed: Castro.
 Canvas: 25 x 30 in. 64 x 76.5 cm.
 No. 517. *Dutch ships off a Mediterranean port.*
 Signed: Castro.
 Canvas: 25 x 18 in. 64 x 46 cm.

PIETER COOPSE
Flourished Amsterdam 1668-1677.
Pieter Coopse was a pupil of Ludolf Backhuyzen (1631-1708) and a prolific engraver. His pictures are rare and the initials can be mistaken for Pieter van der Croos, although there is little similarity between their styles. There appears to be a different marine artist who also signed P.C. in addition to Pieter van der Croos. Coopse attempts a natural, if sombre, tone. His ships are technically correct although cumbersome. There is an attempt to make the water lively and real but his sea is stiff and artificial.
Coopse composed and grouped his subject well and can sometimes be reminiscent of Gerrit Pompe, who was also a pupil of Backhuyzen. The pair of canvases at Munich are two of the best examples of Pieter Coopse's work.
Signatures:
 P.C., P. COOPSE.
Signed Examples:
GREENWICH National Maritime Museum.
 Vessels in a choppy sea off Den Briel.
 Signed: P.C.
 Canvas: 35 x 50 in. 89 x 127 cm.
MUNICH Alte Pinakothek.
 No. 1305. *Shipping at anchor, with smaller vessels under way.*
 No. 1306. *Companion picture* (see figure 18).
 Signed: P. Coopse.
 Pair on Canvas: 40½ x 52½ in. 103 x 133 cm.

ANTONIE JANSZ VAN DER CROOS or CROOST
Born 1606, died after 1662.
Little is known of the life of Antonie Jansz van der Croos. He resided in The Hague between 1634 and 1647, and was in Alkmaar in 1649.

14

The earliest known dated picture is 1636 and he worked in the style of Jan van Goyen (1596-1656) (see figure 19).

Signatures:

AV CROOS F. The AV usually being in monogram.

Signed Examples:

BUDAPEST Museum of Fine Arts.

Signed and dated 1651.

A pair with the view of the Rhine above.

Canvas: 86.5 x 100 cm.

JACOB VAN DER CROOS

Flourished in Amsterdam between 1660-1690.

Jacob van der Croos, the marine painter, is most probably the same man as the landscape artist. He was a cousin of Antonie van der Croos (1606-after 1662) and Pieter van der Croos (1620-1701).

While Jacob van der Croos' landscapes are close to the Van Goyen School, his seascapes have more relationship with the colouring of Simon de Vlieger (1600-1653).

He is not an impressive artist, however, but an extremely rare one.

Signatures:

J. V. CRO., J. van Croos, J.V. Cr. f.

Signed Examples:

GREENWICH National Maritime Museum.

Shipping in the Bosphorus (see figure 20).

Signed: J. van Croos.

Canvas: $20\frac{1}{2}$ x 26 in. 52 x 67 cm.

Fishing boats in a shallow sea.

Signed: J. v. Cro. f.

Panel: 18 x $26\frac{1}{2}$ in. 46 x 67.5 cm.

PIETER VAN DER CROOS

Born Alkmaar, c1620, died Amsterdam 1701.

Pieter van der Croos was a Dutch painter of seascapes and landscapes and a brother of Antonie van der Croos, a landscape painter of rather wider fame. He was in the Lucas Guild in the Hague in 1647, in the Guild of Alkmaar in 1651 and at Amsterdam in 1661.

Pieter van der Croos was a close follower of Simon de Vlieger, but he lacked the confidence that de Vlieger had and was inclined to overload his sea pieces with detail, using drab browns and greys and muddy colouring – said to be a family failing.

His paintings depict mostly shipwrecks, rough seas and ships near jetties or harbour entrances. His skies are usually heavily clouded and seas violently choppy, or possibly better described as turbulent. There is frequently a foreground of dark and sunlit patches of water.

Van der Croos' pictures are sometimes taken for those of Bonaventura Peeters and his signature has in the past been confused with that of Pieter Coopse.

Signatures:

P.C., P.v.d. Croos or P. Croos, the s at the end of the name often lying on its side.

Signed Examples:

GREENWICH National Maritime Museum.

No. 27.182. *Dutch ships in a rough sea off a pier* (see figure 21).

Signed: P. Croos.

Panel: 17 x $25\frac{1}{2}$ in. 43.2 x 65 cm.

THE HAGUE Gemeentemuseum, formerly, sold in 1960.

No. 125. *Sailing boat passing by a jetty in a rough sea.*

Signed: P. V. Croos.

Panel: $21\frac{1}{2}$ x $17\frac{1}{2}$ in. 54.5 x 45 cm.

ALBERT CUYP

Born Dordrecht 1620, died Dordrecht 1691.

Pupil of his father Jacob Gerritsz (1594-1651) he is chiefly known for his landscape painting with animals and for portraits and river scenes, but painted a few seascapes, chiefly of Dordrecht across the estuary of the Maas, sometimes with ships returning from the Indies or simple coasting vessels. He was also instructed by Van Goyen (1596-1655) and his influence is noticeable in his early paintings. He was a master of atmospheric effects with golden luminosity and where clouds are banking he lightens the mood by edging them with light.

He was a man of means and like Van de Cappelle painted for pleasure.

Signatures:

A. Cuyp or A. Cuiyp.

Signed Examples:

LENINGRAD State Hermitage Museum.

No. 1024. *Three vessels becalmed at Moonlight.*
Signed: A. Cuyp.
Panel: 30 x 40¼ in. 77 x 107 cm.
No. 947. *A vessel close hauled in a breeze off a harbour.*
Signed: A. Cuyp.
Panel: 16 x 28 in. 41 x 71.5 cm.

LONDON The Iveagh Bequest, Kenwood.

No. 46. *View of Dordrecht* (see figure 22).
Signed: A. Cuyp on oar.
Canvas: 38½ x 54¼ in. 97.8 x 137.8 cm.

LONDON Wallace Collection.

No. 59. *Ferry boat on the Maas.*
Signed: A. Cuyp.
Panel: 28 x 35½ in. 71 x 90 cm.

PHILADELPHIA John G. Johnston Collection.

No. 627. Fishing boats on the Maas.
Signed: A. Cuyp.
Panel: 18¼ x 28¾ in. 46.5 x 73.5 cm.

ADRIAEN VAN DIEST

Born The Hague 1655, died 1704 London.

Adriaen van Diest was probably both the son and pupil of Willem van Diest. Although primarily a painter of landscapes, he painted some admirable seascapes.

At the age of 17 he came to London and while in England painted many landscapes and coastal views with castles and ruins of a southern character, sometimes Mediterranean. His pictures have golden colouring and good perspective, but his style is inconsistent and it has been said that this was the result of his frequent moments of dire poverty, when he rushed pictures in order to keep alive and these are careless and overcrowded. One of the finest of Adriaen van Diest's pictures is of the Battle of La Hogue and can be seen in the National Maritime Museum, Greenwich. The drawing and colouring in this painting is accurate and balanced.

When at his best, van Diest is an exceptionally skilful painter of ships.

Signatures:

A. V. Diest or A. Diest.

Signed Examples:

GREENWICH National Maritime Museum.

No. 33-37. *Battle of La Hogue, Destruction of 'Soleil Royal'.*
Signed: A. Diest.
Canvas: 36 x 59½ in. 91.5 x 151 cm.
No. 34-43. *Battle of La Hogue, 23 May 1692* (see figure 23).
Signed: A. Diest fe.
Canvas: 35½ x 44 in. 90.5 x 112 cm.

16

JERONYMUS VAN DIEST

Born The Hague 1631, died The Hague 1673.

Jeronymus van Diest was the son of Willem van Diest and a very much older brother to Adriaen van Diest (1655-1704).

Little is known about him and his pictures are rare. He painted in a brownish tone with light grey clouds, grey sea and, in many of his pictures, a sunlit patch on the water. The seas are usually slightly ruffled by the wind, with the little waves edged with white in a rather precious and stilted manner.

Jeronymus van Diest was a precise painter who paid attention to detail both in the foreground and background, with fairly well painted ships which, however, do not move easily through the water, if they give the impression of moving at all. The staffage is good and neatly composed.

Van Diest sometimes shows the influence of Willem van de Velde the Elder (1611-1693), especially in the painting which hangs in the Rijksmuseum, No. 780 of the 'Royal Charles' taken into captivity. He used large canvases and his signature can be confused with that of Jacob de Vries (flourished 1628-1640).

Signatures:

I.V.D. or J.V.D.

Signed Examples:

AMSTERDAM Rijksmuseum.

No. 780H2. *The captured 'Royal Charles' in the river Maas* (see figure 24).

Signed I.V.D.

Canvas: $26\frac{3}{4}$ x $40\frac{1}{2}$ in. 68 x 103.5 cm.

GREENWICH National Maritime Museum.

No. 33-29. *'The Eendracht'*.

Signed: I.V.D.

Canvas: 41 x 65 in. 104 x 166 cm.

(Might be by J. de Vries and not by J. van Diest).

WILLEM VAN DIEST

Born The Hague ?1610, died The Hague after 1663.

Willem van Diest was the father of Adriaen van Diest (1655-1730) and Jeronymus van Diest (1631-1673).

Although he painted some allegories, he was primarily a sea and river painter in the style of Salomon Ruysdael (1600-1670), Jan van Goyen (1596-1656) and a little of Julius Porcellis (1605-1645) with Ruysdael colouring.

The ships are sometimes stilted in appearance, heavy and black, with hard waves and figures, but his later pictures are an improvement on his earlier works in all aspects. His waves and figures have become more naturally constructed and the calm water has a more delicate and pleasing atmosphere.

Signatures:

W. V. DIEST.

Signed Examples:

THE HAGUE Gemeentesmuseum.

No. 3-188. *Beach at Scheveningen.*

Signed: W. V. DIEST 1646.

Panel: $20\frac{3}{4}$ x $26\frac{1}{2}$ in. 52.5 x 67.5 cm.

GREENWICH National Maritime Museum.

No. 63-38. *Ship's boats going ashore from a Dutch ship* (see figure 25).

Signed: W. V. DIEST.

Panel: $12\frac{1}{2}$ x $10\frac{3}{4}$ in. 32 x 27.5 cm.

PRAGUE National Gallery.

No. 0/17. *Calm Sea.*

Signed: W. V. DIEST 1652.

Canvas: 23 x 37 in. 58 x 94 cm.

WURZBURG Martin von Wagner Museum.

No. 452. *Seascape.*

Panel: $11\frac{1}{2}$ x $13\frac{3}{4}$ in. 29 x 35 cm. Signed: W. V. DIEST.

HENDRIK JACOBSZ DUBBELS

Born Amsterdam 1621, died Amsterdam 1676.

Dubbels is one of the finest sea painters of Holland but a man whose art has been too little examined. For many years his pictures were attributed to other masters for he is often very similar to W. van de Velde the Younger, de Vlieger, L. Backhuyzen or Cappelle.

His early work was of a light grey tone and somewhat influenced by de Vlieger, though different in composition. He began with simple motives giving increasing importance to atmosphere and painting of the sky. The picture at the Schwerin museum, (No. 42), is typical of his work up to about 1640 where accent is laid on billowing clouds and sails.

Later he found and mastered the charming technique of painting reflecting water but still retained the grey tones with light and dark contrasting clouds and sails. Gradually he concentrated more on the open sea than on the inland waterways and the grey tones changed to a lighter and more delicate atmospheric composition. He painted more interest into the picture. There were several ships and figures where beforehand he had concentrated on one vessel. He used more blues and became very close to Van de Cappelle yet still retained a distinctive feeling and a slightly different colouring. Nearly pure white sails shine luminously in strong sunlight. His important National Gallery picture is almost a pure blue with most delicate touches of rusty brown and white, and the picture at Kassel (No 569) of a shore scene is possibly the nearest to Cappelle.

A later series of pictures seems once again to favour a choppy sea with broadly painted clouds and stylistically drawn waves which we see often in the work of L. Backhuyzen, who was possibly a pupil of Dubbels. One of these masterpieces is at the Rijksmuseum, Amsterdam, and depicts the fleet of Admiral Wassenaar-Obdam in the Helder.

Another characteristic of Dubbels, together with his painting of different shaded sails and a contrasting dark cloud, is to place a small strip of land in the foreground of the picture with a figure study of a fisherman loading or unloading a boat.

Dubbels also painted several winter scenes. His pictures are usually signed but very rarely dated.

Signatures:

DVBBELS, DUBBELS, I.D., H. DUBBELS, I.HD., H.D.

Signed Examples:

AMSTERDAM Rijksmuseum.

No. 813. *The Fleet of Admiral Wassenaar-Obdam leaving the Texel 1665* (see figure 26).
Signed: Dubbels.
Canvas: 55 x 77 in. 140 x 196 cm.

COPENHAGEN Royal Museum of Fine Arts.

No. 191. *Seascape.*
Signed: DUBBELS.
Canvas: $53\frac{1}{2}$ x $75\frac{1}{2}$ in. 136 x 193 cm.

No. 192. *Shore Scene with Shipping lying at Anchor in Calm Waters.*
Signed: H. Dvbbels.
Canvas: 23 x 26 in. 58 x 66.5 cm.

KASSEL Staatliche Kunstsammlung.

No. 1749/569. *Shore Scene in a Calm.*
Signed: DUBBELS.
Canvas: $22\frac{3}{4}$ x $35\frac{3}{4}$ in. 58 x 90.7 cm.

GREENWICH National Maritime Museum.

No. 27-66. *Dutch Vessel at a Pier.*
Signed: DUBBELS.
Canvas: 19 x 24 in. 49 x 61.5 cm.

MADRID Prado Museum.

A frozen harbour.
Signed: DUBBELS.
Canvas: 26 x 36 in. 67 x 91 cm.

ROTTERDAM Boymans-van Beuningen Museum.

No. Br.L2. *Harbour at sunset.*
Signed: Dubbels.

Canvas: 20 x 26 in. 51 x 66 cm.
No. Br.53. *Seascape.*
Signed: dubbels.
Canvas: 20 x 26½ in. 51 x 67 cm.
Formerly in the collection of Captain Spencer Churchill.
SCHWERIN Staatliches Museum.
No. 42. *The Binnen Sea.*
Signed: DUBBELS.
Canvas: 19½ x 19½ in. 49.9 x 49.5 cm.

ANDRIES VAN EERTVELT, ERTVELT or ARTVELT

Born Antwerp 1590, died Antwerp 1652.

The earliest of the 17th Century Flemish marine painters. In 1609 at the age of 19, he was a Master of the Antwerp Guild. He was influenced by Pieter Breughel the Elder. Eertvelt has the dramatic sense of the early Dutch painter Hendrik Vroom (1566-1640) particularly in the use of colours, where green dominates. He painted ships, battles and storms at sea. It is easy to mistake his monogram for that of Aert van Antum but the two painters are not similar. Eertvelt is easily recognised by the striking and sharp touches of white with which he highlights his little figures or parts of ships, usually a reefed sail. His colour is not so pure as that of the other panoramists except when he had spent a certain amount of time in Genoa at about the age of 37. Thereafter he painted with more feeling for colour, although his pictures are very immaturely composed – a trait which remained with him throughout his life.

Eertvelt was back in Antwerp by 1630 and among his pupils were Gaspard van Eyck (1613-1673) and Hendrik Minderhout (1632-1696). Had he been a greater painter he would have inspired a whole school of Flemish painters. The Flemish attraction for painting on copper can be noticed but he was probably the only Flemish sea painter to use metal. Eertvelt's pictures are usually large.

Signatures:
Andries van Eeertvelt, AE, A. v. E, A. V. ERTVELT.
Signed Examples:
GREENWICH National Maritime Museum.
No. 35-34. *Action between English and Spanish Ships.*
Signed: Andries van (Ertvelt).
Panel: 17 x 26½ in. 43 x 67.5 cm.
No. 62-24. *An Algerine Ship off a Barbary port.*
Signed: AE
Panel: 17¼ x 25 in. 44 x 63.5 cm.
No. 62-25. *A Dutch ship running out of a harbour.*
Signed: AE
Panel: 28 x 39 in. 71 x 99 cm.
No. 35-25. *Embarkation of Spanish troops.*
Signed: A. V. ERTVELT
Panel: 29½ x 48 in. 75 x 122 cm.
No. 62-26. *The Santa Maria.*
Signed: AE
Panel: 31½ x 26 in. 80 x 66 cm.
No. 27-70. *Dutch yachts racing.*
Signed: AE
Panel: 48½ x 79½ in. 123 x 197 cm.
No. 36-57. *Spanish engagement with Barbary pirates* (see figure 27).
Signed: Andries van Ertvelt.
Panel: 21 x 28 in. 53.5 x 71 cm.
No. 62-28. *Spanish ships in a harbour.*
No. 62-29. *Spanish ships at anchor.*
Signed: AE. A pair.
Canvas: 17½ x 25½ in. 44.5 x 65 cm.

LENINGRAD State Hermitage Museum.
 No. 6416. *Spanish fleet fighting the Dutch at the siege of Haarlem. May 1573.*
 Signed : A.v.E.
 Panel : 53 x 65 in. 134 x 165 cm.
VIENNA Kunsthistorisches Museum.
 No. 595. *Harbour with Spanish warships.*
 Signed : AE.
 Canvas : 72 x 125 in. 185 x 317 cm.

ALLAERT VAN EVERDINGEN
Born Alkmaar 1621, died Amsterdam 1675.

Allaert van Everdingen, a brother of Caesar van Everdingen, was a pupil of Roland Savery in Utrecht and Pieter Molyn in Haarlem. He became a Guild Master in 1645 and numbered Ludolph Backhuyzen among his pupils. In 1640 he travelled with Jacob van Ruisdael through Sweden and Norway and then is spoken of as being in Amsterdam in 1651.

He is best known as a landscape painter of waterfalls, but he also painted very fine open seascapes. These belong to the earlier realistic period and have original and fairly bright colouring, but some are in a grey monotone, rather more heavy and sombre than de Vlieger.

He painted rough and lively seas with sometimes very exaggerated waves.

Signatures :
 A.V.E., A. v. Everdingen, A : VAN : EVERDINGEN.

Signed Examples :
DRESDEN Gemaldegalerie.
 No. 1835. *Seascape.*
 Signed : A. v. EVERDINGEN. 1649.
 Panel : 17½ x 25 in. 45 x 64 cm.
FRANKFURT Stadelsches Kunstintitut.
 No. 777. *Stormy seas with small sailing boat off a rocky coast.*
 Signed : A.V.E
 Canvas : 39 x 55 in. 99 x 140.6 cm.
HAARLEM Frans Hals Museum.
 No. 92. *View of Haarlem from the Noordner Spaarne.*
 Signed : A.V.E
 Canvas on Panel : 15 x 26 in. 39 x 65.5 cm.
LEIPZIG Museum der Bildenden Kunste.
 No. 1007. *Small vessels in a very rough sea* (see figure 28).
 Signed : AVE.
 Panel : 10½ x 14½ in. 26.5 x 37.5 cm.
MUNICH Alte Pinakothek.
 No. 250 WAF. *Man-of-War going aground off a rocky coast.*
 Signed : AVE.
 Panel : 23½ x 36 in. 60 x 92 cm.

GASPARD (JASPER, KASPAR), VAN EYCK
Born Antwerp 1613, died Brussels, 1673.

A Flemish painter who was the son of the well-known collector Nicholas van Eyck. His rare pictures, most of which were Mediterranean coast and harbour scenes, are in the style of Andries van Eertvelt whose pupil he was in 1625. He showed excellent talent in his work and would probably have achieved greater fame and painted more pictures but for the fact that he suffered from a severe intermittent madness after his parents died in 1656.

He was a Master of the Antwerp Guild in 1632 and thereafter spent most of his time in Genoa with the artist Claes de Wael, later trying to establish himself in Brussels in spite of his illness.

His pictures have usually many figures, more often than not directly in the foreground, which are not very well painted, and his skies often seem to have been casually finished. Yet his compositions are always alive

and interesting. In his Mediterranean scenes there are always several galleys and one or two men-of-war in calm water sparkling in the sun.

He rarely signed his work and when he did the signature was:

G.V.E. or K. VAN EYCK.

Signed Examples:

MADRID Prado Museum.

No. 1508. *Battle between Christians and Turks* (see figure 29).
Signed: K. VAN EYCK. F.1649.
Canvas: 34 x 46½ in. 86 x 118 cm.

JOOST VAN GEEL

Born Rotterdam 1631, died Rotterdam 1698.

Van Geel is best known as a pupil of Gabriel Metsu (1629-1667) whose style he followed quite successfully. He was, however, responsible for some excellent beach and harbour scenes, rather tight in composition but with good colouring and in this field is seen to have a style not unlike that of Simon de Vlieger (1600-1653), with figures of a distinct Italian feeling. There is an etching of Jacob Quack after Joost van Geel.

Signatures:

J. V. GEEL, I. V. GEEL.

Signed Examples:

LYON Museum.

Shipwreck (see figure 30).
Signed: J. V. GEEL.
Canvas: 32¼ x 72½ in. 82 x 184 cm.

I. GERST

Active *c*1690.

Apart from the grisaille illustrated, the only other picture known to date was sold in W. D. Zimmerman's sale, Rotterdam, 1789, Lot 130, *Eenzel met schepen op een witte grond met zwart als gewassen.*

Signatures:

I. GERST.

Signed Example:

FORMERLY IN THE AUTHOR'S COLLECTION.

The warship 'Utregt' (Utrecht) (see figure 31).
Signed: I. GERT.
Grisaille on panel: 18 x 25 in. 46 x 63.5 cm.

HANS GODERIS

Worked at Haarlem 1625 and 1640.

Little is known about the painter Goderis except that he worked in Haarlem. He usually depicted small vessels in calm waters near the mouth of an estuary and was reputed to be the pupil of Jan Porcellis, though his style is more close to that of Julius Porcellis. His pictures are thinly, yet subtly, painted with a great feeling for delicacy, especially in the sea, where the water is slightly ruffled, the ripples edged with white and soft patches of light fall on the water. The boats float stiffly, although they are occasionally seen to be very well drawn.

Random facts seem to indicate that Hans Goderis died young and that he would have been a far greater painter had he lived longer. His best pictures are in private hands and there are only a few in public galleries.

Signatures:

HGoderis, with the H and G in monogram.

Signed Examples:

GREENWICH National Maritime Museum.

No. 63-31. *A fishing boat with sail lowered, near the shore.*
Signed: HGoderis.
Panel: 11 x 17 in. 28 x 43.5 cm.
No. 63-27. *Dutch fishing boats in a strong breeze.*

Signed : HGoderis.
Oval panel : 14½ x 18½ in. 37 x 47 cm.
GRONINGEN Museum voor Stad en Lande.
No. 1959-130. *Small vessels in calm waters at the mouth of an estuary.*
Signed : HGoderis.
Panel : 8 x 13 in. 21 x 30 cm.
ROTTERDAM Boymans-van Beuningen Museum.
No. 1236. *Estuary with ships.*
Signed : HGoderis.
Panel : 10 x 18 in. 27 x 45.5 cm.
FORMERLY IN THE AUTHOR'S COLLECTION.
Vessels off Flushing (see figure 32).
Signed.
Panel : 8 x 11 in. 20.5 x 28 cm.

JAN VAN GOYEN

Born Leyden 1596, died The Hague 1656.

Chiefly a painter of estuary and river scenes, but painted a few seascapes.

Van Goyen is well known today to every lover of Dutch pictures. He was popular in England in the 18th Century when he was found in collections but in mid-Victorian days the love for photographic exactness caused his sketches and monochromatic style to fall from favour and only at the end of the last century did he return to favour with the collector. Today his name is continually in catalogues of picture sales where his contemporaries' works are often credited with his name.

In 1612 he worked among the Hoorn school under Willem Gerritz. Following this he travelled to Paris in about 1615 where he painted several marine pictures, a type of picture as yet unknown in Paris, there being no marine school in France at all.

Independent and successful van Goyen worked under Esiais van de Velde in Haarlem and then formed his own school in The Hague in 1631.

The freedom of his style surprises us today and must have astounded the critics of his time. His earliest works are predominantly green. His monochromatic period does not commence until about 1640 and in later years he again acquired colour but with lofty sky space. In this period he painted a few large panoramics. Naturally this Haarlem school was in close contact with its neighbours but there is a marked difference between the works of van Goyen and his contemporary de Vlieger. Their choice of composition was often similar when they painted estuaries, but the treatment differed widely. Van Goyen painted as a landsman, and gave much less thought to the movement of water than did de Vlieger. He passed hastily but most skilfully over it, intent on the effect of a general impression. De Vlieger, on the other hand, with the eye of a sailor, goes deeper. The water was his real interest.

Van Goyen was gifted with an exceptional sensitivity and a graphic expressionism of his own which has raised him to the great level at which we consider him today.

Signatures :

Most often the monogram VG but also I. V. GOIEN, I. V. GOYEN, JVG, VGOYEN.

Signed Examples :

FRANKFURT Stadelsches Kunstinstitut.
No. 1017. *The Haarlem Sea.*
Signed : VG 1656.
Panel : 15½ x 21¼ in. 39.5 x 54.2 cm.
GENEVA Musee d'Art et d'Histoire.
No. CR68. *Seascape with shore and jetty.*
Signed : JVG.
Panel : 15 x 24 in. 16.5 x 27 cm.
GREENWICH National Maritime Museum.
No. 62-60. *Fishing boats in an estuary.*
Signed : VG.

Panel: 10 x 12 in. 25.5 x 30.5 cm.

HAGUE Mauritshuis.
 No. 551. *View of Dordrecht* (see figure 33).
 Signed: V. Goyen 1633.
 Panel: $18\frac{1}{4}$ x $28\frac{3}{4}$ in. 46.5 x 72.7 cm.

KARLSRUHE Staatliche Kunsthalle.
 No. 1843. *Seascape with a gathering storm.*
 Signed: VG 1647.
 Panel: 18 x 27 in. 45.9 x 69 cm.

PARIS Musee du Louvre.
 No. 1035. *Seascape.*
 Signed and dated 1647/9.
 Panel: 29 x $42\frac{1}{2}$ in. 74 x 108 cm.

ROUEN Musee des Beaux-Arts.
 No. 907-I-83. *Beach scene.*
 Signed and dated 1653.
 Panel: $11\frac{1}{2}$ x $15\frac{1}{2}$ in. 29 x 40 cm.
 No. 818-I-7. *Vessels moored on a river bank.*
 Signed: V.G.
 Panel: 13 x $16\frac{3}{4}$ in. 33 x 42.5 cm.

ROTTERDAM Stichting Willem van der Vorm.
 No. 32. *Sailing ships on the Kagermeer.*
 Signed: V.G. 1639.
 Panel: $18\frac{1}{2}$ x $27\frac{1}{2}$ in. 47 x 70 cm.

VIENNA Akademie der Bildenden Kunste.
 No. 736. *Dutch harbour scene.*
 Signed: VG.
 Panel: 10 x 16 in. 25.2 x 41.5 cm.
 No. 814. *View of Dordrecht.*
 Signed: VG 1648.
 Panel: $25\frac{3}{4}$ x 38 in. 65.5 x 97 cm.

JACOB DE GRUYTER
Worked in Rotterdam between about 1658 and 1689.
De Gruyter is a rare and individualistic painter over whose history people differ widely. His signed works are few and those that do bear a signature are fairly well painted. He seems to have the habit of cramming a large number of ships into his pictures, but neverthless does not seem to sacrifice his feeling for space and depth (see figure 34).
The sterns of his ships are delicately painted, with flags and sails soft in appearance with a sharp and unusual V shaped kink in the material of the flag. The pendants often have an exaggerated curl, and, like the flags, his seas have a soft appearance, with areas of light over the water and ripples edged with white. Although De Gruyter has an individual style, it is by no means a very great one.
Signatures:
 J. de Gruyter, sometimes followed by a date.
Signed Examples:

AMSTERDAM Rijksmuseum.
 No. 116. *Dutch ships.*
 Signed: J. de Gruyter.
 Panel: 39 x $31\frac{1}{2}$ in. 100 x 80 cm.

GREENWICH National Maritime Museum.
 No. 62-83. *A rock in a calm sea.*
 Signed: J. de Gruyter.
 Panel: $17\frac{1}{2}$ x $20\frac{1}{2}$ in. 44.5 52 cm.

J. C. VAN DER HAGEN

Born The Hague ?1676, died Dublin *c*1745.

Until recently the works of van der Hagen were frequently attributed to Willem van de Velde the Younger (1633-1707) or Peter Monamy (1683-1749). There is often a marked similarity to Van de Velde's late works, with not quite the master's skilful touch. His colouring tends to be more pale than that of Van de Velde's.

It appears that van der Hagen came to London late in the 17th Century, joined the studio of the Van de Veldes and then married the daughter of the Younger. He is said to have had much custom with his seascapes and then early in the 18th Century to have continued his success in Dublin.

Several paintings have recently come to light signed by J. V. Hallken. The style and colouring of these is very close to J. C. van der Hagen and it is most likely that they are in the same hand.
Signatures:

J. V. Hagen, J. C. Hagen, J. van Hagen.
Signed Examples:

GREENWICH National Maritime Museum.
English Ships in a Storm (see figure 35).
Signed.
37½ x 50 in. 95.5 x 127 cm.

FORMERLY IN THE AUTHOR'S COLLECTION
Dutch warships and a yacht at sea.
Signed: J. V. Hagen.
Oils on canvas: 17 x 24 in. 43 x 61 cm.

LICHTENSTEIN Fuerstliche Sammlung.
No. 600. *Ships in a calm sea.*
Signed: J. C. v. Hagen fe.
Oval in copper: 4½ x 5¾ in. 11.3 x 14.6 cm.
No. 601. *Battle at sea.*
Signed: J. C. v. Hagen: Fe.
Oval in copper: 4 x 5¾ in. 11.2 x 14.7 cm.
No. 635. *Warship.*
Signed: J. van der Hagen.
Canvas: 17 x 24 in. 43 x 61 cm.
No. 636. *Open sea.*
Signed: JCv. Hagen.
Canvas: 17 x 24 in. 43 x 61 cm.
No. 1013. *Seascape.*
Signed: JCv Hagen.
Canvas: 21½ x 26½ in. 55 x 67 cm.
No. 1014. *A large warship.*
Signed: J C van der Hagen.
Canvas: 21½ x 26¼ in. 55 x 66.5 cm.
No. 1257. *Sinking ships off rocky cliffs.*
Signed: IV Hagen.
On copper: 4½ x 7 in. 11.4 x 18 cm.

WILLEM VAN DER HAGEN

Active in the last quarter of the 17th Century to about 1736.

Nothing is known of Willem van der Hagen's life, although there appear to be some ten works known to bear his signature. His style is a derivation of Willem van de Velde the Younger (1633-1707) and there is some similarity to Hendrick Minderhout (1632-1696).

Most of the paintings being views in England or subjects of English interest, one is tempted to think that van der Hagen painted in England like his namesake, J. C. van der Hagen, who was possibly a relation.
Signatures:

W. V. Hagen, W. Vanderhagen.

Signed Examples:
STRANMILLIS Ulster Museum.
William III landing at Carrickfergus in 1690 (see figure 36).
Signed: W V Hagen.
Oils on canvas: 71 x 51 in. 180 x 130 cm.

JAN VAN LEYDEN

Works dated between 1661 and 1675.

Little is known of the history of this painter who seemed to paint only seascapes. Jan van Leyden is known for his few historical battle scenes between the years of 1666 and 1667 commemorating victories over England. The pictures were good in design but badly painted and he was a poor colourist.

Signatures:
JVL or JvLeyden.
Signed Examples:
AMSTERDAM Rijksmuseum.
No. 1451. *Dutch fleet attacking the English off the coast at Chatham, 20th June 1667* (see figure 37).
Signed: JvLeyden.
Panel: 36½ x 61½ in. 92 x 156 cm.
GATESHEAD Shipley Art Gallery.
No. SB467. *A Shipwreck.*
Signed: JVL.
Panel: 16 x 37 in. 41 x 94 cm.

JACOB GERRITZ LOEFF or LOEF

Worked at Enkhuizen between 1646 and 1648 in his early forties.

Jacob Loeff was a completely unknown artist until a few years ago, when Mr. J. A. Renckens of the Art Historical Section of the State Bureau in The Hague brought this master to notice and was able to attribute a number of works to him on the grounds of style and technique.

The National Maritime Museum at Greenwich have two pictures by Loeff bearing the monogram I.G.L. One of these is of de Witte in action with Dunkirkers off the coast of Nieuport in 1641.

Very few paintings are known by this rare and pleasing artist, whose manner of painting compares with the art of Jan Porcellis (1585-1632), Simon de Vlieger (1600-1653) and Willem van Diest (1610-1663).

Signatures:
I.G.L. or I. G. Loef.
Signed Examples:
GREENWICH National Maritime Museum.
No. 62-69. *De Witte in action against Dunkirkers off the coast of Nieuport in 1641.*
No. 62-70. *Same subject* (see figure 38).
Both signed: I.G.L.
Panel: 15 x 28½ in. 38.25 x 72.5 cm.

PHILIP VAN MACKEREN or MACHEREN

Worked c1650-1672 in Rotterdam and around Middelburg.

Philip van Mackeren was a painter of no great skill, who owes his fame more to the confusion of his work with that of Jacob Ruisdael than anything else. He worked in the middle of the century and has left a work in the Stadthuis of his native town of Veere, which records all the vessels belonging to that port in 1651. He is also spoken of as having gone to sea to report ship actions more accurately. (There is no evidence of this).

Signatures:
P.M.R. or Ph. van Macheren.
Signed Examples:
VEERE Stadthuis.
Crowded scene in Veere harbour of Dutch vessels of all classes (see figure 39).
Signed: Ph. v. Macheren 1651.
Canvas: 39 x 49½ in. 99 x 126 cm.

MICHIEL MADDERSTEG

Born Amsterdam 1659, died Amsterdam 1709.

Maddersteg is sometimes called the ablest scholar of Ludolph Backhuyzen whose work he imitated most successfully. He seldom signed his pictures and one is therefore led to believe that many pictures by him must be attributed to his master.

In 1698 he was employed by the Court of Berlin where he passed the greater part of his life until his return to Amsterdam where he turned dealer and eventually died in 1709.

Signature:

When used it was with the initials M.M.

Signed Examples:

AACHEN Museum der Stadt Aachen.

No. GK284. *Sailing ships on the open sea.*

Panel: 22½ x 34½ in. 57 x 88 cm.

WURZBURG Martin von Wagner Museum.

No. 455. *A rough sea* (see figure 40).

Panel: 25¾ x 32½ in. 65.5 x 82.5 cm.

CORNELIS MAHU

Born Antwerp c1613, died there 1689.

Mahu is better known for his still-life painting, although he produced a few seascapes of interest and originality. His palette is an exciting mixture of greens and browns emphasised with broad touches of white highlights in the waves. He comes close to Jacob Ruisdael (1625-1682) in the latter's painting of a choppy sea. Master of Antwerp Guild 1638.

Signatures:

C. MAHU.

Signed Examples:

DORDRECHT Museum Exhibition of "Sea and River Paintings," 1964.

Catalogue No. 51. *Vessels in a high wind on an estuary* (see figure 41).

Signed: C. MAHU.

Panel: 16½ x 22½ in. 42 x 57 cm.

ABRAHAM MATTHUYS, MATTHYS, MATHYSSENS

Born Antwerp 1581, died Antwerp 1649.

Matthuys was one of the many Antwerp men whose scope included, though was not confined to, sea subjects.

Born in Antwerp in 1581, he travelled to Italy at the age of 22 and when he returned home in 1619, forsook his studio to sail with his father, a whaling merchant, for the space of three years.

On his return he produced several pictures of whaling ships and fleets and painted the subject for its own sake, with accuracy and realism, carrying the theme a long way since the work of Herri met de Bles of c1500.

Matthuys painted most admirably, the cold seas of the Arctic and his ships were accurately depicted, but they float heavily and the grey and green waves are rather stiff. His pictures often show the ships and crews in action and the flensing of the whales.

A pupil of Tobias Halent, Matthuys also painted landscapes, religious subjects, still-life and even portraits, but appears seldom to have signed his work. He painted a portrait of Bonaventura Peeters the Elder, which is now in Hoboken Church where Peeters is buried.

Example:

GREENWICH National Maritime Museum.

The whaling fleet in action (see figure 42).

Not signed.

Canvas: 23½ x 39 in. 60 x 99 in.

HENDRIK DE MEYER

1620 Rotterdam 1690.

There are several historical and landscape pictures by de Meyer of average competence in Dutch museums. The figures in the Hague Gemeentemuseum picture are rather stylised and coarse, yet the river ceremonial panel in the Copenhagen museum is more fine and careful in treatment. Other river scenes show a similarity to Albert Cuyp.

Signatures:

H. de Meyer, H. de Meijer.

Signed Examples:

COPENHAGEN Statens Museum.

Embarkation of troops on a Dutch river (see figure 43).

Signed.

Panel: 36 x 58½ in. 91.5 x 149 cm.

THE HAGUE Gemeentemuseum.

Departure of King Charles II from the beach of Scheveningen, 1660.

Signed.

Canvas: 46½ x 67 in. 119 x 170 cm.

HENDRIK VAN MINDERHOUT

Born Rotterdam 1632, died Antwerp 1696.

Hendrik van Minderhout was a talented painter of seascapes who was a Dutchman strongly influenced by the Flemish, having lived in Bruges from 1652 to 1672. In 1663, he was elected to the Guild of that City, the Guild of St. Luke, and went to Antwerp in 1672. It is quite possible that there were two Minderhouts working at the same time, for while it is understandable for a painter to show different styles in his painting, it is difficult to accept that all his signed paintings are authentic. There is a wide margin between his paintings in the Flemish style and those of Mediterranean scenes and between his best and his poorest signed works. There are also one or two church interior paintings known to exist. At his best, Minderhout has the quality of Willem van de Velde (1633-1707). However, his style is really individualistic and there are two pictures, one at the Antwerp Koninklijk Museum and the other at the Brussels Musee de Beaux-Arts, which show best his Mediterranean style.

He painted large pictures and was inclined towards a theatrical effect, especially in the Mediterranean scenes.

Signatures:

Hvan Minderhout, HVMINDERHOUT, Minderhout, or the monogram HMDh bunched tightly together.

Signed Examples:

ANTWERP Koninklijk Museum.

No. 438. *A Levantine Port.*

Signed: HVan Minderhout Int.F.Anno 1675.

Canvas: 90 x 88 in. 229 x 223 cm.

BRUGES Museum.

The harbour of Zeebrugge.

Signed: Hvan Minderhout 1652 und Viva Vlanderen 1653.

DRESDEN Gemäldegalerie.

No. 1165. *Mediterranean Scene.*

Signed: Hvan Minderhout 1673.

Canvas: 33½ x 46 in. 85.5 x 117 cm.

DUNKIRK Museum.

No. 218. *Mediterranean Harbour Scene.*

Signed and dated 1695.

Canvas: 58¼ x 97½ in. 148 x 248 cm.

GREENWICH National Maritime Museum.

No. 36-63. *Shipping at Leghorn* (see figure 44).

Signed: HMINDERHOOT dated 1670.

Canvas: 58 x 103 in. 147.5 x 262 cm.

MADRID Musee del Prado.
 No. 2105. *A large river boat coming alongside a quay.*
 No. 2109. *Passengers disembarking from a river boat.*
 Pair signed : HMDh 1688.
 Canvas : $27\frac{1}{2}$ x $65\frac{1}{2}$ in. 70 x 167 cm.
OSLO National Gallery.
 Mediterranean view with ships alongside a quay.
 Signed : Hvan Minderhout.
 Canvas : 57 x 100 in. 147 x 254 cm.
ROUEN Musee des Beaux-Arts.
 No. 818-I-16. *View of a Levantine harbour.*
 Signed : Hvan Minderhout.
 Canvas : 42 x $86\frac{1}{2}$ in. 107 x 220 cm.
ST. OMER *A harbour in the Levant.*
 Signed : Hvan Minderhout 1670.
 Canvas : 59 x $86\frac{1}{2}$ in. 150 x 220 cm.

CORNELIS PIETERSZ DE MOOY
Born Rotterdam 1656, died Antwerp 1701.
A Dutch grisaille painter who worked in Rotterdam, Cornelis de Mooy is considered to be one of the best of the grisaille painters.
His earliest dated grisaille is 1666 and his last known one 1692, the subjects being mainly merchant vessels rather than men-of-war. De Mooy's style is fine and meticulous, the design light and crisp with hardly a heavy line, the stern flags always prominent.
Unfortunately attributions differ widely with Mooy and there are many clumsy and less pleasing grisailles which are under his name.
Signatures :
 C. P. Mooy, C. P. Mooij or C.P.M., B. Mooy.
Signed Examples :
ARNHEM Gemeentemuseum.
 Seascape.
 Signed : C. P.Mooij.
 Grisaille on panel : 12 x $19\frac{1}{4}$ in. 31 x 49 cm.
CAEN Musee des Beaux-Arts.
 No. 14. *Two men-of-war in a rough sea.*
 Signed : C. P. Mooy 1691.
 Grisaille on panel : 11 x $13\frac{3}{4}$ in. 28 x 35 cm.
GREENWICH National Maritime Museum.
 No. 33-35. *A Dutch dogger, a whaler and other vessels off a Dutch port.*
 Signed : CPMooy.
 Grisaille on panel : $15\frac{1}{2}$ x 21 in. 39.5 x 53.5 cm.
 No. 27-324. *The Eendracht, Zeven Provincien and other men-of-war* (see figure 45).
 Signed : 'Mooy'
 Grisaille on canvas : 32 x 47 in. 81.5 x 119.5 cm.
 No. 36-91. *Dutch flute 'St. John Baptist'.*
 Signed : P. Mooy 1668.
 Grisaille on panel : 22 x 37 in. 57 x 94.5 cm.
 Note : There may be also a P. C. Mooy, a grisaille artist who died about 1730 (e.g. National Maritime Museum, Greenwich No. 38-959). The larger paintings may be by P. C. Mooy and not C. P. Mooy.
KASSEL Staatliche Kunstsammlung.
 No. 1749/1263. *Shipping off Rotterdam.*
 Signed : C.P.M.
 Grisaille on panel : $14\frac{3}{4}$ x $19\frac{1}{2}$ in. 37.2 x 49.5 cm.

ROTTERDAM Prins Hendrik Museum.
 No. 1686. *Warship in a storm off some rocks.*
 Signed : C.P.M.
 Grisaille on canvas : 15 x 22 in. 38.8 x 56 cm.

PIETER MULIER THE ELDER
Born Haarlem 1615, died Haarlem 1670.
Chairman of the Haarlem Guild in 1640, Pieter Mulier was the father of Pieter Mulier the Younger, called 'Tempesta' and the master of Frans de Hulst (1610-1661).
Mulier is widely known as a follower of the Porcellis, de Vlieger grey monotone school, although he had not the breadth of treatment of de Vlieger. He was a good draughtsman, but his tone was cold, favourite themes depicting fishing boats in a rough or choppy sea close inshore. An idiosyncracy of Mulier's was to pick out the ships with sharp touches of white. The rough seas often have pointed waves with the wind blowing across the water as if it were sweeping all before it. There is inevitably a large area of sunlit water where there are white streaks accentuating the movements of the waves.
Signatures :
 P.M.L. or sometimes the monogram P.M.
Signed Examples :
AMSTERDAM Rijksmuseum.
 No. 1684BI. *Ships in a breeze.*
 Signed : PM.
 Panel : 15 x 23½ in. 38.5 x 60 cm.
DRESDEN Gemäldegalerie.
 No. 1378. *Fishing vessels on the shore.*
 Signed : PML.
 Panel : 13½ x 13½ in. 34.5 x 34.5 cm.
GREENWICH National Maritime Museum.
 No. 62-37. *Dutch ship in a breeze off a rocky coast.*
 Signed : PM
 Panel : 15½ x 20 in. 39 x 51 cm.
 No. 62-38. *A shallow sea with fishing boats.*
 Signed : PML.
 Panel : 12½ x 22 in. 32 x 56 cm.
 No. 62-39. *Ships in a heavy sea running before a storm* (see figure 46).
 Signed : PM.
 Panel : 15½ x 21 in. 39.5 x 53.5 cm.
 No. 62-40. *Shipping in a breeze off a rock.*
 Signed : PM
 Oval panel : 15½ x 21 in. 39 x 56 cm.
LENINGRAD State Hermitage Museum.
 No. 3482. Reserve Collection.
 Three ships running before a gale in a very heavy sea.
 Signed : PML.
 Panel.
PRAGUE National Gallery.
 No. DO-4343. *Vessels in a choppy sea.*
 Signed : PML.
 Panel : 18½ x 25 in. 47 x 63.5 cm.

PIETER MULIER THE YOUNGER
Called also Tempesta and Pietro Mulier.
Born Haarlem 1637, died Milan 1701.
Pieter Mulier the younger was a man of impetuous character with an interesting history. He is far better known in Italy than in his native Holland.

He was a painter of considerable skill and interest. His major work is perhaps the fresco decoration of the Palazzo Colonna in Rome for which he produced a series of tempestuous and calm seascapes. These are very Italianate and while they are reminiscent of Brill and Claude, they also look forward to the rough seas of Marco Ricci.

Dating to about 1660, the frescoes are similar to the fine seascapes in the National Maritime Museum, Greenwich.

Mulier's works are sometimes superficially painted but are always dramatic and theatrically effective. The storm scenes are always full of energetic cloud and light effects; seas whipped up by a strong gale and ships foundering in foul weather, usually off a rocky Mediterranean coast. The colouring of his tempests is a green-grey and that of his coastal views green and brown, always very fresh.

Earlier works were more in the style of his father and it is probable that not only was Tempesta a pupil of his father, but was also mistaken for him in his early works.

Mulier's life makes him a more interesting figure for study. Having murdered his wife in Italy, been continually hunted by the police and finally gaoled for some years in Genoa, his fame was outstanding and colourful. His work made him wealthy and he lived the life of a grand seigneur.

Roethlinberger goes so far as to call him 'the most important figure in Northern Italy, hardly second to Gaspard in Rome'. See B.M. article. M. Roethlinberger.

Signatures: PM., P.f., Tempest.

Signed Examples:

GREENWICH National Maritime Museum.
Shipping in a storm off a rocky coast (see figure 47).
Signed.
Canvas: 16 x 28 in. 41 x 71 cm.
Fresh breeze in the Mediterranean.
Signed.
Canvas: $27\frac{1}{2}$ x 67 in. 70.5 x 171 cm.

ROME Palazzo Colonna.
Panels showing stormy seascapes.
Fresco: 315 x 220 cm.
Details showing coastal view.
Fresco: 315 x 220 cm.

REINIER NOOMS called ZEEMAN
Born Amsterdam 1623, died Amsterdam 1667 or later.

Reinier Nooms stands high in the order of sea painters and especially etchers. Formerly a professional Dutch sailor, hence the signing of his name Zeeman (seaman) and not usually Nooms, he visited much of the world in his short life, making sketches for his pictures which he painted in Amsterdam.

Nooms concentrated on subjects of nautical interest and had the eye of a genuine sailor. He showed in detail what a landsman might only vaguely have indicated by a vague impression, but his standard of draughtsmanship varies. He also painted sea battles, many Southern ports and coastal views of North Africa.

Nooms has a tendency to use dark tones, with touches of red and with yellow and light blue in his skies, but using more light grey in his later pictures.

He had an inclination to tell a story or illustrate a certain place or event. A favourite theme of his was to show a ship on its side with caulkers working on a raft. Occasionally, he painted night scenes with ships on fire and many people on the foreshore.

The ships are cleverly distributed, flags hang down in a peculiarly pointed and characteristic manner, and another mannerism of Nooms was to paint sails in the same picture in different colours. He was detailed and accurate in his work and did many drawings with Michael Mozyn glorifying the exploits of Admiral Marten Tromp.

He painted most of his pictures on canvas.

Signatures:
R. Zeeman, Zeeman, Seeman.

Signed Examples:

30

AMSTERDAM Rijksmuseum.
 No. 1753. *The Battle of Leghorn 1653.*
 Signed : R. Zeeman.
 Canvas : 56 x 88½ in. 142 x 225 cm.
 Scheepvaartsmuseum.
 View of the Y near Amsterdam.
 Signed : R. Zeeman.
 Canvas : 24 x 26 in. 61 x 66 cm.
BERLIN Gemaldegalerie.
 No. 875. *Calm sea with vessels ashore.*
 Signed : R. Zeeman.
 Canvas : 9½ x 8½ in. 24 x 22 cm.
BRUNSWICK Herzog Anton-Ulrich Museum.
 No. 342. *Italian coast scene.*
 Signed : Zeeman Ao 1659.
 Canvas : 16 x 15 in. 41 x 38 cm.
COPENHAGEN Royal Museum of Fine Arts.
 No. 516. *Men-of-war at anchor and under repair* (see figure 48).
 Signed : R. Zeeman.
 Canvas : 42 x 54½ in. 107 x 138 cm.
COPENHAGEN Royal Museum of Fine Arts.
 No. 517. *Mediterranean Harbour.*
 Signed : R. Zeeman.
 Canvas : 23 x 30½ in. 59 x 77 cm.
GREENWICH National Maritime Museum.
 No. 33-30. *Battle of Leghorn 4th March 1653.*
 Signed : R. Zeeman.
 Canvas : 25½ x 46 in. 65 x 117 cm.
 No. 27-363. *Ships under repair.*
 Signed : R. Zeeman.
 Canvas : 12 x 16 in.
KASSEL Staatliche Kunstsammlung.
 No. 1749/1560. *Southern Harbour.*
 Signed : R. Zeeman.
 Canvas : 30¼ x 42¼ in. 154 x 215 cm.
LENINGRAD State Hermitage Museum.
 No. 8881. *Mediterranean harbour scene.*
 Signed : R. Zeeman.
 Panel : 15 x 16½ in. 38 x 42 cm.
RENNES Museum.
 No. 172. *Naval battle.*
 Signed and dated 1633.
 Copper : 10½ x 21 in. 27 x 53 cm.
 No. 168. *Small vessels drawn up on the shore.*
 Signed : Zeeman.
 Canvas : 11¾ x 17½ in. 30 x 44.5 cm.
ROTTERDAM Boymans-van Beuningen Museum.
 No. 1598. *Men-of-war anchored close inshore.*
 Signed : R. Zeeman.
 Canvas : 15¾ x 17¼ in. 40 x 44 cm.
 Stichting van der Vorm.
 No. 57. *Bay with ships, probably in the Mediterranean.*
 Signed : Seeman.
 Panel : 22¼ x 32 in. 57 x 81 cm.

SCHWERIN Staatliches Museum.
 No. 34. *A harbour at sunset.*
 Signed : R. Zeeman A. 1663.
 Canvas : $16\frac{1}{2}$ x $22\frac{3}{4}$ in. 42.3 x 57.8 cm.
STOCKHOLM National Museum.
 Dutch vessels being overhauled in a harbour.
 Signed : R. Zeeman.
VALENCIENNES Musee des Beaux-Arts.
 Seascape.
 Signed : R. Zeeman.
 Canvas : $12\frac{1}{2}$ x $15\frac{1}{4}$ in. 32 x 39 cm.
VIENNA Akademie der Bildenden Künste.
 No. 1397. *Frigates at anchor.*
 Signed : R. Zeeman.
 Canvas : $12\frac{1}{2}$ x $15\frac{1}{2}$ in. 32 x 39 cm.

BONAVENTURA PEETERS THE ELDER

Born Antwerp 1614, died Hoboken 1652.

The Flemish family of Peeters produced five notable artists in the 17th Century – Bonaventura Peeters and his brothers Gillis and Jan Peeters, his sister Catharina and Bonaventura the younger son of Gillis Peeters. Bonaventura the Elder was the best known of the five. He is thought to have been first a pupil of Andries van Eertvelt (1590-1652) and, later, of Simon de Vlieger (1600-1653), where a similarity of style is often much in evidence. It is also probable that part of his early life was spent at sea, for his paintings show an intimate knowledge of ships and their behaviour in lively seas.

His early paintings show a continuing tradition in the panoramist style, with boats, water and backgrounds rather wooden and stiff. Later, under de Vlieger's influence, he developed a much freer and more easy style and his appreciation of atmosphere gave his paintings a pleasing degree of realism.

Though Peeters' most favoured subject was views of the Scheldt, he painted a variety of scenes, including views of the South American coast. So far it has not been possible to establish as to whether he actually travelled to the Southern Hemisphere or whether he relied on accounts given by his elder brother Gillis, who was the more likely traveller and who also painted scenes from those regions.

It seems improbable that Peeters travelled for he was a man of ill health. He never married and in his latter days lived in the country at Hoboken with Catharina and Jan. Besides his painting, he earned a reputation as a poet.

In his painting his portrayal of the *Amelia* has won wide acclaim. It is considered to be the best painting of Tromp's famous flagship.

Signatures :
 B.P., B. Peeters and, rarely, Bonaventura Peeters.
Signed Examples :
AMSTERDAM Rijksmuseum.
 No. 1847. *Shipping near a pier on the Scheldt.*
 Signed : B.P.
 Panel : $14\frac{1}{4}$ x 27 in. 36.5 x 69 cm.
BASLE Kunstmuseum.
 No. 486. *Stormy seas.*
 Signed : B. Peeters.
 Panel : $15\frac{1}{2}$ x $20\frac{1}{2}$ in. 39.5 x 52 cm.
BERLIN Gemäldegalerie.
 No. 939. *Men of war in a choppy sea.*
 Signed : B.P. 1636.
 Panel : 19 x 28 in. 48 x 41 cm.
BRUSSELS Musee des Beaux-Arts.
 No. 1072. *An Eastern port.*
 Signed : B. Peeters 1651.

Panel : 26½ x 37 in. 67.5 x 94.5 cm.

No. 676. *Storm at sea.*

Signed : B.P.

Panel : 9½ x 13½ in. 24 x 34 cm.

No. 1216. *Calm sea.*

Signed : B.P.

Panel : 14 x 27½ in. 24 x 34 cm.

MUNICH Alte Pinakothek.

No. 2055. *Estuary scene with a yacht firing a salute, surrounded by other vessels.*

Signed : B. Peeters.

Canvas : 21 x 38 in. 54 x 97 cm.

No. 2187. *Galleys in a Mediterranean harbour.*

Signed : B. Peeters with a faint date.

Canvas : 27½ x 41½ in. 69.5 x 105 cm.

No. 6332. *Estuary scene with cargo boat off a town* (see figure 49).

Signed : Bonaventura Peeters.

Canvas : 23½ x 35 in. 60 x 89 cm.

ROTTERDAM Prins Hendrik Museum.

No. 1504. *Jetty with vessels.*

Signed : B.P.

Panel : 21 x 30 in. 54 x 76 cm.

No. 1683. *View of a harbour.*

Signed : B. Peeters.

Panel : 16½ x 25 in. 42 x 64.5 cm.

No. 1484. *Mouth of a harbour.*

Signed and dated 1637.

Canvas : 12 x 17½ in. 30.5 x 44.2 cm.

SCHWERIN Staatliches Museum.

No. 357. *Harbour scene.*

Signed : B.P.

Panel : 20½ x 34½ in. 52 x 87.5 cm.

No. 2307. *Seastorm and shipwreck.*

Signed : B.P.

Panel : 9 x 13½ in. 23.5 x 43.5 cm.

VIENNA Akademie der Bildenden Kunste.

No. 800. *Marine landscape with shore fire.*

Signed : B.P. 1643.

Canvas : 14½ x 17½ in. 36.8 x 44.5 cm.

No. 1001. *A port with wounded soldiers disembarking.*

Signed : B.P.

Panel : 18½ x 25 in. 47 x 63 cm.

No. 1781. *Seascape.*

Signed : B.P.

Panel : 18½ x 24½ in. 47 x 62 cm.

BUDAPEST National Gallery.

Arrival of a ship.

Signed : B. Peeters 1637.

CAMBRIDGE Fitzwilliam Museum.

No. 347. *Beach scene with ship and fishing boat.*

Signed : B.P.

Panel : 12½ x 17¾ in. 32 x 45.5 cm.

DELFT Stedelijk Museum.

No. 99. *Antwerp harbour. The reception by the Governor of the Netherlands of the Cardinal Infanta Ferdinand of the Spanish delegation to Munster. Dutch squadron in the background.*

Signed: B. Peeters.
Canvas: 53 x 85 in. 135 x 215 cm.

EMDEN Ostfriesches Museum.

No. 910. *Coast with a rough sea.*
Signed: P.B.
Panel: 9¾ x 13¾ in. 25 x 34 cm.

GREENWICH National Maritime Museum.

No. 62-44. *Dutch fishing boats in a fresh breeze.*
Signed: B.P.
Panel: 8 x 10 in. 20 x 25 cm.
No. 45-43/7. *View of Archangel with shipping.*
Signed: B.P. 1644.
Canvas: 15½ x 26½ in. 39.5 x 67.5 cm.
No. 63-46. *A dismasted ship in a rough sea. An island in the background.*
Signed: B.P. 1647.
Panel: 16 x 28 in. 41 x 71.5 cm.

HAMBURG Kunsthalle.

No. 302. *Harbour scene.*
Signed: B. Peeters 1649.
Canvas: 45 x 80 in. 114 x 203 cm.
No. 303. *Men-of-war in a harbour.*
Signed and dated 1649.
Canvas: 45 x 80 in. 114 x 203 cm.

HANOVER Landesgalerie.

No. PAM 836. *Stormy Seas.*
Signed: B.P.
Panel: 15¼ x 23½ in. 39 x 59 cm.

LENINGRAD State Hermitage Museum.

No. 2153. *A harbour scene.*
Signed: B.P.

LICHTENSTEIN Fuerstliche Sammlung.

No. 417. *Storm at sea.*
Signed: B.P. 1647.
Canvas: 29½ x 44 in. 75 x 112 cm.

PEETERS, JAN

Born Antwerp 1624, died Antwerp 1680.

A Flemish painter who was the brother and pupil of Bonaventura Peeters the Elder whose style he continued, without being able to achieve the greatness of the master. His pictures are more hard and are designed to give greater dramatic effect than even those of his father. He is best known for his pictures of rough seas where boats are being tossed violently on the water or being dashed against the rocks. He can, however show great skill in his scenes with calm water. One of his finest paintings can be seen in the museum at Nancy where the water is as calm as in a picture by Dubbels and cloud formations are delicately executed. There is no drama; only quiet.

His greatest idiosyncracy is in his paintings of clouds. These are almost always composed of tightly packed little balls, and the edge of each cloud is always rimmed with a puffy outline, and the clouds give the appearance of being in layers. His drawing of ships is not masterly, but it is effective and one is never aware of any technical failing in his pictures. It is true to say that he is not to many people's taste; but one feels he must surely be to everybody's interest.

He also painted winter scenes and town views. These are more rare.

Signatures:

His monogram is very like that of Jan Porcellis but there is no similarity in the paintings. J.P. or I.P.

Signed Examples:

BESANCON Musee des Beaux-Arts.

A storm scene.
Signed : I.P.
Panel : 19 x 24.7 in. 48 x 63 cm.
KASSEL Staatliche Kunstsammlung.
 No. 1819/3'81. *Battle at sea.*
 Signed : I.P. 1667.
 Canvas : 11 x 16 in. 28.5 x 41 cm.
LENINGRAD State Hermitage Museum.
 No. 3241. *Ships wrecked on a rocky coast.*
 Signed : I.P.
 $23\frac{1}{2}$ x 38 in. 60 x 98 cm.
MUNICH Alte Pinakothek.
 Seascape with two three-masters off a rocky coast.
 Signed : IP.
 Panel : 14 x 23 in. 36 x 58 cm.
NANCY Musee des Beaux-Arts.
 No. 267. *Eastern Port Scene.*
 Signed : I.P.
 Canvas : 25 x $31\frac{1}{2}$ in. 64 x 80 cm.
SCHWERIN Staatliches Museum.
 No. 2300. *A sea storm.*
 Signed : P.
 Panel : $10\frac{1}{4}$ x $12\frac{1}{4}$ in. 26.5 x 31 cm.
VIENNA Kunsthistorisches Museum.
 N.477. *Stormy sea with shipwreck* (see figure 50).
 Signed : I.P.
 Canvas : $33\frac{3}{4}$ x 40 in. 86 x 102 cm.
 No. 668. *Rocky harbour with ships.*
 Signed : I.P.
 Panel : $9\frac{3}{4}$ x 14 in. 25 x 36 cm.

MATTHIEU VAN PLATTENBURG, (PLATTE-MONTAGNE, DE MONTAGNE)
Born Antwerp 1608, died Paris 1660.
Plattenburg painted landscapes and portraits in addition to marine pictures. He is reputed to be a pupil of Eertvelt but one cannot be sure. When he was young he lived for some years in Florence, painting with Asselijn pictures that were fairly highly rated at the time and the Italian influence in his style is very prominent.
When he moved to Paris in the 1620's, he changed his name to Platte-Montagne and his gravestone names him Matthieu de Montagne. In Paris he was elected a founder member of the French Academy and became 'Peintre du Roy pour les mers', although his early years were lean and not very successful.
His storms at sea are vividly coloured, the water over-exaggerated in its turbulence and often his ships are high on the crest of a wave surrounded by foam and spray. The ships are drawn in a similar style to those of Eertvelt and nearly all have high-fluted sterns. He is alike to Claes Wou in colouring and alike to Tempesta Mulier in composition. He had a son, M. de Platte-Montaigne, who worked in France.
Signatures :
 Platte-Montagne, Montagne or Montaigne.
Signed Examples :
GREENWICH National Maritime Museum.
 No. 62-32. *Estuary scene.*
 Signed.
 Canvas : 24 x 36 in. 62 x 92 cm.
 No. 62-33. *A Dutch ship in a storm off a high coast.*
 Signed.
 Canvas : $26\frac{3}{4}$ x $37\frac{1}{2}$ in. 68 x 95.5 cm.

No. 62-35. *Ships wrecked on a rocky coast* (see figure 51).
Signed.
Canvas: 39¼ x 54¼ in. 99 x 137 cm.

GERRIT POMPE
Worked in Rotterdam 1670-1690.

A painter whose pictures are rare and about whose life little is known, except that he was a pupil of Ludolf Backhuyzen. He inherited from Backhuyzen the stiffness and formality, without being able to find the skill to enliven the composition. The waves are uniquely and heavily drawn but his strong point lies in being able to paint sails which he does with a certain amount of skill.

His picture at the National Gallery of Ireland in Dublin, a shore scene with ships at anchor in a calm sea, is near to the style of some pictures by Storck. In it there is more genuine feeling, although the whole tone of the painting is very stiff and unrelaxed, as in the Greenwich picture.

There is sometimes a similarity to the works of Pieter Coopse.

Signatures:
 G.P. or G. Pompe.
Signed Examples:
DUBLIN National Gallery of Ireland.
 No. 850. *Ships at anchor off the shore in a calm.*
 Signed: G. Pompe 1690.
 Panel: 18½ x 15½ in. 47 x 39 cm.
GREENWICH National Maritime Museum.
 No. 35-30. *Shipping off a Dutch harbour* (see figure 52).
 Signed: GPOMPE Ao 1680.
 Canvas: 33½ x 44½ in. 85 x 113 cm.
ROTTERDAM Boymans-van Beuningen Museum.
 No. 1671. *The river Maas near Rotterdam with several men-of-war and a yacht in the foreground.*
 Signed: G: Pompe.
 Copper: 11¾ x 16 in. 30 x 41.5 cm.
ROTTERDAM Collection Willem van der Vorm.
 No. 60. *Frigates off Enkhuyzen.*
 Signed: G. Pompe Pinx A.o 1671.
 Canvas: 36¼ x 60 in. 92 x 153 cm.

JAN PORCELLIS
Born Ghent *c*1584, died Leiden 1632.

Of Flemish Spanish origins, Porcellis led a restless life. Going very early to Rotterdam, where he married for the first time, he was driven back to Antwerp by adverse circumstances. In 1617 he became a Master of the Antwerp Guild.

He moved again and in 1622 he married for the second time in Haarlem.

Marine painting was basically the depiction of events which take place on the surface of the sea. Porcellis' tone and mood paintings were revolutionary in that atmosphere was all important, ships actions being sublimated to the tonal painting of sea and sky.

These paintings in the 1620's were the forerunners of a recognisably Dutch school of seascape paintings which was influential for the next thirty years, until the return of more colourful and eventful sea pieces.

In Porcellis' work the composition is of the simplest; small fishing boats at work, occasionally frigates in the distance with perhaps a small strip of land. The fine and subtle gradation from a more darkly shaded foreground to a misty light on the horizon giving effective contrast to the silhouettes of boats and sails. Above this, three-quarters of the whole composition is filled by the sky, with clouds lightly massed or darkly towering, moved by the wind and letting through a sunbeam to illuminate the centre of the picture. In the all-enveloping grey tone, the only accent on colour being on a flag or a red fisherman's beret.

This monotone style was unique in the 1620's, when artists still used all the unblended colours of the palette. One can only appreciate fully the art of Jan Porcellis when one sees how he influenced so many great painters who came after him.

Simon de Vlieger was inspired by and further refined the realism of Porcellis. He was appreciated by Jan van Goyen (1596-1656) and collected by Jan van de Cappelle (1624-1679) and Rembrandt.

Signatures:

He usually signed his pictures simply J.P., which sometimes caused confusion with that of Julius Porcellis (1609-1645) and Jan Peeters (1624-1677). Also I.P., I. Porcel and very rarely in full.

Signed Examples:

BERLIN Gemäldegalerie – Berlin Dahlem.

No. 832. *Choppy sea with fishing boats.*

Signed: I.P.

Panel: 13¼ x 15¾ in. 34 x 40 cm.

DARMSTADT Hessisches Landesmuseum.

No. 301. *Small vessels off the shore in calm water.*

Signed: I.P.

Canvas: 13 x 27 in. 33 x 69 cm.

DESSAU Amalienstift.

No. 75. *Whaling ships.*

Signed: I.P. 1624.

Panel: 13 x 22 in. 33 x 69 cm.

EMDEN Ostfriesches Landesmuseum.

No. 125. *Seascape.*

Signed: I.P.

Canvas on Panel: 12¼ x 22½ in. 31 x 57 cm.

GREENWICH National Maritime Museum.

No. 63-39. *A fishing pink on a windy day.*

Signed: I.P.

Panel: 12 x 17 in. 30.5 x 43.5 cm.

No. 62-46. *Sailors sheltering under rocks, a fishing pink in a rough sea.*

Signed: I.P.

Panel: 17½ x 27 in. 44.5 x 69 cm.

THE HAGUE Bredius Museum.

No. 87-46. *Stormy sea with ships.*

Signed: I.P.

Canvas: 20½ x 27 in. 52 x 69 cm.

No. 88146. *Vessels in a choppy sea.*

Signed: I.P.

Canvas: 13½ x 18½ in. 34 x 47 cm.

LEIDEN Stedelijke Museum.

No. 359. *Vessels in a rough sea in an estuary.*

Signed: I. PORCEL 1629.

Panel: 10½ x 14 in. 27 x 35.7 cm.

LENINGRAD State Hermitage Museum.

No. 3404. *Shore scene.*

Signed: J.P. 1630.

Panel: 11 x 16 in. 27.8 x 42 cm.

MUNICH Alte Pinakothek.

No. 5472. *Rough sea with ships.*

Signed: Johannes Porcellis 1629.

Panel: 7 x 9½ in. 18.5 x 24 cm.

OXFORD Ashmolean Museum.

No. 342. *Seascape with fishing boats.*

Signed: I.P.

Panel: 15 x 22 in. 39 x 55 cm.

ROTTERDAM Boymans-van Beuningen Museum.

No. 1675. *Small vessels entering shallow choppy sea* (see figure 53).

Signed : J.P.

Panel : 23 x 31¾ in. 58.5 x 80.7 cm.

Stichting van der Vorm.

No. 61. *Ships at the mouth of an estuary in a breeze.*

Signed : J.P.

Panel : 13 x 17 in. 33 x 43 cm.

SCHWERIN Staatliches Museum.

No. 2341. *Choppy sea with ships.*

Signed : I.P.

Panel : 7½ x 9½ in. 19.5 x 24.8 cm.

JULIUS PORCELLIS

Born Rotterdam 1605, died Leiden 1645.

Julius Porcellis was the pupil and follower of his great father Jan whose style he approached in his early days. His pictures are on the whole more quiet than those of his father. He used the latter's monochrome and has the ability of giving his paintings an aesthetic beauty which is very pleasing and not unlike the calm monochrome pictures of de Vlieger by whom he may have been influenced since de Vlieger was in Rotterdam much of the time when Julius was at his best. He used more colours than his father - sometimes a rusty brown or brown green and concentrates on painting staffage more accurately. There is a warm delicate light, the clouds are effulgent and there is an overall glow. The water is often calm and the ripples edged most pleasingly with white.

Signatures :

I.P. or J.P. Not to be confused with the monogram of his father Jan and Jan Peeters.

Signed Examples :

BERLIN Gemaldegalerie.

No. 832A. *Ships on a calm sea.*

Signed : I.P.

Panel : 8½ x 7 in. 22 x 18 cm.

DARMSTADT Hessisches Landesmuseum.

No. GK303. *Calm sea.*

Signed : I.P.

Canvas on Panel : 12½ x 22½ in. 32 x 57 cm.

FRANKFURT Stadelsches Kunstinstitut.

No. 593. *Choppy sea with sailing boats and ships.*

Signed : I.P.

Panel : 12 x 14 in. 30 x 38 cm.

GREENWICH National Maritime Museum.

No. 62-48. *Mussel Fishing* (see figure 54).

Signed : IP

Panel : 14¼ x 23¾ in. 36.5 x 60.5 cm.

No. 62-47. *Mussel Fishing.*

Signed : I.P.

Canvas : 20 x 25 in. 51 x 64 cm.

No. 62-49. *Shore scene with fishermen.*

Signed : I.P.

Panel : 15½ x 21½ in. 39.5 x 54.5 cm.

HAGUE Bredius Museum.

No. 88146. *A stormy sea.*

Signed : I.P.

Canvas : 13½ x 18½ in. 34 x 47 cm.

ROTTERDAM Boymans-van Beuningen Museum.

No. 1676. *Stormy sea.*

Signed : IP

Panel : diameter 13¼ in. 33.5 cm.

JAN CLAESZ RIETSCHOOF

Born Hoorn 1652, died Hoorn 1719.

Jan Claesz Rietschoof was the father of Hendrik Rietschoof (1687-1746), a pupil of Ludolph Backhuyzen (1631-1708). His works are interesting and well composed. Most of his work is reminiscent of Backhuyzen, but there is less thorough examination of wave formation. This is made up for by his competent drawing of shipping and clouds. His rare calm scenes are probably his best works.

Signatures:

C.J.R., C.R. or C. Rietschoof.

Signed Examples:

AMSTERDAM Rijksmuseum.

No. 2032. *Vessels in calm waters with a moored Yacht* (see figure 55).

No. 2033. *Vessels off a jetty on a breezy day.*

Pair signed: CJR.

Canvas: 23½ x 32 in. 61 x 81 cm.

AMSTERDAM Scheepvartmuseum.

The roads of Amsterdam with whaling ships.

Signed: CJR.

Panel: 10¼ x 15 in. 26 x 38 cm.

Dutch roads with several whaling vessels.

Signed: CJR.

Panel: 10¼ x 15 in. 26 x 38 cm.

GREENWICH National Maritime Museum.

No. 35-36. *A Dutch whaler close-hauled in a breeze.*

Signed: Indistinct.

Canvas: 18½ x 24 in. 47 x 61 cm.

LENINGRAD State Hermitage Museum.

No. 1016. *Boats at sea in a calm.*

Signed: C. Rietschoof.

Canvas: 24 x 31½ in. 60.5 x 80.5 cm.

MAINZ Altertumsmuseum.

No. 183. *Seascape.*

Signed.

Panel: 17 x 25 in. 43 x 63 cm.

WURZBURG Martin von Wagner Museum.

456. *Seascape.*

Signed.

Canvas: 20½ x 24½ in. 52 x 62 cm.

ADRIAN or ABRAHAM VAN SALM

Worked in Delftshaven from about 1706 to 1719, but worked elsewhere earlier.

A grisaille painter about whom little is known. He visited the Cape, according to Wurzbach, from where he executed a number of paintings and etchings. He has rather a heavy touch but some of his whaling pictures are very attractive. Although a very good draughtsman of ships, sometimes in the style of Van De Velde the Elder, he paints sails which look like cardboard and waves which are too stiff. Since very little is known about him, attributions differ widely and there is a wide difference between the grisaille No. 1293 in the Prins Hendrik Museum, Rotterdam, of a whaling fleet in action and another in the same museum of a three-master in rough water, No. 1225.

Signatures:

AS, AvS, AvSalm.

Signed Examples:

GREENWICH National Maritime Museum.

No. 36-64. *Dutch ships off Rotterdam.*

Signed.

Panel: 19½ x 27½ in. 49.5 x 70 cm.

No. 32-44. *Shipping off Delftshaven.*
Signed : ... Salm
Panel : 27 x 35 in. 69 x 89 cm.
No. 36-65. *A whaling scene.*
Signed : AvSalm
Panel : 28 x 40 in. 71 x 102 cm.
No. 30-19. *Whalers in the ice.*
Signed : AvSalm.
Canvas : 34½ x 49 in. 88 x 124.5 cm.
No. 32-55. *The Dutch herring fishery.*
Signed : A. Salm
Panel : 29 x 42 in. 74 x 107 cm.
No. 27-269/I. *Whalers.*
Signed : A. Salm.
Panel : 10¾ x 15½ in. 27.5 x 39.5 cm.
No. 27-269/2. *Herring fishery.*
Signed : A. Salm.
Panel : 15½ x 16¾ in. 39.5 x 43 cm.
No. 32-60. *Herring fishery.*
Signed : A. Salm.
Panel : 15½ x 16¾ in. 39.5 x 43 cm.
No. 32-61. *Whalers.*
Signed : A. Salm.
Panel : 16½ x 26½ in. 42 x 67 cm.
No. 38-18. *Dutch merchantmen and small craft.*
Signed : A. V. Salm.
Panel : 14 x 19 in. 36 x 48.5 cm.
No. 32-54. *Dutch Whaling Scene.*
Signed : AvSalm.
Panel : 8½ x 18 in. 22 x 46 cm.
No. 42-185. *Dutch herring fishery.*
Signed : A Salm.
Panel : 12½ x 15½ in. 32 x 39.5 cm.
ROTTERDAM Prins Hendrik Museum.
 No. 1223. *Three-masted galliot.*
 Signed : A SALM.
 Panel : 6½ x 10 in. 17 x 25 cm.
 No. 1224. *A three-master weighing anchor.*
 Signed : A SALM.
 Panel : 6½ x 10 in. 17 x 25 cm.
 No. 1225. *Fluteship off a rocky coast in rough weather* (see figure 56).
 Signed : AS
 Panel : 6½ x 10 in. 17 x 25 cm.
ROTTERDAM Collection Willem van der Vorm.
 No. 74. *Three-masters in a stormy sea.*
 Signed : A. Salm. Panel : 19 x 27 in. 49 x 69 cm.

ROELOF or REYNIER VAN SALM

1688-1765.

There are several paintings, all grisailles, which are signed with the signature R. V. Salm or the initials R.V.S. In the face of so little information, it is assumed that these represent the work of the second child of Adriaan van Salm, born on 4th February 1688 and registered as being called Roelof. He moved from Delftshaven to Rotterdam before marrying in Delftshaven in 1717. He then moved to Prinseland, where he died on 12th December 1765.

Signatures:
 R. V. Salm or R.V.S.
Signed Examples (all grisailles):
GREENWICH National Maritime Museum.
 No. 36-67. *Dutch whalers in ice.*
 Signed: R. V. Salm.
 Panel: 23½ x 30½ in. 59.5 x 78 cm.
 No. 35-27. *Dutch herring fishery.*
 Signed: R. V. Salm.
 Panel: 23 x 30½ in. 59 x 78 cm.
 No. 27-367. *Dutch herring fishery.*
 Signed: R. V. Salm.
 Panel: 22½ x 30½ in. 57.5 x 78 cm.
 No. 38-677. *Dutch whalers* (see figure 57).
 Signed: R. V. Salm
 Panel: 9¼ x 11¾ in. 23.5 x 30 cm.
ROTTERDAM Prins Hendrik Museum.
 No. 1494. *Sea Battle.*
 Signed: R. V. Salm.
 Panel: 31½ x 41¾ in. 101 x 105.7 cm.

PIETER SAVERY

Flourished in Haarlem *c*1593-1637.
Little is known of this rare painter who was probably a member of the large Utrecht family of that name, which included the animal painter Roeland Savery (1576-1639) and the very rare seascape painter Hans Savery (1597-1655).
Pieter Savery was a member of the Haarlem Guild in 1593, so he must be considered as one of the founder members of the Netherlands Marine School. Three of the four pictures by Savery known to the author depict galleys in battle and all the ships and figures are carefully and colourfully painted.
A fourth picture, of a whale stranded on Scheveningen beach, attributed to him and dated 1614, is in the Rijksmuseum.
Signatures:
 SAVERY (rare).
Signed Examples:
SOMETIME IN THE AUTHOR'S COLLECTION
 The Battle of Lepanto 1571 (see figure 58).
 Signed: Savery.
 Panel: 12½ x 20½ in. 32 x 52 cm.
 Mediterranean Battle Scene.
 Signed: Savery.
 Panel: 13 x 17½ in.

WILLEM SCHELLINKS

Born Amsterdam 1627, died Amsterdam 1678.
Willem Schellinks was a designer, poet and painter of landscapes and shore scenes and also known for his drawings.
Some of his shore scenes are of a high standard, among his best known works is the *Departure of Charles II for England before the Restoration* that he painted for the Witsen family. The drawing for this important work has been kept at the Rijksmuseum in Amsterdam.
There is much confusion over the authenticity of many of his paintings. In some cases the painting of the figures was done by J. Lingelbach (1622-1674), whose pupil he was in 1650 and many of his unfinished works were completed, either by Lingelbach or by one of his other masters – Karel de Jardin (1622-1678), Jan Wynants (1630-1685), who was a close friend, or perhaps Frederick Moucheron (1633-1686) or Nicolaes Berchem (1620-1683).

Signatures:
 WS., or W. Schellinks.
Signed Examples:
AMSTERDAM Rijksmuseum.
 Burning of the English fleet by De Ruyter on the Medway off Rochester (see figure 59).
 Canvas: 45 x 67 in. 114 x 171 cm.
GENEVA Musee d'Art et d'Histoire.
 No. 1834-8. *Destruction of the English Fleet off Chatham in 1667 by Cornelis de Witt and Admiral de Ruyter.*
 Signed.
 Canvas: 30 x 38 in. 76 x 96 cm.
LENINGRAD State Hermitage Museum.
 No. 1724. *Shore Scene.*
 Signed: WS.
 Canvas: 41 x 53¼ in. 104 x 136 cm.
 No. 6058. *Shore scene.*
 Signed: W. Schellinks.
 Canvas: 41 x 53½ in. 104 x 136 cm.

C. W. SCHUT

Active in Dordrecht and Amsterdam during the middle of the 17th Century.

C. W. Schut was not primarily a seascape painter. He worked in Amsterdam and Dordrecht, where he belonged to a large family of painters of the same name. There is no connection at all with the Flemish painter Cornelis Schut (1597-1655).

We know nothing about his life. His seascapes, which are usually of calm waters with reflections, are reminiscent of Albert Cuyp (1620-1691) and Hendrik de Meyer (1620-1690) and it would be easy to confuse their styles, however, his skies are usually clouded in his own very stylised manner.

Signatures:
 CW Schut.
Signed Examples:
HAMBURG Kunsthalle.
 No. 164. *Vessels in a calm with Dordrecht in the background and a ferry boat in the foreground* (see figure 60).
 Signed: CS Schut.
 Panel: 28 x 41¾ in. 71 x 106 cm.

EXPERIENS SILLEMANS

Born Amsterdam 1611, died Amsterdam 1653.

Sillemans was the son of an Englishman, Geoffry Sillemans, who was an important citizen in Amsterdam and closely connected with the shipping world. Experiens may well not have started life as an artist but may have later become interested through his father's connections, because his earliest grisaille is dated as late as 1649. This is very late in life when compared to his exact contemporary Willem Van De Velde the Elder, who painted a grisaille of the Battle of the Downs at the National Maritime Museum of Greenwich dated 1639.

This 1649 grisaille is very much in the style of Willem Van De Velde, but without the technical brilliance and with a rather harder tone. Later works such as that of 1652 at Greenwich are already softer and show an interest in light and shade.

There are many sketches by Sillemans, some of them much earlier than 1649, but that year sees the start of his grisaille painting upon which rests his reputation.

Signatures:
 E. Silleman, Silleman, Sillimans.
Signed Examples:
AMSTERDAM Rijksmuseum.
 No. 2200. *Dutch Harbour with Ships* (see figure 61).

Signed: E. Silleman fecit 1649
Panel: $30\frac{1}{4}$ x $41\frac{3}{4}$ in. 77 x 106 cm.
AMSTERDAM Scheepvaartmuseum.
Ship in a Bay with Figures Ashore.
Signed: Sillem a.f.
Panel: $11\frac{1}{2}$ x $15\frac{3}{4}$ in. 29 x 40 cm.
GREENWICH National Maritime Museum.
No. 51.44. *Dutch Yacht off a Pier.*
Signed: Silliman 1652
Panel: $5\frac{3}{4}$ x 8 in. 14.6 x 20.4 cm.

ADAM SILO
Born Amsterdam 1674, died Amsterdam 1766.
Silo was a many-talented painter who belongs almost to the 18th Century, though he painted a large number of good pictures before 1700.
He became a successful ship builder in Holland, Sweden and Russia. Here he was employed by Peter the Great as adviser for ship building and built the warship 'Peter and Paul' for the Russian Navy. Silo also designed and made navigational instruments and wrote several books on the subject of ship building, one of which we know to have been published in 1728.
He was the pupil of Abraham Storck (1644-1710) whose style he followed without being so great or so decorative.
Signatures:
adam silo, A.S., his signature is often very small and difficult to see.
Signed Examples:
GREENWICH National Maritime Museum.
No. 27-377. *Dutch whaler in the ice.*
Signed: A.S.
Canvas: 24 x 31 in. 61 x 79 cm.
No. 27-20. *Dutch whaler in the ice* (see figure 62).
Signed: Adam Silo.
Canvas: $17\frac{1}{4}$ x $24\frac{1}{4}$ in. 44 x 62 cm.
LENINGRAD State Hermitage Museum.
No. 3304. *Sailing vessel in rough water.*
Signed: adam silo.
Canvas: 12 x 16 in. 31 x 40 cm.
ROTTERDAM Prins Hendrik Museum.
No. 1583. *Calm water with shipping.*
Signed: A.S.
Panel: 11 x $13\frac{1}{2}$ in. 27.7 x 34.5 cm.

AERNOUT SMIT
Born Amsterdam 1641, died Amsterdam 1710.
Works dated 1667 to 1678.
Smit was a Dutch painter who was the pupil of Jan Theunisz Blankerhoof (1628-1669). Some of the latter's influence is obvious in his seas, but improves upon him as a colourist. Smit's later pictures show more of the influence of Ludolph Backhuyzen (1631-1708).
The early pictures are in a grey tone, there is often a contrast of blue and yellow in his skies with the flags painted in a manner close to that of Backhuyzen. It would appear that he travelled, as some of his pictures of both the Southern seas and Greenland were probably painted from nature.
Although he is not an outstanding draughtsman of ships, his rough seas are most convincing.
Signatures:
A. Smit, or A.S.
Signed Examples:
COPENHAGEN Royal Museum of Fine Arts.

No. 667. *Two three-masters and a galley off a Mediterranean harbour in a stiff breeze.*
Signed: 1677.
Canvas: $46\frac{1}{2}$ x 61 in. 118 x 155 cm.
KARLSRUHE Kunsthalle.
No. 1877. *Storm at sea* (see figure 63).
Signed: A. Smit.
Canvas: $35\frac{1}{4}$ x 58 in. 89.5 x 147 cm.
SCHWERIN Staatliches Museum.
No. 352. *Ships foundering in a stormy sea off a rocky coast.*
Signed: A Smit.
Canvas: $25\frac{3}{4}$ x $33\frac{1}{2}$ in. 65.4 x 85.5 cm.
DARMSTADT Hessisches Landesmuseum.
No. gk274. *Vessels in a choppy sea.*
Signed: A.S.
Panel: $10\frac{1}{2}$ x 16 in. 27 x 50 cm.

LUCAS SMOUT THE YOUNGER

Born Antwerp 1671, died Antwerp 1713.
A Flemish painter of the coast, country and scenes of contemporary naval warfare, Lucas Smout was not an important artist. He was a pupil of Hendrik Minderhout whose style is evident in some of his pictures, although some of his beach scenes are reminiscent of Bout and Boudewyns. His output was limited on account of his suffering severely from gout.
He was the son of Lucas Smout The Elder.
Signature:
 L. Smout.
Signed Examples:
COPENHAGEN Royal Museum of Fine Arts.
 Sea battle off Kjogebucht 4th October 1710.
 Signed: L. Smout f.
ANTWERP Koninklijk Museum voor Schone Kunsten.
 Beach at Scheveningen (see figure 64).
 Canvas: 14 x $17\frac{3}{4}$ in. 0.36 x 0.45m.

PIETER CORNELISZ VAN SOEST

Flourished in the mid 17th Century.
A historical painter of sea battles who concentrated on the defeat of the English in the year of our troubles with war, plague and fire. He is represented by a capable work in the Scheepvaartmuseum in Amsterdam but has little originality. An important citizen in Amsterdam round about 1642.
Signatures:
 P. van Soest, P. V. Soest, V.S.
Signed Examples:
AMSTERDAM Scheepvaartmuseum.
 The Four Days Battle 1666 (see figure 65).
 Signed: P. Van Soest.
 Panel: 26 x $42\frac{1}{2}$ in. 66 x 108 cm.
GREENWICH 34-33. *Four Days Battle.*
 Signed: P. van Soest.
 Canvas: 37 x $50\frac{1}{2}$ in. 94 x 128 cm.
 37-2048. *Dutch attack on Medway, June 1667.*
 Signed: P. V. Soest.
 26 x 43 in. 66 x 109 cm.
KARLSRUHE Staatliche Kunsthalle.
 No. 1270. *Sailing ships on a calm sea.*
 Signed: V.S. Panel: 10 x 14 in. 25.5 x 37 cm.

HENDRIK MARTENSZ SORGH (SORG, SORCH, ZORGH)

Born Rotterdam 1611, died Rotterdam 1670.

Sorgh was a sea painter, the son of a cargo-boat captain travelling between Rotterdam and Dordrecht and consequently may have done a great deal of work from nature. He was Chairman of the Rotterdam Guild in 1659.

A pupil of David Teniers the Younger (1610-1690), he is better known for his genre scenes and his seascapes seem to be, for the most part, a product of his later life.

These rare, warmly and pleasingly painted pictures belong to the grey school of Jan Porcellis (about 1585-1632) and Simon de Vlieger (1600-1653), the most beautiful of which may be seen in the Rijksmuseum. The paintings usually depict fishing vessels on a choppy sea, the foreground bathed in sunlight.

Sorgh's work can also be poor and casual, hence it is difficult to recognise all his work, although this may well tend to emphasise that the few seascapes that he executed in his early life were quite successful and he was happier with genre subjects for the greater part of his life.

Signatures:

Sorgh, H. Sorgh, Sorg or Svrgh.

Signed Examples:

AMSTERDAM Rijksmuseum.

No. 2215. *Storm on the Maas with fishing vessels* (see figure 66).
Signed: H. Sorg 1668.
Panel: 18¾ x 25½ in. 47.5 x 64.5 cm.

LENINGRAD State Hermitage Museum.

No. 1025. *Vessels close-hauled in a breeze with a distant view of the coast.*
Signed: Sorgh 1660.
Panel: 16 x 19½ in. 39 x 49.6 cm.

ROTTERDAM Boymans-van Beuningen Museum.

No. 1817. *View of the Maas.*
Signed: HM Sorg 1644.
Panel: 23½ x 32 in. 60 x 83 cm.

HENDRIK STAETS

Flourished c1630-1660.

A painter about whom we know little. He seemed to specialise in painting shipwrecks and rough seas but his pictures are not dark in colour as is often the case with Dutchmen who liked to paint storm and shipwreck pictures.

The spray of the waves is a noticeable characteristic of Staets. It has a speckled appearance and reaches higher than the waves falling often on rocks which have the strange and unrealistic appearance of many of the rocks painted by Dutchmen who have probably never seen rocks.

Signatures:

H. Staets, H.S.

Signed Examples:

GREENWICH National Maritime Museum.

No. 62-57. *Ships wrecked on a rocky coast* (see figure 67).
Signed: H. Staets.
Panel: 21½ x 34½ in. 54.6 x 88 cm.
No. 62-58. *Dutch ship floundering off a rocky coast.*
Signed with monogram H.S.
Panel: 10 x 14½ in. 25.5 x 37 cm.

DUBLIN Collection Serge Philipson Esq.

Three-master off a rock in rough sea.
Signed: HS Panel: 6¼ x 12½ in. 16 x 32 cm.

EGMONT CORNELIS STOOTER

Born Leiden 1620, died Leiden 1655.

Stooter was a rare marine and portrait painter who was the pupil of Julius Porcellis. In 1648 he was Deacon

of Leiden Guild. His pictures are, however, more in the style of Peeters than Porcellis and usually portray fishing vessels in choppy seas of a characteristic green colour. He occasionally painted in a style slightly similar to Van Goyen (1596-1656), but with an individuality of his own. He painted some portraits of the Prince of Orange, but these have been burnt. A rare master.

Signatures:

STO. He is not known to have used an initial for his Christian name and in the past his works were attributed to his brother Leonard (?-1692).

Signed Examples:

DRESDEN Gemaldegalerie.
Fishing Sloops in a choppy sea.
Signed: STO

DUBLIN Collection Serge Philipson Esq.
Various vessels offshore in a choppy sea.
Signed: STO.
Panel: 16½ x 24½ in. 42 x 62.5 cm.

GREENWICH National Maritime Museum.
Vessels in a choppy sea (see figure 68).
Signed: STO.
Panel: 16 x 22¼ in. 40 x 60.5 cm.

LEIDEN Stedelijk Museum.
No. 417. *Seascape.*
Signed: STO.
Panel: 18 x 24 in. 46 x 61.6 cm.

ABRAHAM JANSZ STORCK

Original name Sturckenburg, later Sturck, but usually Storck.
Born Amsterdam 1644, died Amsterdam 1710.

Abraham Storck is one of the finest of the later school of Dutch sea painters although his work is perhaps a little too decorative and fanciful. His works are so prolific that it is evident he employed many assistants in his studio, often signing and touching up their work. He is a fine draughtsman and his ships are true in technical detail, yet he painted a blue Mediterranean sky in a view of Amsterdam and his ships glide too easily and unreally through the water. Boats are filled sometimes with colourfully dressed passengers, often at the occasion of a regatta or a similar ceremony – all of which was excellent material for Storck.

Primarily he was influenced by the younger Van de Velde and Ludolf Backhuysen and there is always evidence of these influences in his work. Battle scenes and pictures of men-of-war are very near to Van de Velde and one feels that when looking at his crowded battle and regatta scenes there must be few people who can fill a picture so completely.

The figures, which he drew exceptionally well, are dressed elegantly and colourfully and these groups are often the rich of the town, sometimes on the shore, sometimes on the jetty or in a magnificent yacht.

In his Dutch scenes which show land he frequently paints a mongrel dog; in some of his Mediterranean scenes a man with a moustache.

His brother, Jacobus Storck, painted in a similar style, yet not so competently. Abraham signed A: Storck and frequently A. Storck fecit, occasionally A:S.

Signed Examples:

AMSTERDAM Scheepvaartmuseum.
The ship Peter and Paul on the Y, 1698.
Signed: A. Storck F.
Canvas: 33 x 43¼ in. 84 x 110 cm.
Mock battle staged for Peter the Great on the river Y.
Signed: A. Storck Fecit. 1697.
Canvas: 26 x 36 in. 66 x 92 cm.
The naval battle of Etna 22 April 1676.
Signed: A. Storck.
Canvas: 33 x 51 in. 84 x 129 cm.

View of the Y.
Signed : A : Storck.
Canvas : 25 x 32 in. 64 x 81 cm.
Italian Harbour with French man-of-war.
Signed : A : Storck.
Canvas : 21¼ x 29 in. 54 x 74 cm.

AMSTERDAM Rijksmuseum.
No. 2263. *The dam at Amsterdam.*
Signed : A. Storck Fecit Ao 1675.
Canvas : 50½ x 33 in. 128 x 169 cm.
No. 2266. *In the roads at Enkhuysen.*
Signed : A. Storck.
Canvas : 34 x 46½ in. 86 x 117 cm.
No. 2266A2. *Whale fishing.*
Signed : A. Storck fecit.
Canvas : 20 x 26½ in. 50.5 x 66.8 cm.
No. 2264. *Sailing into a harbour.*
No. 2265. *Leaving a harbour.*
Signed : A. Storck F.
Pair on canvas : 28 x 33½ in. 71 x 85 cm.
No. 2266A. *Visit of Muscovian Legation to Amsterdam 29th August 1697.*
Signed : A. Storck f.

HAARLEM Frans Hals Museum.
No. 4896. *View of Haarlem in winter, seen from the Noordner Spaarne.*
Signed : A : Storck Fecit.
Canvas : 10½ x 11½ in. 27 x 29 cm.

LEIPZIG *Museum der Bildenden Künste.*
No. 1063. *View of an Italian harbour.*
Signed : A Storck.
Canvas : 19 x 28 in. 48.5 x 71 cm.

LENINGRAD State Hermitage Museum.
No. 8517. *Two bezan Yachts and other vessels in a moderate breeze on a canal, probably near Haarlem.*
Signed : A. Storck fecit.

LONDON National Gallery.
No. 146. *View of the Maas at Rotterdam.*
Signed : A Storck Fecit.
Canvas : 23 x 29 in. 58 x 73 cm.

MAINZ Altertumsmuseum.
No. 166. *Italian harbour scene.*
Signed : 1685.
Panel : 6½ x 10 in. 17 x 25 cm.

MUNICH Alte Pinakothek.
No. 6476. *Shore scene.*
Signed : A :S
Canvas : 48 x 64 in. 19 x 25 cm.
No. 2888. *Harbour scene with several ships.*
Signed : A : Storck Fecit.
Canvas : 19¼ x 25 in. 49 x 63 cm.

ROTTERDAM Prins Hendrik Museum.
No. 719. *Dutch whaling fleet* (see figure 69).
Signed : A. Storck fecit
Canvas : 23½ x 30½ in. 60 x 77.5 cm.

ROTTERDAM Boymans-van Beuningen Museum.
No. 1831. *Italian harbour.*

Signed : A. STORK

Panel : $9\frac{1}{2}$ x 12 in. 24 x 30.5 cm.

No. 1832. *Dutch harbour in winter.*

Signed : A : Storck.

Canvas : 31 x $35\frac{1}{4}$ in. 79 x 89.5 cm.

VIENNA Harrach Museum. Graf Harrach'sche Gemäldegalerie.

No. WF78. *Seascape.*

Signed : A. Storck fecit

Canvas : $20\frac{1}{2}$ x $24\frac{1}{2}$ in. 52 x 62 cm.

WEIMAR Schlossmuseum.

No. G99. *Harbour scene.*

Signed : A Storck.

Panel : 7 x $8\frac{1}{2}$ in. 18 x 22 cm.

COPENHAGEN Royal Museum of Fine Arts.

No. 689. *Squall at sea.*

Signed and dated : A. Storck Fecit Ao 1636.

Panel : 19 x 26 in. 49 x 66 cm.

DRESDEN Gemaldegelerie.

No. 690. *Encounter between English and Dutch fleets.*

Signed and dated.

Canvas : $33\frac{1}{2}$ x 39 in. 85 x 99.5 cm.

Gemaeldegalerie.

No. 1673. *Amsterdam Harbour.*

Signed : A : Storck F. 1689.

DUBLIN National Gallery.

No. 228. *Entrance to a harbour.*

Signed : A. Storck fecit.

Canvas : $29\frac{1}{2}$ x 35 in. 75 x 89 cm.

GREENWICH National Maritime Museum.

No. 48-719. *The Four Days' Battle 1-4th June 1666.*

Signed : A. Storck fecit.

Canvas : 31 x $43\frac{1}{2}$ in. 79 x 110.5 cm.

No. 38-389. *Venetian pilgrim ship in an Italian port.*

Signed : A. Storck fecit. 1697.

Canvas : 30 x 36 in. 76.5 x 91.5 cm.

No. 34-85. *A Dutch ship passing a fort.*

Signed : A. Storck fecit.

Canvas : 34 x 27 in. 86.5 x 68.5 cm.

No. 27-5/1. *Shipping off Amsterdam.*

Signed : A. Storck fecit.

No. 27-5/2. *Shipping off Amsterdam.*

Signed : A Storck

Pair on Canvas : 21 x $26\frac{1}{2}$ in. 53.5 x 67.5 cm.

No. 44-99. *Dutch Yachts on the river Y.*

Signed : A : STORCK : FECIT.

Canvas : 42 x 59 in. 107 x 150 cm.

JACOBUS or JOHANNES STORCK
Worked in Amsterdam between 1641 and 1693.

Jacobus Storck is better known as a canal and river painter, although he is known to have painted a few open sea views. He is most probably the brother of the more famous Abraham Storck, painting in a very similar style and producing pictures equally pleasing as those of his brother. One of his best works is probably the canal scene hanging in the Wallace Collection, London, and in this he quite excels himself. In the painting

of architecture Jacobus surpasses his brother; he is more accurate and pays more attention to this kind of detail.

His palette, which emphasises the pastel shades, is more delicate than that of Abraham, and a characteristic of his is to paint the water in symmetrical ripples. His pictures are frequently fairly large.

Signatures:

I. Storck, J. Storck.

Signed Examples:

AMSTERDAM Rijksmuseum.
The castle at Nyenrode.
Signed: I. Storck.
Canvas: $18\frac{1}{2}$ x $24\frac{1}{2}$ in. 47 x 63 cm.

COPENHAGEN Royal Museum of Fine Arts.
No. 691. *Harbour scene with ancient ruins.*
Signed: J. Storck 1671.
Canvas: 15 x 21 in. 37 x 53.5 cm.
No. 692. *River estuary.*
Signed: J. Storck 1683.
Canvas: 29 x 40 in. 74.5 x 102 cm.

LONDON Wallace Collection.
No. 208. *Castle on a river in Holland* (see figure 70).
Signed: I. Storck.
Canvas: $35\frac{1}{2}$ x $45\frac{1}{2}$ in. 90 x 114 cm.

CORNELIS VAN DE VELDE

*c*1675-1729.

Cornelis Van De Velde is believed to be the son of Willem Van De Velde the Younger (1633-1707).

Very few of his signed paintings are in existence, but the evidence of these shows a strong stylistic similarity with the paintings of Peter Monamy (*c* 1683/89-1749). Through the works of these two we can see how very strong was the influence of Willem Van De Velde the Younger on the early English Marine School.

Signatures:

C.V.V

Signed Examples:

LONDON Author's collection.
Royal Yachts and other yachts in a calm sea (see figure 71).
Signed: CVV
Canvas: 36 x 55 in. 91.5 x 140 cm.

PIETER VAN DE VELDE or VAN DEN VELDE, VAN DE VELDEN

Born Antwerp 1634, died after 1687 Antwerp.

A rare Flemish painter of seascapes who is unlikely to have been a distant relation of the more famous Van de Velde who was Master of the Lucas Guild in 1654.

He painted shipwrecks, coastal scenes, foreign and home ports. The rough seas are reminiscent of Jan Peeters especially when he painted his own staffage which was weak but essentially Flemish. At his best he is good and pleasing to the eye. His picture of the burning of the English Fleet at Chatham in the Rijksmuseum (No. 2455DI) is a very fine work and, one feels, must be a perfect example of where his figures have been painted by Teniers or, more likely Erasmus, his father.

His choppy seas are very stylised and the ripples usually have a flaxen appearance. His painting of ships is probably his strongest attribute. The predominant colours in his pictures are brown and grey. There may have been a painter in the 18th century named P. V. Velden.

Signatures:

PVV, P. V. d. Velde, P. V. Velden.

Signed Examples:

AMSTERDAM Rijksmuseum.
No. 2455DI. *The burning of the English off Chatham, 20th June 1667* (see figure 72).

Signed : P.v.v.
Panel : 28½ x 42½ in. 73 x 108 cm.
ANSBACH Schloss Galerie.
 No. 6. *Dutch harbour with frigates.*
 Signed : PvVelden
 Panel : 12 x 16 in. 31 x 41 cm.
GREENWICH National Maritime Museum.
 Ships at Anchor in a Mediterranean harbour.
 Ships in a stormy sea.
 Signed : Pvvelde
 Canvas : 5½ x 3½ in. 14.5 x 9.5 cm.

WILLEM VAN DE VELDE THE ELDER

Born Leiden 1611, died Greenwich 1693.

Van de Velde the Elder, the father of Willem the Youger, worked at Leiden and Amsterdam before coming to England in 1672. The greatest ship draughtsman of possibly any period, he was a sailor in his youth, before he turned his mind very seriously to drawing, and it is from those early days that he gained an intimate knowledge of the sea to help him achieve that degree of skill that we see in his work. It is not known for sure whether he was ever under the guidance of any master but it is possible that a relation of his, Esaias van de Velde, may have helped him through the rudimentary stages.

He was among the first to use the grisaille technique of painting, together with Heerman Witmont and Experiens Sillemans, and these grisailles fetched, according to the records, large sums of money in the salerooms. When working in England, however, he found little demand for this style of painting and as a result, concentrated on drawing.

He instructed his son for a few years in Holland but later sent him to the studio of Simon de Vlieger in Weesp to learn the techniques of oil painting. Van de Velde the Elder himself only executed very few oil paintings and the majority of these are attributed to his son, or were so poor that they go under the name of another painter. When he came to England he was officially only a draughtsman. The Royal Charter of 1675 from Charles II requesting the two Van de Veldes to paint for him at Greenwich reads as follows: 'We (Charles II) have thought fit to allow the salary of one hundred pounds per annum unto WILLIAM VANDEVELDE the elder, for taking and making draughts of sea fights; and the like salary . . . to WILLIAM VANDEVELDE the younger, for putting the said draughts into colour'. Therefore on this occasion it is clear that the son was the greater painter and the father the recognised superior in draughtsmanship.

The grisaille technique, which involves working with a pen and indian ink over a prepared oil base which has hardened, on panel or canvas, lent itself perfectly to the accurate drawing of Van de Velde; paint and colour would have lessened the fineness and quality since they would only have blurred the detail. He paid little attention to anything apart from the ships.

His battle scenes are easily recognisable for their similarity of topic. The sea full of wreckage, crews in the water near their sinking ships, and a sea of flags and masts above the debacle. Yet this similarity in topic which was a result of his having to fulfil his role as official illustrator and historiographer did not detract in the least from his greatness. His subject was each time so thoroughly discussed and at so many different angles that each picture is excitingly new and active. He was able to illustrate so many objects and so vast a subject in a picture and to obtain such a wide panorama that his works seem to be, each one, an immediate experience. Some drawings are of the same ship in different positions.

It is interesting to note the very different styles of Van de Velde the Elder and Younger in their drawings. In every case, the Younger used a few quick lines to convey loosely what the father would have shown in meticulous detail. The former emphasised the beauty of movement and elegance; the latter of design and craftsmanship.

Signatures :
 W.V.V., W. V. VELDE, w. v. velde most often in Roman figures, but occasionally in a flourishing hand, like that of his son.
Signed Examples :
AMSTERDAM Scheepvaartmuseum.
 Squadron of seven men-of-war putting to sea.

Signed : Willem van de Velde de Oude. 1653.

Grisaille on panel : 33 x 45½ in. 84 x 116 cm.

The 'Golden Sun'.

Signed : W. V. Velde.

Grisaille on Panel : 29 x 41½ in. 74 x 105 cm.

AMSTERDAM Rijksmuseum.

No. 2456. *The Battle of ter Heyde 10 August 1653.*

Signed : W. V. Velde f Ao 1657 d'galjoot van velde.

Grisaille on canvas : 67 x 114 in. 194 x 290 cm.

No. 2457. *The Battle of Dunkirk 18th Feb. 1639.*

Signed : W. v. velde f. 1659.

Grisaille on canvas : 48½ x 72¾ in. 123 x 185 cm.

No. 2458. *The Battle of the Downs. 21st October 1639.*

Signed : W. V. Velde f 1659.

Grisaille on canvas : 48¾ x 75 in. 124 x 190 cm.

No. 2459. *The Battle of Leghorn 14th March 1653.*

Signed : W. V. Velde.

Grisaille on panel : 38½ x 55½ in. 97 x 141 cm.

No. 2462. *The Dutch victory over the Swedish fleet in the Battle of the Sound.*

Signed : w. v. velde. f 1665.

Grisaille on canvas : 41¾ x 61 in. 106 x 155 cm.

No. 2463. *The unsuccessful attempt by the English fleet to overrun the return fleet from the East Indies at Bergen in Norway, 12th August 1665.*

Indistinctly signed : w. vd ve. de. 1669.

Grisaille on canvas : 33½ x 74 in. 85 x 188 cm.

No. 2464. *The Four Days Battle, 11th-14th June 1666.*

Signed : w. v. velde f 1668.

Grisaille on canvas : 47 x 72 in. 119 x 182 cm.

No. 2466. *Dutch men-of-war at sea.*

Signed : w. v. velde.

Grisaille on panel : 27½ x 35½ in. 70 x 90 cm.

No. 2467. *The Prince's yacht and the State Yachts at Bergen-op-Zoom.*

Signed : w. v. velde.

Grisaille on panel : 24 x 31½ in. 61 x 80 cm.

No. 2467AI. *Ships after a battle.*

Signed : w. v. velde.

Grisaille on canvas : 32 x 43¾ in. 81.5 x 111 cm.

GREENWICH National Maritime Museum.

No. 34-36. *H.M.S. Royal Prince.*

Signed : W. V. Velde. 1678.

Canvas : 30 x 36½ in. 76 x 93 cm.

No. 30-12. *The Battle of Scheveningen 31st July 1653.*

Signed : w. v. velde. Ao1655.

Grisaille on canvas : 45 x 61½ in. 114 x 156 cm.

No. 27-320. *The Dutch fleet off Sheerness during the attack on the Medway in 1667.*

Signed : W. v. velde f. 1669.

Grisaille on canvas : 21½ x 29½ in. 55 x 75 cm.

No. 39-626. *The first attack of Schoonveld. 28 May 1673.*

Signed : W. v. velde f. 1684 oudt 73 Jaren.

Grisaille on panel : 19½ x 38 in. 50 x 96.5 cm.

No. 32-49. *The second attack of Schoonveld 4th June 1673.*

Signed : W. v. velde.

Canvas : 53 x 79 in. 135 x 100.5 cm.

No. 30-14. *English ship in light airs.*

Signed : W. v. velde. 1680/5 ?
Grisaille on canvas : 12 x 18 in. 30.5 x 46 cm.
No. 30-II. *Dutch East Indiamen.*
Signed : W. v. velde. Stern of the nearest ship bears 'Anno Catarina 1649'.
Grisaille on panel : 32 x 44 in. 81.5 x 112 cm.
No. 32-46. *Dutch merchantmen.*
Signed : W. v. velde.
Grisaille on panel : 24 x 33 in. 61 x 84 cm.
No. 27-329. *Dutch flagship close inshore.*
Signed : W. v. velde. 1654.
Grisaille on panel : 36 x 48 in. 91.5 x 122 cm.
No. 38-669. *Dutch men-of-war and barges off a jetty.*
Signed : W. V. Velde.
Grisaille on panel : 20½ x 26½ in. 52 x 67.5 cm.
ROTTERDAM Prins Hendrik Museum.
No. 1061. *Two Dutch pleasure yachts.*
Signed.
Grisaille on panel : 23¼ x 33 in. 59.5 x 83.5 cm.
No. 1181. *Estuary scene with ships.*
Signed and dated 1649.
Grisaille on panel : 18½ x 25 in. 47 x 63.3 cm.
No. 1552. *Men-of-war at anchor with the 'Eendracht'* (see figure 73).
Signed and dated 1668.
Grisaille on canvas : 44 x 68 in. 112 x 174 cm.
No. 963. *Battle of the Sound.*
Signed : W. V. Velde.
Grisaille on panel : 38¼ x 56 in. 97.5 x 142 cm.

WILLEM VAN DE VELDE THE YOUNGER
Born Leiden 1633, died London 1707.

The greatest 17th century seascape painter. Son of the grisaille ortist Willem van de Velde the Elder and elder brother of Adriaen van de Velde (1636-1672), he started as a pupil of his father in Amsterdam, but later became a pupil of Simon de Vlieger at Weesp, who greatly influenced his early pictures.

In 1652 he was living in Amsterdam and accompanied his father to sea on expeditions to draw actual naval actions for the States General of Holland. The French invasion and the war up to 1672 made it difficult to earn a living in Holland and as a result of a declaration by Charles II encouraging Dutch people to live in England, father and son came to England in the same year.

The elder and younger Van de Veldes were both offered £100 a year for painting in the service of the King (see notes on Willem van de Velde the Elder). Paid by the Treasurer of the Navy and given a studio at Greenwich in the Queen's House, which is now part of the National Maritime Museum. The Van de Veldes appear to have had little national feeling in coming to England. But art has no boundaries, and the debt we owe as a nation to the Van de Veldes, and especially to the son for his influence on our marine painters Peter Monamy, Francis Swaine and Charles Brooking, is immense.

In 1691 the Van de Veldes moved from Greenwich to Westminster, where the father died in 1693 and the son in 1707 on the 6th of April. Willem the Younger had two sons. One was named Cornelis, who was born in 1667 and lived in London from 1710 to 1729. He is known to have copied his father's pictures and later painted in the style of Peter Monamy. Few are signed.

Van de Velde's best pictures were painted in Holland. In England his pictures represented more often specific naval vessels and events. Van de Velde the Younger had many imitators and followers who continued to paint in an adaption of his style throughout the 18th century. Only a few pictures by his son have been authenticated.

The English, who appreciated his outstanding talent, purchased most of his works and his best pictures are in this country, although he did have clients as far afield as Genoa and Venice, such as the Duke of Tuscany and the Cardinal de Medici.

It is believed that he painted about 600 pictures during his life; Smith's Catalogue Raisonne mentions about 300. His work is excellent in every respect, a cohesive composition of sea and ships, with beautiful perspective and natural atmosphere. His ships are the living things right down to the last bit of rigging and his calm seas with reflections are particularly valued. Many early pictures are small in size but the pictures of historical events are large. Both the elder and the younger Van de Veldes are also famous for their drawings.

He signed W. V. Velde, Velde de Jonge and W.V.V. in about a dozen ways of signature and while in England he often signed on the reverse of a picture. He sometimes did not sign at all and many pictures appear to have been signed after his death if they were formerly attributed to him. Like several of the seascape painters, he painted versions of the same picture if a commission was popular. There are three versions of 'The Royal Sovereign', seven of 'The Surrender of the R. Prince' and no less than ten versions of 'The Battle of Solebay'.

He usually clung to the prototype and as he received commissions, simply copied, so far as can be traced, the same picture. Van de Velde painted these pictures often with the help of students working under his supervision at Greenwich.

Especially fine examples of his paintings may be seen in the National Maritime Museum, the National Gallery and the Wallace Collection, London, the Rijksmuseum, Amsterdam and the Mauritshuis in The Hague.

Signatures:

W.V.V., W. V. Velde J., W. V. Velde the Jonge, W.V.V.J., W. V. d. Velde, W. V. Velde.

Signed Examples:

AMSTERDAM Rijksmuseum.

No. 2469. *The Harbour at Amsterdam* (see figure 74).
Signed: w. v. velde J 1686
Canvas: $35\frac{1}{4}$ x 124 in. 90 x 316 cm.

No. 2471. *The prizes taken in the Four Days Battle.*
Traces of a signature on a flag.
Canvas: 23 x 32 in. 58 x 81 cm.

No. 2478. *The canon-shot.*
Signed: w. v. velde J
Canvas: 31 x $26\frac{1}{2}$ in. 78.5 x 67 cm.

No. 2479. *The squall.*
Signed: w. v. velde J.
Canvas: $30\frac{1}{2}$ x 25 in. 77 x 63.5 cm.

No. 2482. *Turbulent waters.*
Signed: w.v.v.
Panel: 20 x $18\frac{1}{2}$ in. 51 x 47.5 cm.

No. 2482AI. *The Battle of Kijkduin, 21st August 1673.*
Signed: w.v.v.
Canvas: 45 x 72 in. 114 x 183 cm.

No. 2483. *The Battle of Solebay, 7th June 1672.* *now No A 1716 Cat p 562.*
Signed: w. vand velde int
Canvas: 44 x 72 in. 112 x 182 cm.

No. 2482 A2. *Ships in calm waters.*
Signed: w.v.v.
Panel: 24 in. 35.5 cm. in diameter.

AMSTERDAM Scheepvaartmuseum.

View off the English coast, in the foreground a saluting frigate.
Signed: W. V. Velde 1691.
Canvas: 15 x $21\frac{1}{2}$ in. 38 x 55 cm.

ANTWERP Koninklijk Museum.

No. 399. *Calm sea, yacht firing a salute and other smaller vessels at anchor.*
Signed: W.V.V.
Canvas: 42 x 53 in. 107 x 135 cm.

BERLIN Gemäldegalerie.

No. 1679. *Frigate firing.*

Signed: w.v.v. 1668.

Canvas: 34 x 39¼ in. 86 x 100 cm.

DUBLIN National Gallery of Ireland.

No. 237. *Dutch men-of-war at sea.*

Signed: WVV

Canvas: 16 x 24 in. 41 x 61 cm.

FRANKFURT Stadelsches Kunstinstitut.

No. 1139. *Ships anchored in a calm sea off a jetty.*

Signed.

Canvas: 13¾ x 14¼ in. 35 x 36.5 cm.

GREENWICH National Maritime Museum.

No. 381957. *H.M.S. Resolution in a gale.*

Signed: W. V. Velde J

Canvas: 47 x 40 in. 120 x 102 cm.

No. L36-42. *The Battle of Solebay 28th May 1672.*

Signed on the reverse: W. V. Velde J.

Canvas: 50 x 73 in. 127 x 186 cm.

No. 35-33. *Burning of the Royal James at the Battle of Solebay 28th May 1672.*

Signed: W. V. Velde

Canvas: 42 x 60 in. 107 x 154.5 cm.

No. 36-43. *Royal visit to the fleet 10th September 1672.*

Signed: W. van de Velde de Jonge ao 1674.

Canvas: 65 x 128 in. 166 x 327 cm.

No. 34-38. *The Battle of the Texel 11th August 1673.*

Signed: W.V.V.J.

Canvas: 45 x 73 in. 114.5 x 186 cm.

No. 52-2. *Ditto.*

Signed: W. V. Velde J 1687.

Canvas: 59 x 118 in. 150 x 300 cm.

No. 31-14. *Ditto.*

Signed: W. V. velde f.

Panel: 11 x 15 in. 28 x 38 cm.

No. 34-37. *The Battle of the Texel 1673.*

Signed: W.V.V.

Canvas: 32 x 57 in. 81.5 x 145 cm.

No. 35-34. *English yachts at sea.*

Signed on the reverse: W. V. Veld J 1689.

Canvas: 30 x 39 in. 76 x 99 cm.

No. 33-38. *English merchantmen in a Mediterranean harbour.*

Signed: W. V. Velde J 1694.

Canvas: 28½ x 35½ in. 72.5 x 90.5 cm.

No. 42-85. *Dutch vessels off a pier.*

Signed and dated: 1654.

Canvas: 8½ x 11½ in. 21.5 x 29.5 cm.

No. 58-10. *A ship lying-to in a gale.*

Canvas: 12½ x 15 in. 32 x 38 cm.

No. 65-1. *Dutch ships in a storm driving onto a rocky coast.*

Signed: W.V.V. 1651.

Canvas: 31 x 41 in. 79 x 104 cm.

No. 32-50. *Journey of William and Mary of Orange to Holland in November 1677.*

Signed: W. V. Velde J

Canvas: 50 x 72 in. 127 x 183 cm.

HANNOVER Landesgalerie.

No. 394. *The Battle of Solebay.*

Signed: W. v. .v. Velde . . . 1673.
Canvas: 13½ x 20 in. 34.5 x 50 cm.

KASSEL Staatliche Kunstsammlung.

No. 1749/168. *Calm sea.*
Signed: W. V. Velde 1653.

No. 1749/683. *Coastal scene.*
Signed: WVV
Panel: 16 x 21 in. 41 x 53.4 cm.

No. 1749/2047. *Seascape.*
Signed: WVV.
Panel: 10¾ x 14½ in. 27.5 x 37 cm.

LENINGRAD State Hermitage Museum.

No. 1021. *A yacht and many other vessels becalmed.*
Signed: W. V. Velde 1653.
Canvas: 16½ x 19 in. 42 x 48 cm.

No. 1202. *Calm. Fishing boats ashore in low water.*
Signed: W.v.V.
Panel: 9½ x 12½ in. 24.2 x 32.5 cm.

LONDON National Gallery.

No. 979. *Dutch men-of-war, a yacht and other small vessels in a breeze.*
Signed: W.V.V.
Canvas: 13 x 14 in. 33 x 36 cm.

No. 980. *Boats pulling out to a yacht in a calm with men-of-war saluting.*
Signed: WVV
Canvas: 17 x 20 in. 43 x 50 cm.

No. 981. *Three ships in a gale.*
Signed and dated: W. VANDE. Velde. Londe 1673.
Canvas: 29 x 37 in. 74 x 94 cm.

No. 2573. *Dutch man-of-war and small vessels off a coast in a strong breeze.*
Signed: W. V. VELDE 1658.
Canvas: 29 x 37 in. 55 x 71 cm.

No. 2574. *Small Dutch vessels close inshore and other shipping in a calm.*
Signed: W.V.V.
Canvas: 13 x 14 in. 33 x 37 cm.

No. 149. *Two small Dutch vessels inshore in a calm.*
Signed: W.V.V.
Panel: 8 x 11 in. 20 x 27 cm.

No. 150. *Dutch vessel in a squall reducing sail to wait for a boat.*
Signed: W.V.V.
Canvas: 9 x 13 in. 23 x 33 cm.

No. 870. *Dutch men-of-war and small vessels in a calm.*
Signed: W. V. Velde 1657.
Canvas: 21 x 24 in. 55 x 62 cm.

No. 871. *Dutch vessels close inshore at low tide and men bathing.*
Signed: WVVelde 1661.
Canvas: 24 x 28 in. 63 x 73 cm.

No. 872. *Dutch men-of-war and small vessels offshore in a breeze.*
Signed: WVV
Panel: 16 x 23 in. 41 x 58 cm.

No. 874A. *English vessel and a Dutch man-of-war in a breeze.*
Signed: WVV.
Panel: 8 x 10 in. 22 x 27 cm.

No. 875. *Two small vessels and a Dutch man-of-war in a breeze.*
Signed: W.V.V.

Panel : 9 x 11 in. 24 x 29 cm.

No. 876. *A small Dutch vessel close-hauled in a strong breeze, and a man-of-war in the distance.*

Signed : W.V.V.

Canvas : 13 x 16 in. 33 x 40 cm.

No. 977. *Small Dutch yacht surrounded by many smaller vessels, saluting.*

Signed : W/VV ... ANNO 1661.

Canvas : 35 x 50 in. 90 x 126 cm.

LONDON Wallace Collection.

No. 145. *Ships in a calm.*

Signed : W. V. Velde.

Canvas : 12½ x 14 in. 32 x 36 cm.

No. 194. *Embarkation of Charles II, 1660.*

Figures by A. van de Velde.

Signed : W.V.V.

Canvas : 19 x 22 in. 48 x 57 cm.

No. 215. *Ships in a breeze.*

Signed : W.V.V.

Panel : 16¼ x 21½ in. 41 x 55 cm.

No. 221. *A coast scene with shipping.*

Signed : W. V. Velde 1675.

Panel : 15 x 19 in. 37 x 48 cm.

No. 246. *Landing from ships of war.*

Signed : W. V. Velde.

Canvas : 23¾ x 29 ¼ in. 60 x 74 cm.

No. 77. *A naval engagement.*

Signed : W.V.V.

Canvas : 33½ x 42¾ in. 85 x 109 cm.

No. 137. *A Dutch man-of-war saluting.*

Signed : W. V. VELDE

Canvas : 66 x 90¾ in. 168 x 231 cm.

No. 143. *Boats at low water.*

Signed : W.V.V.

Canvas : 12¾ x 14 in. 32 x 36 cm.

LICHTENSTEIN Fuerstliche Sammlung.

No. 918. *Calm sea.*

Signed : W.v.d. velde

Canvas : 17½ x 21½ in. 45 x 55 cm.

MUNICH Alte Pinakothek.

No. 1060. *Men-of-war at anchor.*

Signed : W.v.Velde fecit.

Canvas : 25 x 33½ in. 63 x 91 cm.

No. 1032. *Calm sea.*

Signed : WvV

Canvas : 20½ x 23½ in. 52 x 59 cm.

PHILADELPHIA John G. Johnson Collection.

No. 590. *Calm sea.*

Signed : WvVelde

Canvas : 16½ x 24¼ in. 42 x 62 cm.

ROTTERDAM Boymans-van Beuningen Museum.

No. 2533. *The dunes at Zandvoort.*

Signed : WvVelde.

Panel : 9½ x 11¾ in. 24.3 x 29.8 cm.

No. 1892. *The roads at Texel.*

Signed : W. V. Velde in Londe 1673.

Canvas: 18¾ x 26¾ in. 47.8 x 68 cm.
No. 2534. *Calm sea with fishing boats.*
Signed: WvV
Panel: 9 x 12 in. 23 x 31 cm.
ROTTERDAM Willem van der Vorm Collection.
No. 81. *Shore scene.*
Signed: W.V.V.
Panel: 9½ x 11¾ in. 24 x 29.7 cm.
No. 82. *Seascape.*
Signed: W.V.V.
Canvas: 12½ x 17 in. 31.5 x 43 cm.
VIENNA Akademie der Bildenden Künste.
No. 868. *Calm sea.*
Signed: W.V.V.
Panel: 24 x 32 in. 61 x 82 cm.
WEIMAR Schlossmuseum.
No. G80. *Estuary on the Maas.*
Signed and dated.
Panel: 9½ x 13 in. 24 x 32 cm.
Lost in 1945.
No. G112. *Calm sea.*
Signed: W. V. Velde 1661.
Canvas: 25½ x 30 in. 65 x 76 cm.
Lost in 1945.

CORNELIS or CORNELIUS VERBEECK or VERBEECQ
Born Haarlem 1590, died Haarlem ?1631.
A Dutch marine painter who was the father of the animal painter P. C. Verbeecq (1610-54). He was recorded as being a member of the Haarlem Guild in 1610 but little is known about his life, although there have recently come to light a number of his works.
He is often confused with other panoramist seascape painters, notably Hendrik Vroom and Aert van Antum, very occasionally with A. van Eertvelt. Verbeecq painted ships and figures with great care and precision which are very pleasing to the eye. On many of his pictures there is a tall rock, often jutting unaccountably out of the water. He has an individualistic method of painting and a fine example can be seen at the Scheepvaartmuseum, Amsterdam, *The Dutch fleet off St. Helena.*
He has the ability to render a very angry and lively sea, of which the foam is usually speckled, a feature common to a number of other styles of this period, and his ships – invariably men-of-war – are sometimes followed by a whale or dolphin.
Signatures:
VB (in monogram), C.V.B., VBH, CVBH and Verbeeck.
Signed Examples:
AMSTERDAM Scheepvaartmuseum.
The Dutch fleet off St. Helena.
Signed: VBH
Panel: 9¼ x 12 in. 24 x 30 cm.
CHELTENHAM Art Gallery.
GI899:2. *Houtman's Fleet.*
Signed and dated 1623.
Canvas: 32 x 60 in. 81 x 152 cm.
GATESHEAD Shipley Art Gallery.
No. SB425. *Three-master and small vessel off a beach.*
Signed: Verbeeck.
Panel: 8 x 18 in. 20 x 46 cm.

GREENWICH National Maritime Museum.
No. 35-26. *Battle between Dutch and Spanish.*
Signed : CVBH
Canvas : 36½ x 54 in. 92 x 136 cm.
No. 62-22. *Dutch ships in a rough sea.*
No. 62-23. *A Yacht and a smaller vessel under way off a Dutch harbour.*
Pair signed : CVB.
Panel : 4½ x 9½ in. 11.5 x 24 cm.
HAARLEM Frans Hals Museum.
No. 509. *Three-masters off the shore* (see figure 75).
Signed : VB Canvas : 19 x 38 in. 49 x 97 cm.

LIEVE VERSCHUIER
Born Rotterdam 1630, died Rotterdam 1686.
A Rotterdam painter of Dutch quayside scenes and seascapes with a sunset, Verschuier's career started as a sculptor and he became eventually Chairman of the Guild in Rotterdam. He may have been a pupil of de Vlieger, Bellevois or Julius Porcellis, but we cannot be sure and he was certainly never influenced greatly by any of these masters. His quayside scenes are reminiscent in design of Cuyp or Cappelle with a wide scope of style. Most noticeable of all his characteristics are the ripples which are very formal and stylised and more so towards his later days. He was a lover of pomp and ceremony and preferred to paint crowded compositions. For example *The Fire of London* (Budapest Gallery), *The arrival of Charles II in Rotterdam on his way to England* (Rijksmuseum, Amsterdam), *The Keel hauling* (Rijksmuseum) are very neat and well arranged compositions, although the tone is a little hard.
Pictures of what seems to be the style of a different man show sunsets over a Mediterranean sea and reveal a certain amount of Italian influence that Verschuier gained on his travels through Italy with Johan van der Meer between 1652 and 1656.
In all his pictures there is considerable artistic merit, especially in the composition of his skies.
Signatures :
L. Verschuier, VS or L.V.S.
Signed Examples :
AMSTERDAM Rijksmuseum.
No. 2530. *King Charles arriving in Rotterdam on his way to England* (see figure 76).
Signed : L. Verschuier.
Canvas : 48 x 88½ in. 124 x 225 cm.
No. 2531. *The keel-hauling.*
Signed : L. Verschuier.
Panel : 41¾ x 62½ in. 106 x 159 cm.
No. 2532. *Rippling water.*
Signed : L. Verschuier.
Panel : 14¾ x 19¼ in. 37.5 x 49 cm.
ROTTERDAM Boymans-van Beuningen Museum.
No. 1903. *Italian coast in the morning.*
Signed : LvS
Panel : 7½ x 9¼ in. 18.2 x 23.5 cm.
No. 1904. *Italian coast in the evening.*
Signed : LvS
Panel : 7½ x 9¼ in. 18.2 x 23.5 cm.
GREENWICH National Maritime Museum.
No. 35-31. *Dutch states yacht.*
Signed : L. Verschuier.
Canvas : 20 x 32 in. 51 x 81 cm.
No. 34-35. *Action between Dutch fleet and Barbary pirates.*
Signed : L. Verschuier.
Canvas : 57 x 84½ in. 145 x 215 cm.

No. 27-68. *Fishing boats at Scheveningen.*
Signed.
Canvas: 24 x 30 in. 61 x 76 cm.
MUNICH Alte Pinakothek.
No. 871. *Ships in a harbour.*
Signed.
Canvas: $40\frac{1}{2}$ x 49 in. 103 x 125 cm.
No. 5524. *Harbour scene.*
Signed.
Canvas: $32\frac{1}{2}$ x 53 in. 83 x 134 cm.

ABRAHAM DE VERWER called also BURGSTRATE

Born *c*1590, died 1650 Amsterdam.

A landscape and marine painter who was also an architect and engineer, and the father and a master of Justus de Verwer. He worked at Amsterdam in 1617, Paris in 1639 for several years and then returned to Amsterdam where he painted for Prince Frederick of Nassau. He is also known to have worked in Le Havre, Nantes and Belgium.

Verwer's early painting is not unlike that of Aert van Antum although his style is more crude than Antum's. He painted pictures of naval battles, past and contemporary. His work of the Battle of the Zuyder Zee, for example, was painted 50 years after the event. One of his most noticeable characteristics in early years is his tendency to paint pointed and full-blown sails.

Verwer was, however, no conventional painter. His early panoramic style developed into something akin to that of de Vlieger with grey monotone predominating (Palmer Collection shows a good example) and later to an imitation of Van Goyen with green and slatey blue predominating.

Although receptive to change and pleasantly versatile, Verwer was never a great artist, for his colours are cold and forbidding and his later painting was too feeble an imitation to be convincing. His drawings are well executed and, like his paintings, rare.

Signatures:
A. D. Verwer, Verwer. He sometimes painted on copper.

Signed Examples:

AMSTERDAM Rijksmuseum.
The Battle of the Zuyder Zee 6th October 1573.
Signed and dated 1621. A. D. Verwer in fecit 1621.
Canvas: 60 x $133\frac{1}{4}$ in. 153 x 340 cm.

GREENWICH National Maritime Museum.
No. 62-68. *A ship in a calm sea* (see figure 77).
Panel: $18\frac{1}{4}$ x 20 in. 47 x 51 cm.
Signed: Verwer.
62-20. *Dutch and English ships off a harbour.*
62-21. *Dutch ships in a rough sea.*
Companion pictures on copper.
Signed.
5 x 10 in. 13 x 25 cm.

MANNHEIM No. 1914-204. *Seascape with a town in the background.*
Signed. Panel: $21\frac{1}{2}$ x $34\frac{3}{4}$ in. 55 x 88.2 cm.

JUSTUS DE VERWER

Born *c*1626, died Amsterdam *c*1688.

The son and pupil of Abraham de Verwer. Little is known about him and there are very few of his paintings. They are somewhat alike to those pictures executed by his father in his grey period. His colours also are cold and unsympathetic, his ships even more stiff, and his waves more mannered.

His youth was spent for the most part in the East Indies and then he returned to Amsterdam and Gouda during his later days.

Signatures:
 J.D.V. (I.D.V.). Very similar to that of Joachim de Vries.
Signed Examples:
LONDON Private Collection.
 Naval skirmish (see figure 78).
 Signed: I.D.V.
 Panel: 13¾ x 18¾ in. 35 x 48 cm.

WIGERUS VITRINGA
Born Leeuwarden 1657, died Leeuwarden 1721.
Wigerus Vitringa's work is a most agreeable fusion of several styles and he is mentioned as having joined the Alkmaar Guild in 1696.
His paintings of skies and rough seas are well executed and reminiscent of Ludolph Backhuyzen (1631-1708), although sometimes a little coarse. The figures, usually on a strip of land in the foreground are also comparable to that painter's. In these rough sea pictures, one can also see occasionally a similarity to the works of van de Velde the Younger (1633-1707) for he shows light falling on the sails and the compositions are decorative.
However, in no case are his works mere imitations. They are a pleasant and convincing mixture of styles executed with a certain amount of talent and skill.
Later pictures sometimes showed views of Southern ports, accentuating architectural features.
Vitringa was also a lawyer, active all his lifetime and a greatly respected citizen.
Signatures:
 His signed pictures are rare, w: vitringa, w: witrna.
Signed Examples:
DUSSELDORF Werner Dahl Collection.
 Dutch Harbour Scene.
 Signed: w: vitringa 1674.
GREENWICH National Maritime Museum.
 A Bear-hunt in the Arctic (see figure 79).
 Signed: w. vitringa 1696.
 Canvas: 17½ x 22½ in. 44.5 x 57 cm.
LENINGRAD State Hermitage Museum.
 No. 3198. *Southern Port.*
 Signed: w: vitringa.
 Canvas: 18½ x 21½ in. 47 x 55 cm.

SIMON DE VLIEGER
Born Rotterdam c1600, died Weesp 1653.
Although de Vlieger painted a few portraits and landscapes, it is in his marine paintings that he excelled himself and became one of the greatest 17th century Dutch seascape painters. He was the pupil of Jan Porcellis and Willem van de Velde the Elder and bestowed some of his talent on his pupils Willem van de Velde the Younger, Jan van de Cappelle, Hendrik Dubbels and the lesser known Hendrik van Anthonissen. He improved on the style of Porcellis and took the themes of light and monotone into higher spheres of painting.
It was not difficult for de Vlieger to make his life successful. He was greatly appreciated by all his contemporaries and his painting enabled him to buy a great deal of property.
In 1634 he is first mentioned in the Guild of Delft. His pictures of vessels near foreign coasts with exaggerated rock formations sometimes in calm, sometimes in rough waters are less pleasing. At this time in his career de Vlieger had several commissions from churches.
After the 30's de Vlieger turned his attention to calm home waters and painted scenes of Dutch shipping, well distributed on the water, amongst glowing stretches of sunlight with a misty haze enveloping the pictures and a delicate horizon behind. At this time, before going to Amsterdam, de Vlieger was very closely copied by many of his followers.

60

But in 1638 in Amsterdam, where his style was perfected to such an extent that he far outreached all his followers, he became more poetic in his compositions, his surfaces shimmered, there was more silent drama, more mist and cloud. It is most likely that he was emulating Rembrandt, who was now also in Amsterdam. After the mid-forties de Vlieger tended to favour more the landscape and shore scene, the ceremonial or representative picture. He painted more figures – elegant aristocrats and fishing folk – rather in the style of Ruisdael. These pictures are magnificent and well executed but they have not the spirit and pure soul of the earlier compositions.

In 1650 however, de Vlieger retired to the town of Weesp where he had all the peace and solitude he could ever have wished for. In these last few years he returned from the fashionable pictures in Amsterdam to his 'atmospheric' paintings and some of these pictures are amongst the most soulful and profound.

Signatures:

Usually in capital letters – S. DE VLIEGER, S. DE V., S. Vlieger, S. DE VLIER., S.VL., S.D.V.

Signed Examples:

AMSTERDAM Rijksmuseum.

No. 2560. *Naval combat on the Slaak, 1631.*

Signed: S. DE VLIEGER. 1633.

Canvas: 41 x 70 in. 104 x 179 cm.

No. 2564. *A storm at sea* (see figure 80).

Signed and dated 1640.

Canvas: $43\frac{1}{2}$ x 72 in. 111 x 182 cm.

BASEL Kunstmuseum.

No. 1354. *Ships on the sea.*

Signed: S.D.V.

Panel: $13\frac{1}{4}$ x 16 in. 34 x 41 cm.

BERLIN Gemäldegalerie.

No. 934. *Boats off Estuary in a choppy sea.*

Signed: S. DE V . . EGER 1637

Panel: $12\frac{1}{2}$ x $17\frac{1}{2}$ in. 32 x 44 cm.

CAMBRIDGE Fitzwilliam Museum.

No. 345. *Shipwreck on a rocky coast.*

Signed.

Panel: 11 x $14\frac{1}{4}$ in. 28 x 37 cm.

COLOGNE Wallraf-Richartz Museum.

No. WRM 2563. *View of Scheveningen.*

Signed.

Panel: 16 x 21 in. 41 x 53 cm.

COPENHAGEN Royal Museum of Fine Arts.

No. 779. *The river Maas off Rotterdam.*

Indistictly signed.

Canvas: 42 x 73 in. 107 x 185 cm.

DELFT Stedelijk Museum.

No. 128. *Admiral Tromp off den Briel.*

The largest ship is 'Huys te Brederode', Tromp's flagship in the Battle of Ter Heide.

Signed: S.D.V.

Canvas: $32\frac{1}{2}$ x $50\frac{1}{2}$ in. 83 x 128 cm.

FRANKFURT Stadelsches Kunstinstitut.

No. 537. *The salute: frigates and fishing boats on a calm sea.*

Signed: S.D.V.

Panel: $9\frac{3}{4}$ x $13\frac{1}{4}$ in. 25 x 34 cm.

GOETTINGEN Georg-August-Universitat.

Storm on the Lake.

Signed: S. de Vlieger 1637.

Canvas: 33 x $39\frac{1}{2}$ in. 84.5 x 101 cm.

GREENWICH National Maritime Museum.

No. 62-52. *The ferry boat before the wind.*
Signed : S. de Vlieger.
Canvas : 33 x 32 in. 84 x 81.5 cm.
No. 62-53. *Shipwreck.*
Signed : S. de Vlieger.
Panel : 29½ x 40 in. 75 x 102 cm.
No. 62-54. *Beach at Scheveningen.*
Signed : S. de Vlieger Ao 1633
Panel : 27 x 42 in. 68.5 x 107 cm.
No. 62-55. *Fishing boats in a rough sea.*
Signed : S. Vl. 1644.
Panel : 17½ x 23 in. 44.5 x 58.5 cm.
No. 62-56. *Dutch ships revictualling off a rocky coast.*
Signed : S. V R
Panel : 21 x 39 in. 53.5 x 99 cm.
No. 57-22. *Shipping off the English Coast.*
Signed : S. DE VLIEGER
Panel : 24 x 32 in. 61 x 81.5 cm.

HAGUE Mauritshuis.
The beach at Scheveningen.
Signed : S. DE VLIEGER Ao 1643
Panel : 23¾ x 33 in. 60.6 x 83.5 cm.

HAMBURG Kunsthalle.
No. 597. *Seascape.*
Signed : S. DE Vlier
Panel : 16 x 24 in. 41 x 62 cm.

KASSEL Staatliche Kunstsammlung.
No. 1875/1105. *Seascape.*
Signed : S. de Vlieger.
Panel : 32½ x 44 in. 83 x 112 cm.

LE HAVRE Museum.
River Estuary with port in the distance.
Signed.
Panel : 14½ x 15¾ in. 37 x 40.

LENINGRAD State Hermitage Museum.
No. 3246. *Rough sea and sailing vessels.*
Signed : S de Vlieger
Panel : 28½ x 42 in. 72.5 x 107 cm.
No. 1026. *Boats in a strong wind.*
Signed. S.V. 1624.
Canvas : 11 x 18 in. 30 x 46 cm.
No. 1033. *Arrival of William of Orange at Rotterdam.*
Signed : S. de Vlieger
Canvas : 64 x 102 in. 161.5 x 257.5 cm.
No. 797. *A calm sea with a wijdschip close into a bank with reeds.*
Signed : S de Vlieger.
Panel : 14½ x 15½ in. 37.5 x 39 cm.

LICHTENSTEIN Fuerstliche Sammlung.
No. 826. *Man-of-War.*
Signed : SDV
Panel : 28 x 41½ in. 71 x 106 cm.

LONDON National Gallery.
No. 3025. *A Dutch man-of-war and various other vessels.*
Signed : VLIEGE(R ?)

62

Panel : 16 x 22 in. 41 x 55 cm.
No. 4455. *View of an estuary with Dutch vessels and man-of-war at anchor.*
Signed : S de VLIEGER
Panel : 35 x 48 in. 88.5 x 122 cm.

MUNICH Alte Pinakothek.
No. 867. *Rough sea and a sailing yacht.*
Signed : S DE VLIEGER
Panel : $22\frac{1}{2}$ x $42\frac{1}{2}$ in. 57 x 108 cm.

PRAGUE National Gallery.
No. DO/4200. *Three-master in a very rough sea.*
Signed : SVD
Canvas : $25\frac{1}{2}$ x $40\frac{1}{2}$ in. 65 x 102.5 cm.
No. DO/5007. *Boats on the open sea in a calm.*
Signed : SVD
Canvas : $17\frac{1}{2}$ x $19\frac{1}{4}$ in. 49 x 44.7 cm.

ROTTERDAM Boymans-van Beuningen Museum.
No. 1923. *Calm water.*
Signed : Signature remaining – DE . . .
Canvas : $25\frac{1}{2}$ x $39\frac{1}{4}$ in. 64.5 x 100 cm.

VIENNA Akademie der Bildenden Künste.
No. 1392. Seascape.
Signed : S. de Vlieger.
Panel : $11\frac{1}{2}$ x $17\frac{1}{2}$ in. 29.5 x 45 cm.

VIENNA Kunsthistorisches Museum.
No. 1339. *Landing of Prince of Orange at Amsterdam.*
Signed and dated 1649.
Panel : 28 x 36 in. 71 x 92 cm.

PIETER VOGELAER

Born Zierikzee 1641, died Amsterdam 1720.

Peter Vogelaer was a Dutch silversmith who became a ship's draughtsman, sculptor and marine grisaille painter, working in Amsterdam. His works are very rare and somewhat in the style of Willem van de Velde the Elder (1611-1693) though not as fine. He appears to pay attention to detailing the drawing of ships, but they are rather stiff and do not float comfortably on the water. In spite of his lack of any great talent, his pictures are always pleasing and interesting in content.

Signatures :
P. Vogelaer in ornate writing, P. Vogelaar.

Signed Examples :

AMSTERDAM Rijksmuseum.
No. 2571. *The Dutch Herring Fleet at Work.*
Signed : P : Vogelaer.
Panel : 33 x 45 in. 84 x 114 cm.

GREENWICH National Maritime Museum.
No. 33-39. *Dutch three-decker, Prins Willem III.*
Signed : PVogelaer.
Grisaille on panel : 43 x 66 in. 109 x 168 cm.
No. 36-69. *Dutch Men-of-War in distress.*
Signed : Pieter Vogelaer.
Grisaille on panel : 38 x 56 in. 97 x 142 cm.

ROTTERDAM Prins Hendrik Museum.
No. 550. *Dutch and Burgundian men-of-war and galleys in the Mediterranean* (see figure 81).
Signed : P. Vogelaar.
Grisaille on panel : $32\frac{1}{4}$ x $39\frac{1}{2}$ in. 82 x 100.5 cm.

JACOB FEYT DE VRIES
Painted in the first half of the 17th century.
Signatures:
 J.F.D.V.
Signed Examples:
AMSTERDAM Stedelijk Museum.
 No. 271. *Battle between Dutch and English ships.*
 Signed: J.F.D.V.
 Panel: 25 x 48½ in. 64 x 123 cm.

JOACHIM DE VRIES
Born Sneek c1650, travelled to Delft and probably died there.
No facts are known about this painter and confusion arises as there are several painters of this time with the same initials. This particular one is the most easily recognised by his subjects and colouring.
De Vries painted grey-green seas and cold skies. The waves are edged with a characteristic spume of foam and he gave prominence to merchant and whaling vessels.
Signatures:
 JDV or JVries.
Signed Examples:
GREENWICH National Maritime Museum.
 No. 62-76. *A Dutch Whaling Fleet* (see figure 82).
 Signed: JDV.
 Panel: 16½ x 27½ in. 42 x 70 cm.
 No. 39-367. *Dutch ship before the wind.*
 Signed: JVRIES.
 Panel: 40 x 58 in. 102 x 147.5 cm.
LONDON Author's collection.
 Vessels in a breeze.
 Signed on flag with monogram IV.
 Panel: 9¼ x 17¼ in.

CORNELIS HENDRIKSZ VROOM
Born Haarlem 1591, died Haarlem 1661.
The son and pupil of Hendrik Cornelisz Vroom. Mentioned as joining the Haarlem Guild in 1635 although he left it after a quarrel some seven years later. He is more commonly a landscape painter where his style is closely allied with men such as Salomon Ruysdael and Esaias Van de Velde, paving the way for Jacob Ruisdael who was under the influence of Cornelis. As is sometimes the case, this position was reversed towards Cornelis's later years and the older man found himself absorbing inspiration from his own pupil. He died in Haarlem in 1661.
His rare seascapes bear no real resemblance to those of his better known father and are rather heavy in their composition, although the picture in the Rijksmuseum, Amsterdam, of Dutch ships running down Spanish galleons is his finest picture known in the museums. He seems to delight in painting staffage, for both pictures in the National Maritime Museum, Greenwich, and the Rijksmuseum show hundreds of teeming crew drawn very tight packed.
Signatures:
 VROOM, CVROOM, CVROM.
Signed Examples:
AMSTERDAM Rijksmuseum.
 No. 2603.FI. *Ships running down Spanish galleons off the Flemish coast . . . in 1602?* (see figure 83).
 Signed: VROOM 1617
 Canvas: 46¼ x 57½ in. 117 x 146 cm.
GREENWICH National Maritime Museum.
 No. 36-59. *Spanish men-of-war engaging Barbary corsairs.*
 Signed: CVROOM 1615/8? Canvas: 24 x 40½ in. 61 x 103 cm.

HENDRIK CORNELISZ VROOM

Born Haarlem 1566, died Haarlem 1640.

Vroom was the father not of sea paintings but of sea portraiture. Pieter Breughel had already painted several seascapes with one or two ships but Vroom was the first to take a detailed interest in the ship itself. Starting his career rather late in life, when his first efforts seem to have been around his late twenties, Vroom became well known for his designs of wallpaper. He travelled widely in the early part of his life with his friend Paul Bril through the Netherlands, Italy, France, Spain, England and soon became internationally recognised as a great painter. At the request of Lord Howard of Effingham he came to London to prepare cartoons for the tapestries depicting the defeat of the Armada in 1588.

Vroom's painting concentrated on sea battles and the important ceremonies, and although there was more imagination in his compositions than historical accuracy, he was a technical draughtsman of considerable merit with a considerable knowledge of ships, and in this respect surpassed most of his school. He appears to have had a decided attraction for gruesome detail as well as his lively imagination. Not only was he the leader of the panoramists but by far the most prolific, and this was as much due to public demand as anything in his character. He appealed to a vast majority of people since everybody was acquainted with the subjects he chose and the sight and sound of war. He painted what the Dutch were proud of. Though never tiring of the earlier victories of his countrymen, he also completed a few peaceful subjects, as, for example, the Beach of Scheveningen, views of Amsterdam, and depictions of the various trades. Although there were towards the end of his life many men who had taken Dutch painting ahead by leaps and bounds, Vroom never changed his style and in fact there would never have been a demand for him to modernise his technique since he was so well liked.

Although the figures in Vroom's pictures play secondary part in the composition, they are usually dramatically grouped and neatly and carefully drawn. The sea is usually a greenish-blue and a light breeze moves the water into very stiff and stylised ripples or waves. The horizon is high and he paints as little of the land as he need for he never mastered the ability to paint a coastline. The towns which often appear in the background are again carefully drawn and with a great effort to include all relevant detail. The foreground is darker than the rest of the picture and the colour becomes lighter as the picture recedes into the background. Whales and fantastic sea animals follow his fleets, spurting water high into the air. The sails of his ships are sometimes filled a little too uniformly. At his best he painted very large colourful pictures.

He was the father of the landscape painter Cornelis Vroom who painted a few seascapes.

Signatures:

VROOM, usually on a flag.

Signed Examples:

AMSTERDAM Rijksmuseum.

No. 2606. *The Hollandsche Tuyn and other ships entering the River Y, 1605* (see figure 84).
Signed: VROOM
Canvas: $56\frac{1}{2}$ x 110 in. 144 x 279 cm.

No. 2606 A5. *East Indiamen sailing out of the Maasdiep.*
Signed: VROOM
Canvas: $40\frac{3}{4}$ x 78 in. 103.5 x 198.5 cm.

No. 2607. *Battle between the Dutch and Spanish ships on the Haarlemmermeer at the unsuccessful attempt to relieve Haarlem on the 26th May 1573.*
Signed: Vroom f
Canvas: $74\frac{1}{2}$ x 106 in. 190 x 268 cm.

GREENWICH National Maritime Museum.

Trading in the Dutch East Indies.
Signed: Vroom 1614.
Canvas: $38\frac{1}{4}$ x $59\frac{1}{2}$ in. 98 x 151 cm.

Return of Prince Charles from Spain 1623.
Inscribed and dated 1623.
Canvas: 50 x 120 in. 127 x 326 cm.

HAARLEM Frans Hals Museum.

No. 300. *The arrival of Frederick V, Elector Palatine with his consort wife Elisabeth, daughter of James I of England, at Flushing in May 1613.*

Signed: VROOM
Canvas: 24 x 48 in. 203 x 409 cm.
HOORN Westfries Museum.
 No. 84. *View of Hoorn from the Zuyder Zee.*
 Signed: VROOM
 Canvas: 40 x 80 in. 101 x 202 cm.
MUNICH Alte Pinakothek.
 No. 4578. *Men-of-war in a harbour.*
 Signed: VROOM F. dated 1630.
 Canvas: 38 x 78 in. 97 x 201 cm.

CORNELIS CLAESZ VAN WIERINGEN
Born Haarlem 1580, died Haarlem 1633.

A marine painter of the panoramist style and one of the founders of the 17th century seascape painting of the Netherlands.

Wieringen was a seaman painting and drawing ships during his time at sea. He became a member of the Haarlem Painters' Guild in 1600 and was still a member of the Seaman's Guild in 1628. He had a son, Claes, who was also a marine painter and a member of the Guild. Cornelis's most important picture was of the Battle of Gibraltar, which was rediscovered by the curator of the Scheepvaartmuseum some years ago, after a three-hundred-year disappearance.

Wieringen was the pupil of Vroom but since Wieringen underpriced his former master for the painting of this event, he was given the commission by the civic authorities of Amsterdam. The picture was a gift to Prins Maurits for his residence in the Binnenhof at the Hague.

His early pictures were colourful but later he used more grey tones like Simon de Vlieger. He was close to, but never more outstanding, than Antum or Vroom. The detail of his ships is excellent and his pictures rare and valuable.

Signatures:
 C.W., C.C.W., C.C. v Wieringen.

Signed Examples:
AMSTERDAM Rijksmuseum.
 No. 2678. *Spanish Armada off the coast of England.*
 Signed: C.CW
 Canvas: 41 x 81 in. 104 x 206 cm.
AMSTERDAM Scheepvaartmuseum.
 The Battle of Gibraltar.
 Signed: C. CvWieringen 1622
 Canvas: 71 x 192 in. 180 x 490 cm.
GREENWICH National Maritime Museum.
 No. 62-15. *The wreck of the Amsterdam.*
 Signed: C.C.W.
 Canvas: 49½ x 70 in. 126 x 176 cm.
HAARLEM Frans Hals Museum.
 No. 308. *The arrival of Frederick V., Elector Palatine, with his consort wife Elisabeth, daughter of James I of England, at Flushing in May 1613* (see figure 85).
 Signed: C. C. Wieringen.
 Canvas: 49½ x 70 in. 126 x 176 cm.
MADRID Prado Museum.
 No. 2143. *A sea battle.*
 Signed in monogram: C.C.W.
 Panel: 28½ x 35½ in. 43 x 90 cm.

ABRAHAM WILLAERTS

Born Utrecht 1603, died Utrecht 1669.

It is very difficult to distinguish between the paintings of Abraham Willaerts and his better known father Adam Willaerts. Their styles are extremely similar as indeed are their signatures.

Abraham was a pupil of his father and Jan Bylaert, then worked with Simon Vouet in Paris, later in Brussels for Prins Maurits and then went with the prince to Rome, earning himself a very distinguished reputation as a marine and portrait painter.

His shore scenes are similar in setting to those of his father with the same imaginary rocks, staffage and stylised waves.

Signatures:

A.W., A. Willaerts, ABWillaerts. Frequently dated.

Signed Examples:

BRUNSWICK Herzog Anton Ulrich Museum.

No. 184. *Shore scene with church on the left.*

Signed: Monogram 1653. A. W. fe 1653.

Panel: 19 x 34 in. 48 x 87 cm.

No. 185. *Shore scene with beach and fishing folk. Castle remains in the background.*

Signed and dated: A.W .. 62. faint.

Panel: 19 x 32 in. 48 x 81 cm.

COPENHAGEN Royal Museum of Fine Arts.

No. 817. *Battle near the coast between Dutch and Spaniards. The Dutch trying to make a landing* (see figure 86).

Signed and dated 1641.

Canvas: 64 x 95½ in. 163.5 x 243 cm.

GREENWICH National Maritime Museum.

No. 33-33. *Spainsh three-decker lying at Naples.*

Signed and dated 1669.

Canvas: 34 x 21½ in. 86.5 x 55 cm.

No. 62-42. *Dutch ship from Zeeland at anchor.*

Signed: A. Willaerts.

Panel: 20 x 27 in. 51 x 69 cm.

No. 38-1354. *Action, probably of the first Dutch war.*

Signed: A Wil . . . 16 . . .

Canvas: 39½ x 49 in. 101 x 125 cm.

LENINGRAD State Hermitage Museum.

No. 8334. *Four ships in a very heavy sea.*

Signed: AW 1626

Panel: 33 x 45 in. 84.5 x 115 cm.

No. 8303. *Dutch ships in a harbour with a castle on the left and a small vessel ashore in the foreground.*

Signed: ABWillaerts 1632.

Panel: 14½ x 21½ in. 37 x 55 cm.

LICHTENSTEIN Fuerstliche Sammlung.

No. 828. *Storm at sea.*

Signed: A.W. 1633

Panel: 22½ x 35½ in. 57 x 90 cm.

ADAM WILLAERTS

Born Antwerp 1577, died Utrecht 1664.

A Flemish born artist who painted in Holland. An early panoramist marine and landscape painter, the father of Abraham Willaerts and the brother of Isaac. In 1600 Adam Willaerts left Antwerp and went to Utrecht where he painted until his death in 1664. He was a member of the Utrecht Guild in 1611 and became chairman in 1620. His early pictures are very panoramic, for example the *Battle of Gibraltar* in the Rijksmuseum and he painted with a good sense of colour and more with a concern for the coastline than his contempor-

aries. Later, however, he changed his style to 'semi-panoramic' and the sea takes a more real form of movement although it is still conventionally painted.

Adam Willaerts' paintings can usually be identified by his rendering of the sea, especially in his early pictures. Both his sons, however, followed the style of their father in his late period and it is not easy to tell the difference between the Willaerts' painting during their later years.

The Dutch painter W. Ormea sometimes painted the still life (usually fish) in the foreground of his pictures.

Signatures:

A.W., A. Willarts, Adam Willarts, A. Willaerts, AD

Wilart, A. Wilates.

Signed Examples:

AMSTERDAM Rijksmuseum.

No. 2683. *Ships off a rocky coast.*

Signed: A. Willaerts. f 1621.

Panel: 24 x 48 in. 62 x 122.5 cm.

No. 2682. *Naval Battle of Gibraltar, 1607.*

Signed: A. D. Willarts 1617.

Canvas: 24¾ x 73 in.

No. 2685. *Storm at sea with a dragon/whale in the waves.*

Signed: AD Wilart 1644.

Panel: Oval – 25½ x 34 in. 65 x 86.5 cm.

No. 2684.AI. *The victory of Admiral Heemskerk over the Spanish fleet under Don Juan d'Alvares d'Avila at Gibraltar on 25 April 1607.*

Signed: A. Willaerts 1639.

Canvas: 53½ x 80½ in. 136 x 204 cm.

No. 2684. *On the shore with Dutch ships off the coast.*

Signed: AW 1628.

Panel: 17½ x 32 in. 45 x 82 cm.

AMSTERDAM Scheepvaartmuseum.

Embarkation of Prince Palatinate (Frederick), before his crossing to Flushing, 1613.

Signed: A. D. Willaerts, f. 161?

Canvas: 34 x 55½ in. 86 x 141 cm.

View of Dutch Roads.

Signed: A. Willarts, f. 1627.

Canvas: 40½ x 62¾ in. 103 x 156 cm.

DORDRECHT Museum.

No. 256. *View of Dordrecht as seen from the North.*

Signed: A. Willarts fe 1629.

Canvas: 72½ x 262¾ in. 185 x 670 cm.

BRUSSELS Musee Royaux de Beaux-Arts.

No. 520. *Departure of warships.*

Signed: A. Willates(?) 1623.

Panel: 24½ x 41 in. 63 x 105 cm.

GREENWICH National Maritime Museum.

No. 35-23. *Dutch fleet attacking a Spanish fortress.*

Signed: 16 A 22 Willarts.

Panel: 16 x 30 in. 41 x 76 cm.

No. 62-41. *Dutch ships anchored off a rocky shore.*

Signed: A. Willaerts.

Panel: 25 x 40 in. 63.5 x 102 cm.

No. 33-28. *Departure of English East Indiamen.*

Signed: A Willarts 1640.

Panel: 25 x 41 in. 63.5 x 104 cm.

No. 32-36. *Embarkation of the Elector of Palatinate, 1613.*
Signed and dated 1622.
Panel: 30½ x 54 in. 77.5 x 137 cm.
No. 27-223. *Dutch ships in a gale with a whale.*
Signed: A. Willarts.
Panel: Oval 19 x 24 in. 48.5 x 61 cm.
HAMBURG Kunsthalle.
No. 336. *Goat hunting party on the shore.*
Signed: A. Willarts.
Panel: 26¾ x 60½ in. 68 x 154.5 cm.
LEIPZIG Museum der Bildenden Künste.
No. 626. *A shore scene.*
Signed and dated 1639.
Panel: 23¼ x 31 in. 59.5 x 78.5 cm.
LENINGRAD State Hermitage Museum.
No. 6113. *Small vessels off a town.*
Signed and dated WF 1643.
No. 4789. *Ship close-hauled in a heavy sea. A whale under the stern.*
Panel dated 1616.
LICHTENSTEIN Fuerstliche Sammlung.
No. 1397. *Storm at sea with rocky coast.*
Signed: A.W. 1633
Shore scene with ships.
Signed: A. Willaerts 1616.
Panel: 33½ x 50 in. 85 x 127 cm.
MARSEILLES Musee Cantini.
A squadron.
Signed: AD WILLARTS 1624
Canvas: 27½ x 43 in. 70 x 109 cm.
MUNICH Alte Pinakothek.
No. 12022. *Harbour and ships.*
Signed: A.W. 1633/4?
Panel: 20 x 35½ in. 50.6 x 90 cm.
OXFORD Ashmolean.
No. 473. *Vessels at sea with fish market in the foreground* (see figure 87).
Signed: A Willarts
Panel: 19 x 42 in. 48 x 106 cm.
PRAGUE National Gallery.
No. 0/1701. *Fishing folk and vessels on a shore with men-of-war at anchor offshore.*
Signed: A.W.
Canvas: 15¼ x 32¼ in. 39 x 82 cm.
No. 0/7603. *Rocky landscape and stormy sea.*
Signed: A.W. 1625.
Circular panel: 8½ in. 21.5 cm.
ROTTERDAM Boymans-van Beuningen Museum.
No. 1982. *The estuary of the Maas by Den Briel. In the foreground the portrait group of a family.*
Signed: A. Willarts. ft 1633.
Canvas: 69 x 151½ in. 175 x 386 cm.
STOCKHOLM National Museum.
No. 1180. *Rocky coast with figures and ships.*
Signed: A.W. 1627.
Panel: 19¼ x 34½ in. 49 x 88 cm.

VIENNA Kunsthistorisches Museum.
 No. 605. *Various vessels in a choppy sea off a fort.*
 Signed: A. Willarts 1631.
 Canvas: 24¾ x 45½ in. 63 x 116 cm.
WURZBURG Martin von Wagner Museum.
 No. 351. *Seaport with fishmarket.*
 Signed: Willaerts 1651.
 Panel: 24 x 30 in. 61 x 76 cm.

ISAAC WILLAERTS
Born Utrecht 1620, died Utrecht 1693.
A marine and landscape painter who was the son of Adam Willaerts and the younger brother of Abraham Willaerts, all seascape painters. Isaac was a member of the Utrecht Guild in 1637 and became Chairman of the Guild in 1666. He first copied the style of his father, but later his compositions were wider in type and ships were not the only feature. His pictures are rare, possibly because all the later pictures by Willaerts are very similar and have been attributed to Adam or Abraham, unless the picture is signed.
Signatures:
 I. W., I. Willaerts, F.W. (Fecit Willaerts?)
Signed Examples:
UTRECHT Centraal Museum.
 No. 346. *Shore view with an Amsterdam Frigate.*
 Signed: I. Willaerts.
 Panel: 16 x 21¾ in. 41 x 55 cm.
LONDON Sometime in the author's collection.
 Dutch ships offshore with fishing folk on the beach
(see figure 88)
 Signed: I. Willaerts.
 Canvas: 15½ x 23 in. 40 x 59 cm.
STUTTGART Staatsgalerie.
 No. L566. *Shore scene with fishing folk.*
 Signed: A. Willaerts. fe Ao 1636.
 Panel: 21 x 32 in. 53 x 81 cm.

HEERMAN WITMONT
Born Delft 1605, died Delft after 1683.
Witmont was a prolific etcher and grisaille painter with rather more industry than talent. He was a member of the Delft Guild in 1644, but little is known about him, though he is believed to have worked with a shipbuilder in Rotterdam. It is known that a few of his grisailles are dated earlier than those of Willem van de Velde the Elder and this prompts a suggestion that he may have initiated the method together with Experiens Sillemans (1611-1653).
Signatures:
 H. Witmont.
Signed Examples:
GREENWICH National Maritime Museum.
 No. 30-10. *The Eendracht.*
 Signed: Anno 1654 H. Witmont.
 Grisaille on panel: 24 x 37 in. 61 x 94 cm.
 No. 32-39. *The Battle of Dunkirk, 1st March 1639.*
 Signed: H. Witmont.
 Grisaille on panel: 25 x 40 in. 66 x 102 cm.
 No. 31-13. *The Battle of Gabbard, 2nd June, 1653* (see figure 89).
 Signed: H. WitMont.
 Grisaille on panel: 44 x 70½ in. 115 x 179 cm.
 No. 37-1729/1. *Dutch Squadron in the Sound.*

No. 37-1729/2. *Anglo-Dutch action.*
A pair dated 1660.
Grisaille on panel : 20 x 27 in. 51 x 79 cm.

CLAES WOU

Born 1592 Amsterdam, died 1665, Amsterdam.
Claes Wou is a painter about whom little is known and to whom attributions differ widely.
He painted many violent storm scenes in grey tones, where the waves are exaggerated and the boats heel heavily in the water. Symmetrical waves, dark foregrounds with white foam edging long sweeping waves and fluffy clouds are all characteristic of Wou. He sometimes shows a certain similarity to the other panoramists, Andries van Eertvelt (1590-1652), Hendrik Vroom, (1566-1640) and C. C. Wieringen (1580-1633) but is less colourful and shows less detail and imagination in his compositions. He painted a few calm seas.
Signatures :
C. WOU, C.C. WOU.
Signed Examples :
EMDEN Ostfriesches Landesmuseum.
No. 112. *Seascape.*
Signed in monogram : C.C.W.F.
Panel : 26¾ x 44½ in. 68 x 113 cm.
GREENWICH National Maritime Museum.
No. 53-9. *Ships in a gale* (see figure 90).
Signed : C. WOU.
Panel : 20 x 38 in. 51 x 97 cm.

PIETER ZEELANDER

Active in Haarlem in the mid-17th century.
Pieter Zeelander was a Dutch sea painter and draughtsman who resided for some time in Rome, where he earned the nickname Caper.
He belongs to the grey school of marine painters and has a certain affinity with Jan Porcellis (1585-1632). His pictures are seldom signed and are often attributed to other painters.
Signatures :
P.Z.
Signed Examples :
MUNICH Alte Pinakothek.
No. 5971. *Ships in a choppy sea, rocks to the right.*
Signed : PZ 1647.
Panel : 11¾ x 19¾ in. 30 x 50 cm.
LONDON Formerly in the author's collection.
Channel Island light craft off the Dutch coast (see figure 91).
Signed : P.Z. 1644.
Panel : 22¼ x 35 in. 56.5 x 89 cm.
WURZBURG Martin von Wagner Museum.
No. 456. *Seascape.*
Signed : P.Z.
Canvas : 20½ x 24½ in. 52 x 62 cm.

History and Paintings

FAMILIARITY WITH Dutch marine paintings of the 17th century brings with it a realisation of how closely they are allied to and how faithfully they record the early creation and development of the United Provinces into one of the great powers of the age rivalling England, Spain and France in commercial enterprise and colonial possession.

The association of painters and tumultuous events came together in the Low Countries at the end of the 16th century and continued for over one hundred years, during which time the Dutch clearly illustrated their supreme mastery in the art of marine painting.

The simplest form of marine art is a picture of a boat fulfilling its function as a means of transport on water and from Egyptian times onwards, the subject has been used as a decorative motif on temples, rock carvings, vases and seals.

However, in the 16th century Pieter Breughel the Elder (1525-1569) seems to have been perhaps the first master inspired to paint a truly marine painting as we know it, with ships struggling through great stormy seas, menaced by great rocks and sea beasts which seem to symbolise the terrors of the uncharted oceans of the age.

About this time, an unknown artist Cornelis Anthoniszoon is believed to have painted a work of Portuguese carracks under sail, a charming and colourful composition now hanging in the National Maritime Museum, Greenwich, but a work quite isolated in its concept; many years were to pass, almost to the turn of the century, to the works of Hendrik Cornelis Vroom (1566-1640) and his followers before a marine school of painting became recognisable in the Netherlands. From that time onwards, marine paintings have left us a historical record of battles won and lost, ceremonies and regattas, naval reviews and state occasions and the more humble pursuits of the fisher-folk going about their work.

Marine painting, however, became more than narrative, for with the work of the great innovator Jan Porcellis (1585-1632) and his followers came the interpretation, not merely of vessels on the sea, but of the sea and sky themselves to which the term 'atmospheric painting' is self-explanatory.

On reflection then, it begins to seem less surprising that the Low Countries should produce the first and greatest school of marine painting. Their artists painted the sea because they were never far from it. Much of Holland as we know it today was still unclaimed and under water, everywhere, the sky over the flat landscape reflected the sea and its atmosphere. Much of the peoples' livelihood depended on its harvest and their attempts at the end of the 16th century to throw off the tyrannous yoke of Spain were largely made and won on the sea.

In the 15th and 16th centuries, the Low Countries comprising the deltas of the Rhine, Maas and Scheldt consisted of the present-day Holland, Belgium, Luxembourg and small parts of France and Germany, under the rule of the Burgundian and later, the Hapsburg dynasties. Fishing and a large commercial ship-carrying trade formed the basis of the economy, for, apart from the great maritime provinces of Holland and Zeeland, the low-lying land lent itself to only a limited amount of agriculture, prone to flooding and consequent famine, causing the people to turn their enterprise outwards to commerce and trade, fishing and whaling, taking advantage of their position half-way between the Baltic and Mediterranean trade routes.

On October 25th 1555, the Hapsburg Charles V abdicated and his empire was divided between his brother Ferdinand and his son Philip II, to whom were given the seventeen provinces of the Netherlands.

A devout Catholic without the wise tolerance of his father, Philip was determined to reduce heresy in his new dominions, especially in the Low Countries, where the Reformation had found many followers and consequently, an army commanded by the Duke of Alva was despatched to subdue the recalcitrants.

There are many reasons why the ten provinces of the southern Netherlands remained under the influence of Spain. One of them is certainly geographical, in that they were easily approached from the landward side by the conquering army. To the north, however, the great rivers formed a natural defensive barrier sheltering the seven northern provinces.

In the south, too, the Counter-Reformation began to gain ground, while in the more inaccessible north, the Reformed Church continued to flourish. Though the Reform movement preached tolerance, this was such a new concept in this intolerant age that many Catholic burghers, mistrustful of it and perhaps influenced by contact with the more extreme members, tended to move south and increase the strength of the Counter-Reformation, while those in the south, wishing for freedom from religious tyranny, moved north.

This migration helped to concentrate and isolate the people of the northern provinces, their revolt against repression by Spain becoming indelibly identified with the freedom of religious thought.

It now only needed a determined leader to bind the seven northern provinces together and in William of Orange they found such a one. Unfortunately, his attempted coup against Alva failed, bringing even more repression in its wake, but this failure led indirectly to the first success of the revolt against Spain. Many of the fugitives had taken to sea-faring and piracy – their name, the 'sea-beggars' or 'water-beggars' epitomises their hand-to-mouth existence on the coast and waterways. On the 1st April 1572 the town of Brill was surprisingly seized by the sea-beggars against little resistance, who, with the aid of disaffected elements amongst the local citizens went on to occupy Flushing and Veere. Next the town of Enkhuyzen declared for William of Orange and opened its gates to the sea-beggars.

Suddenly the rebellion sprang to life, Alva's repressive measures and grinding taxation combined with several disastrous famines helping to fan the flames of resistance amongst the people, which was eventually to lead to the total independence of the northern provinces.

Spasmodic warfare continued for some years, attempts being made by William of Orange to unite and pacify both Protestant and Catholic alike and direct their struggle against Spanish rule rather than against each other. Frequently events were painted long after their occurrence.

Hendrik Vroom (1566-1640) painted a battle scene between Dutch and Spanish ships showing an unsuccessful attempt to relieve Haarlem on 26th May 1573.

The Union of Utrecht of 23rd January 1579 was designed to unite all the Netherlands, but it eventually formed the basis of the Republican constitution of the seven United Provinces to the north, now irretrievably divided from the south.

In 1588, the disastrous loss of the great Spanish Armada sent against the English – an event which was well illustrated by Vroom, Cornelis Claes Wieringen (1580-1633) and Aert van Antum (c 1580-1620) – left the garrisons in the Netherlands isolated. Prince Maurice, the son of William of Orange seized the opportunity, reorganised the army and reduced by siege most of the remaining fortresses and towns. In 1596 he allied himself with France and England against Spain, taking part with the English in the attack on Cadiz, an engagement which was painted at a later date by Abraham de Verwer (1590-1650).

By this time the division of the Netherlands was finally determined and this was forever to remain so, especially after an attempt in 1600 to regain control of the Flemish coast failed.

In 1607 the Dutch fleet scored a great victory by defeating the Spaniards at the Battle of Gibraltar. A fine painting depicting Admiral Heemskirk's success and attributed to Aert van Antum (1580-1620) hangs in the National Maritime Museum, Greenwich. This battle was also painted by Vroom, Wieringen and Adam Willaerts (1577-1664). Adam Willaerts and his two sons, Abraham and Isaac, were notable in that they continued to paint in the same anachronistic manner through the century, ignoring all the developments in tonal painting and changes in composition, though this does not detract in any way from their charm.

In 1609, a Twelve Year Truce was signed with Spain, though the final independence was not achieved until the Treaty of Munster in 1648. During these formative years, the Dutch had, with incredible fortitude and endurance forged for themselves a commercial and maritime empire which encircled the globe. In home waters, the fishing industry in the windswept estuaries of the Netherlands gave great scope to many painters, Jan Porcellis who has already been mentioned, Abraham van Beyeren (1620-1690) who painted several

scenes off Dordrecht, the great Simon de Vlieger (1600-1653) who adopted the form of monochrome paint-ing and then went on to refine it and produce compositions evoking an atmosphere of the most delicate luminosity. The more dangerous industry of whaling had already begun to move far north into Arctic waters to follow the retreating whales inspiring many robust compositions. The grisailles of the members of the van Salm family (c 1690-1765) and the fine oil paintings of Abraham Storck of Amsterdam (1644-1710) illustrate very clearly the activities and dangers of the whaling industry. A small point of further interest in them is the small 'whale flag' worn by the ships at work, though in actual practice it was only flown to indicate a full catch.

The merchants of the Republic began to extend their influence beyond the narrow confines of Europe follow-ing the footsteps of the Portuguese and Spaniards.

Attempts at founding a North-East Passage to Asia had failed, but in the 1590's, trade began to pass through the South Atlantic into the Indian Ocean. In 1594 nine Netherlands merchants organised a 'Company of Far Lands' at Amsterdam and despatched two fleets to Indonesia. The losses in men and ships were enormous, but the profits were equally excessive and tremendous rivalry for this new, immensely rich source of trade sprang up. Hendrik Cornelis Vroom painted the return to Amsterdam of the second expedition to the East Indies under Jacob van der Neck and the departure of Cornelis Houtman's fleet was recorded by Cornelis Verbeeck (1590-?1631).

Prince Maurice, recognising the benefits of co-operation, guided the formation of the East India Company which came into being on the 20th March 1606. Portugal had pioneered the East Indies trade up to now and Dutch expansion on Amboyna, the Moluccas, Malaya, Ceylon and India, was largely based on the cap-ture and exploitation of Portuguese settlements and forts. Against the Spaniards in the Phillipines they were less successful. On the 3rd June 1621 a West Indies Company was formed to trade in the Americas and West Africa, but it suffered too many reverses, settlements never achieved permanence and the venture did not flourish.

At this time there are many delightful paintings which show Dutch ships trading, scenes which must at that time have been repeated throughout the known world. Loading timber (Andries van Eertvelt (1590-1652)), Dutch ships off a rocky shore by Adam Willaerts showing fishermen selling their catch, or, at a later date, a ship lying in the harbour at Naples painted by Adam's elder son, Abraham. Again, in a more war-like vein, a Dutch fleet attacking a Spanish fortress, by the same artist. In the year 1621, the Truce with Spain ended and war broke out again. During the ensuing hostilities, one of the greatest prizes of all time fell to the Dutch Admiral Piet Heyn, with the capture of the entire Spanish silver fleet off Cuba in 1628. The years of war brought no halt to the increasing prosperity abroad and in home waters, but there was to be one great decisive victory to come for the Dutch in 1639 which finally established their position as an independent power.

The port of Dunkirk had remained a Spanish garrison from which they continually menaced Dutch shipping in the Channel, usually successfully. Emboldened by this, the decision to launch another Armada was made with the intention of landing an invasion force to strike once more at the Dutch from the south.

The preparations followed a similar pattern as for the one launched against the English in 1588. An enor-mous and cumbersome fleet was gathered together, which left Corunna in the summer of 1639 and began to move slowly up the Channel. On September 16th the famous Dutch Admiral Marten Tromp went into action against it. The Armada, too heavily laden with transports filled with men and equipment for land fighting, too slow for manoeuverability, was damaged sufficiently to put it on the defensive. Two day later, Tromp attacked again, continuing the action all day until he had to retire to Calais to replenish his supplies of powder. After this, the Armada was so badly crippled it was brought to anchor before the English Downs. There it remained for several indecisive weeks while trying to negotiate with the neutral English for supplies and repairs to the fleet. This however, gave ample time for the Dutch to put every ounce of effort into re-inforcement and replacement until finally, on October 31st, ninety-five Dutch ships with eleven fireships attacked the Armada, still lying at anchor. The victory for the Dutch was total, the fireships particularly causing great havoc amongst the large Spanish ships caught like rats in a trap and their losses in ships and men were enormous.

By the time the Dutch withdrew, their victory was so complete that Spanish sea power was finally broken.

This battle was painted by Hendrik Anthonissen (1605-1656) and Arnoldus Anthonissen (1631-c1703) who shows the destruction of the flagship of the Portuguese Squadron, the *Santa Theresa,* by fireships.

A few years later, negotiations for peace were begun and formalised at the Treaty of Munster in 1648. The Flemish painter, Bonaventura Peeters commemorated this historic occasion in a painting of a reception given by the Governor of the Netherlands to the Cardinal Infanta Ferdinand of the Spanish Delegation.

With the Treaty, Spain finally recognised the Republic as an independent nation, but, however delayed this recognition had been, the wealth and power of the new emergent country were undeniable. Gold, slaves and ivory came from West Africa, sugar from Brazil, silver from Mexico and Peru, spices from the Indies essential to the preserving and flavouring of food, silks and cottons from India and salt from the Leeward Islands and Venezuela to avoid the embargo on salt from the Iberian Peninsula and which was so necessary to the salt fishing industry. A settlement at Formosa even traded with China and Japan in tea and porcelain and in 1652, Jan Riebeck founded a settlement at the Cape of Good Hope.

Naturally ships and convoys travelling immense distances and usually with rich cargoes were prey to pirates, particularly in the Mediterranean. Actions between Christian ships of all nationalities and Turkish or Barbary pirates often occurred and were painted by Gaspar van Eyck (1613-1673) Hendrik Minderhout (1632-1696) and Lieve Verschuier (1630-1686).

During these years of expansion, the English had been greatly concerned with the quarrels between King and Parliament, culminating in seven years of bitter civil war and the eventual execution of Charles I on January 30th 1649.

The Dutch may have looked with some interest and sympathy at the establishment of a Commonwealth in England but this was soon dissipated. With the return to stability, the English, also a sea-faring trading nation began to increase their activities at home and abroad and immediately rival their neighbours across the North Sea.

The English Navigation Act of October 9th 1651 struck a very shrewd blow at the Dutch ship-carrying trade. In essence it meant that no goods were to be imported unless in English ships and taking advantage of the refusal to allow the English the Right of Flag, i.e. all foreign ships should dip their flags first on encountering an English ship, shots were exchanged between Admiral Tromp and the English General-at-Sea Robert Blake, off Dover on May 19th 1652, the English claiming a victory on the occasion. These of course, were simply aggravations, the problem between the two countries being a frank clash of trading interests.

The First Anglo-Dutch War lasted from 1652-4, marked by several violent naval engagements. Reinier Nooms otherwise called Zeeman (1623-1667) painted several of these actions, especially illustrating the exploits of Marten Tromp. The Battle of Livorno on March 4th 1653 was also painted by Nooms and by Pieter Coopse (fl1668-1677).

In the Mediterranean the English had to give way before superior forces, but in home waters the Dutch Navy was less successful, ruled by the jealousies of no less than five Admiralty Boards. Their final defeat came at the Battle of Scheveningen on July 31st 1653, during which the great Dutch Admiral Marten Tromp was killed. Although throughout the war, the Dutch had inflicted heavy punishment, the result was never in doubt and the English emerged victorious.

Once again the threads of comparatively peaceful trading were resumed, but within a short space of time a new source of danger to Dutch trade became apparent.

All the shipping from the Baltic had to come through the narrow passage of the Sound and the policies of Charles X of Sweden became more aggressive towards Denmark, since, to subdue that country would give him a very lucrative stranglehold on the Baltic trade. This upset of the balance of power could not be tolerated by either the Dutch or the English to whom the unrestricted flow of trade through the Sound was essential. The Dutch allied themselves to Denmark and their fleet engaged the Swedes at the Battle of the Sound in October 1658. They were commanded by Lieutenant-Admiral Jacob van Wassenaer with Admirals Witte de With and Jan Evertsen. The famous de With was killed but Evertsen carried the battle for the Dutch.

The Swedes were still not sufficiently reduced either in strength or ambition by this blow and the following year the Dutch Admiral Michiel de Ruyter was called back from retirement and later in the year sailed for

the islands of the Danish Archipelago. The prime object was the fortress of Nyborg on the Island of Funen, the occupation of which was a serious threat to the town of Copenhagen. The combined actions of the Dutch fleet and a Dutch-Danish army ended with the complete reduction of the garrison. With the death of Charles X early in 1660, also died his pretensions to an Empire and unrestricted trade was resumed with the Baltic States.

The Battle of the Sound was painted by Jan Abrahamsz Beerstraten (1622-1666) and Willem van de Velde the Elder (1611-1693) who did several grisailles of the action.

In 1660, the Restoration of Charles II to the English throne was an event of some importance to the Dutch. His departure from the beach at Scheveningen was recorded by several artists. He had acquired a taste for yachting for pleasure while in Holland and introduced it into England. In addition he was a great patron of the arts and in 1673, the two great marine artists, Willem van de Velde the Elder and Younger, were invited to come to England to receive Royal appointments to draw and paint pictures. They were given rooms in the Queens House at Greenwich and each a salary of £100 per annum. Their influence was followed by English marine painters and from their work developed an English school of marine painting which has remained prominent to the present day.

In 1664, when the depredations of pirates in the Mediterranean were becoming too severe, Admiral de Ruyter was given the powers of an Ambassador and treaties were signed with Algeria and Tunis which would supposedly restrict the activities of the predators. Again for a short time there was an uneasy peace, but by 1665, relations between the Dutch and English were once more becoming strained. This time, it was the English Admiral Sir Robert Holmes who sparked off hostilities by capturing the Dutch-held island of Goree and reducing the trading posts on the Guinea Coast. Admiral de Ruyter was promptly and secretly despatched to recover the losses and by the time he returned to the Netherlands, the second Anglo-Dutch War of 1665-7 had been declared.

A large Dutch fleet was mobilised, much bedevilled as before in the appointments of its various commanders by the political jealousies between the Admiralty Boards. The result of this was that though the fleet was again commanded by Admiral Van Wassenaer there were no less than six other Admirals, the whole fleet being divided into seven squadrons. Their first action on putting to sea was to capture a convoy of English-Hamburg merchantmen, which brought the English fleet commanded by H.R.H. the Duke of York out of harbour post-haste to avenge the outrage.

The two fleets met on June 3rd 1665, some miles off the English coast in the region of Lowestoft. The battle went badly for the Dutch almost from the beginning, as Admiral Kortenaer was mortally wounded in the early part of the engagement, his captain turned and left the scene, and most of the squadron, believing him to be retreating, turned and followed him.

Admiral Wassenaer's ship, the famous *Eendracht* blew up with great loss of life while engaging the Duke of York's flagship. Even though Jan Evertsen hoisted his flag as C. in C. following this disaster and many ships continued the fight with great gallantry, large numbers fled in great confusion. The enormity of the disaster led to a series of bitter controversies and courts-martial amongst those who had taken part in the battle. The Battle of Lowestoft being a Dutch defeat was painted only once, a fine composition by Hendrik Minderhout (1632-1696).

It was a year before the fleet could put to sea again. Admiral de Ruyter, once more appointed as Lieutenant-Admiral had the enormously difficult task of welding together a navy which had been not only physically shattered but thoroughly demoralised. Alarmed by the rising power of the English, the French allied themselves with the Dutch and though their fleet never actually appeared in support, it did cause the English to divide their forces in anticipation of their presence. A squadron under Prince Rupert set out to wait for them, leaving the depleted English fleet commanded by the Duke of Albemarle to fight the Dutch.
On the 1st June 1666, commenced one of the greatest sea battles of all time – the Four Days' Fight – as it became known. Albemarle's squadron fought alone for two days, suffering heavy losses and gradually retreating towards Prince Rupert, leaving disabled ships to be taken up by the enemy. Amongst them was the great *Royal Prince,* which when first built had been the finest ship of her time. Though rebuilt twice since then, she was still a prestigious gain for Admiral Tromp (the son of the famous Marten Tromp) who had to burn her to prevent her being recaptured. The loss of the *Royal Prince* was notable, for apart from Grenville in the

Revenge, it was the only occasion when an English Flag Officer hauled down his flag in battle.

By the fourth day, Albemarle and Prince Rupert had joined forces: all attempts at fighting order had been lost; ships fiercely engaging each other as they met and wreckage scattered over miles of sea. The English losses were enormous – almost twice those of the Dutch – and as news of the battle reached London initially as a victory, the revelation of the extent of the losses emphasised all the more the humiliation of the defeat.

One of Abraham Storck's most colourful paintings commemorates this victory. All the colour and vigour of his work seems to embody the sense of achievement by the Dutch in defeating so formidable an enemy. Willem van Diest (1610-1673) also painted the burning of the *Royal Prince,* while Willem van de Velde the Elder painted at least six versions of the battle – actually being present in his galliot during the action.

The rejoicing however was to be short-lived. Six weeks later, the Dutch, hoping now to find the English weakened, proposed to land on the English coast, but instead, found their opponents utterly determined to avenge themselves at whatever cost. On July 25th, St. James's Day, battle was joined once more, this time in the mouth of the Thames. The opposing commanders were as before, Admiral de Ruyter for the Dutch and the Duke of Albemarle and Prince Rupert in joint command of the English. This time, however, the English rising to the desperation of the situation, decisively defeated the Dutch, so heavily in fact, that two weeks later, Sir Robert Holmes was able to enter the Vlie unopposed and burn to destruction a huge Dutch merchant fleet. An occasion always remembered as 'Sir Robert Holmes, his Bonfire'.

The following year (1667), peace terms were sought between the two countries, but the English were so outrageous in their demands – not only were they refused, but Admiral de Ruyter made a swift attack on the unprepared English fleet lying in the Medway.

As may be imagined, this was recorded by many Dutch painters, including Jan van Leyden (fl1661-1675), who is mainly known for his works commemorating the victories by the Dutch over the English, and Willem Schellinks (1627-1678).

Though the Dutch were eventually held, the blow to English pride and prestige was immense. At the first news of the attack, the garrison under Sir Edward Spragge evacuated Sheerness and retreated to Gillingham. The Duke of Albemarle ordered a chain to be slung across the river, with five ships sunk below it and a battery at each end, but the strength of the Dutch attack smashed the chain, allowing them to bring fire-ships through and eventually destroy one of the batteries. For three weeks the Dutch were in the river at the junction of the Medway and the Thames. Not only did they inflict much damage to the navy and shore installations, including the capture of the *Royal Charles,* the pride of the English navy, but also the presence of the enemy paralysed all river-borne traffic.

It was the heaviest and most audacious defeat in naval history, the humiliation being deeply felt and though the Dutch were unable to press on with plans for an invasion, they were in a much stronger position to press for peace terms when they were made at the end of July 1667. Amongst other concessions, the English claim to the Right of Flag was limited to home waters and the Navigation Act was modified. The Dutch, however, lost New Amsterdam, now to be known as New York in honour of James, Duke of York.

The new Republic seemed now to be in a position to enjoy its prosperity and influence. In marine art there was less emphasis on war-like subjects, instead there are magnificent compositions by the Willem van de Veldes, father and son depicting the splendours of fine ships and the gaieties of ceremonial regattas, the new sport of 'yachting' – new to the English, that is – was a favourite subject. In fact, Charles II introduced it to England and no State occasion was complete without this enjoyable spectacle.

About the middle of the century, there had been a return to the use of colour in painting, the monochromes of earlier years giving way to less spiritual but more realistic work. The southern ports of the Mediterranean seemed to have a great attraction for Dutch artists and even if, like Abraham Storck, they never left Amsterdam, it did not deter them from painting gay and colourful foreign scenes.

Many painters did travel, Andries van Eertvelt for instance spent some time in Genoa, and Lieve Verschuier also painted in Italy where the crisp clear colouring of his Dutch scenes gave way to a soft golden warmth.

The rise in power in the Republic became a source of alarm to Louis XIV and in 1667 he claimed part of the Spanish Netherlands as compensation for his wife's unpaid dowry, but the seizure of Franche Comte on

France's eastern frontier alerted all Europe and England, Holland and Sweden formed the Triple Alliance against him. By the Treaty of Aix-La-Chapelle in 1668, he was compelled to give up Franche Comte, though retaining part of the Spanish Netherlands. Though all seemed well for the moment, Louis was far from satisfied and entered into secret negotiations with Charles II to destroy the power of the Republic and so leading to the third Anglo-Dutch War 1672-3.

In May, 1672, the French crossed the Rhine and attacked from the East, while once more the Dutch fleet under Admiral de Ruyter put to sea knowing that the English and French fleets were assembling. The Allied fleets were sighted and then lost again in thick fog. The two commanders, James, Duke of York and the French Admiral Jean d'Estrees anchored in Southwold Bay, not suspecting the near proximity of the Dutch. As the fog cleared, with visibility, the dangers of the situation became apparent – it was the Battle of the Downs of thirty years before repeating itself, with a large fleet caught at anchor in a confined space.

Cables were cut and amidst great confusion, some of the English ships were towed into position to commence fighting. The French squadron left the scene and de Ruyter, detaching a small force to watch them, fell with great fury on the English with the main body of his fleet. It was one of the most fiercely fought engagements of the century. At the third attempt, Lord Sandwich's flagship, the *Royal James* was set on fire by fireships, having successfully resisted grappling and boarding, but in the ensuing confusion of abandoning ship, not only many of the ship's crew, but Lord Sandwich himself was lost. Willem van de Velde the Younger painted this episode in the battle and there are numerous copies of this famous painting to be seen.

The Dutch continued to press their advantage throughout the day and when they broke off the action that evening, they left the English fleet immobilised and incapable of transporting an invasion fleet to the Netherlands.

It was at this time that the young Prince William of Orange, hereditary leader of the Royalist faction in Holland, came to the fore. On attaining his majority, he returned to Zeeland to claim his right to take his place in their assembly and so was poised to take up the great position so soon to be awarded him. The French began the invasion of the Low Countries on April 6th 1672 and in June the Dutch flooded the dykes, halting the French and bringing about a stalemate in the campaign, but causing themselves great harm. The Netherlands, perceiving how desperate was their situation, turned from the Republicans who were ready to accept humiliating peace terms from Louis whose army was deep in their territory, towards the House of Orange under whose inspired leadership they had laid the foundations of their independence in the previous century. Both Holland and Zeeland, the former the most Republican state – appointed William Stadholder and, on 8th July 1672, created him Captain and Admiral General of the Union, his position being further strengthened by the murder of the de Witt brothers, leaders of the Republican Party.

Gradually through that year the French forces were beaten back. Despite his unprepossessing appearance, Prince William was to prove himself the most determined adversary of the French and the most stalwart upholder of the Protestant faith in Europe. The year 1673 saw the last of the Anglo-Dutch battles at sea. De Ruyter was once again commanding the Dutch, but in the English fleet, the Catholic James, Duke of York was banned from holding office under the Test Act and command of the Navy had been given to Prince Rupert though without the title of Lord High Admiral.

The Dutch took the initiative in 1673 by trying to close the mouth of the Thames to the Channel with sunken ships filled with stones, but Rupert managed to evade the trap by sailing through the Narrow to join D'Estrees and the French forces. Once more the English and French were poised ready for an invasion of the Netherlands, but Admiral de Ruyter was waiting off Schoonveld for them and on May 28th came out to fight the combined Anglo-French fleet.

Strategically, the battles of Schoonveld were Dutch victories – a second battle taking place a few days later on June 4th. There are two grisailles by Willem van de Velde the Elder which illustrate the battles, hanging in the National Maritime Museum, Greenwich.

Once more the allies had to fall back and refit, but the invasion threat to the Dutch though averted still existed and continued to do so for another two months until the final decisive clash took place at the Battle of the Texel.

In the middle of July, the Allied invasion fleet had set sail for Dutch waters once more and on 31st July met

the repleted Dutch fleet of sixty ships off the Texel. The French fleet was in the van and De Ruyter, remembering what tardy allies the French had been to him, thought they might prove so again. His supposition was correct, the Dutch attack broke through the Allies, effectively isolating the French who then took little part in the rest of the engagement and directed the brunt of the fierce Dutch onslaught against the English. By seven o'clock that evening when the Dutch broke off the action, the English fleet was crippled. Commemorating this great victory Willem van de Velde the Elder painted a series of six works illustrating the progress of the battle and his son Willem the Younger may have painted as many as ten. These two, the greatest of all the Dutch marine painters, were employed during the course of a battle to make drawings of the actual actions as they took place, in the manner of war artists of today, which could be translated onto canvas at a safer time. Paintings depicting engagements were often commissioned by those taking part or by the Dutch Admiralty.

The effects of the victory of the Texel were both immediate and far reaching. Charles II made peace with the Netherlands and his niece Mary was later betrothed to Prince William of Orange in 1677. Mary was the elder daughter of James, Duke of York, so bringing about a much closer union between England and the Netherlands, though peace between France and the Netherlands was not to be concluded until 1678 and a very uneasy peace it was, between two such implacable enemies as the Protestant William and the Catholic Louis.

Again the departure of William and Mary from England in November 1677 after their marriage was painted by Willem van de Velde the Younger who has left a record of almost every important occasion in the latter part of the 17th century.

In 1685, Charles II died, leaving James, Duke of York to ascend the throne. In that same year, Louis revoked the Edict of Nantes and, in consequence, many French Protestants emigrated to the Netherlands to avoid religious persecution.

Unfortunately, King James II of England was a devout Catholic himself and one determined to bring his subjects back to his faith, but within three years, his unpopularity caused by the severe prosecution of his religious policies led to rebellion. Overtures were made to William of Orange who landed at Torbay to lead a Protestant uprising, usurping James, who, with his wife, took refuge in France.

Neither the landing of William or the escape of James to France were painted by important artists, but three months later, the arrival of Queen Mary at Gravesend in February 1689 was painted by Willem van de Velde the Younger.

Despite the joint crowning of William and Mary, James remained determined to regain his throne with the connivance of Louis XIV.

An invasion was planned from France and supported by Catholic Ireland a large force was landed at Kinsale Bay, without, for some extraordinary and unknown reason, a supply train behind it. Not surprisingly, the effect of the landing was abortive, all the men and their immediate equipment being lost.

The first fleet action of the long Anglo-French wars was the Battle of Bantry Bay in May 1689 in which the English under William fought the French who were supporting James. After this engagement the War of the English Succession was formally declared and was to drag on from 1689 to 1697. A month later the now combined Anglo-Dutch fleet under Lord Torrington met the French at the Battle of Beachy Head – another indecisive action. However, a most decisive naval action off the French coast ended forever James's aspirations to return to England and ensured the safety of the English throne, both for William and Mary and for the English Protestant succession.

This was the Battle of La Hogue, which lasted from May 19-24th 1692.

The English under Edward Russell brought an overwhelming force against the French commanded by the Comte de Tourville. This historic battle was painted by several artists of the time showing the tremendous losses and destruction inflicted by the English – especially in the use of fireships – on the French, the scene most often repeated being the burning of the French flagship the *Soleil Royal*. Peter Monamy executed two compositions, the first, which was in the collection of the Rupert Preston Gallery shows the beginning of the attack on the flagship and a companion painting in the National Maritime Museum, Greenwich, the ship burned almost to the water-line. The destruction of the French fleet was also painted by Adriaen van

Diest, Ludolf Backhuyzen and Willem van de Velde the Younger. It was also painted in more recent times by T. Mitchell and Benjamin West among others.

James, watching from the French shore saw his chance of regaining his throne being destroyed by that very same navy he himself had served so well and done so much to improve. His defeat was decisive and absolute, though the war only finally came to end with the Treaty of Rijswijk in 1697.

A point of interest here is that as a result of the battles, there were so many disabled sailors, that Mary conceived the idea of using the Palace at Greenwich as a home for aged sailors. Orders were given to Christopher Wren to complete Charles II's unfinished palace as Greenwich Hospital and the first pensioners were admitted in 1704.

The Treaty of 1697 was personally important to William in that France recognised him not only as King of Great Britain, but restored to him the Principality of Orange in the South of France which had been annexed by Louis some years before.

The second half of the 17th century had seen the increasing development and consolidation of economic activity and trade, even in the face of competition from Great Britain and France with their protectionist policies in home waters. Unfortunately for the Dutch, the establishment of their Stadholder on the English throne had led to some disaffection in their own country. The close ties which might have been presumed to exist between the two countries in this special circumstance did nothing to decrease English curtailment of Dutch trade at home or competition overseas.

After William's sudden death in 1702, his place on the English throne was taken by Queen Anne, Mary's younger sister and a period without a Stadholder was begun for Holland.

The Republic was overshadowed by its Allies in the recurrent struggles against Louis in what became known as the War of the Spanish Succession (1702-1713) and a gradual decline in the position of the United Provinces as one of the Great Powers began to take place.

The previous hundred years had seen the organisation of revolt against Spanish occupation and repression, the necessity for freedom from religious tyranny and domination by a foreign power giving rise to a desire for national unity.

With the realisation of these aims arose a new nation and a great power which became content to reap the fruits of its splendid achievements.

Précis

MAJOR DUTCH NAVAL EVENTS 1600-1700

DATE	EVENT	ARTIST WHO PAINTED EVENT
1607	25th April. Battle of Gibraltar. Admiral Van Heemsstreck's victory over the Spanish fleet under Don Juan d'Alvarez de Avila.	ADAM WILLAERTS, Rijksmuseum.
1623	Dutch at Amboyna in East Indies seized the English residents, tortured them, murdered ten and drove the rest from the island. This act long rankled with the English at home and was one of the more conscious causes of the First Dutch War in 1652.	
1627	English expedition to La Rochell.	ABRAHAM DE VERWER.
1637	Launching of the *Sovereign of the Seas*. Rebuilt and renamed *Royal Sovereign* in 1701. The first ship to carry 100 guns.	VAN DE VELDE THE YOUNGER painted a portrait of her designer Peter Pett with stern view of the ship in the left background. National Portrait Gallery.
1639	Battle of the Downs. Dutch under Marten Tromp defeated Spanish in English waters, the English remaining neutral at the time.	HENDRICK VAN ANTHONISSEN. Nederlandsch Historisch Scheepvaart Museum, Amsterdam.

DATE	EVENT	ARTIST WHO PAINTED EVENT
1641	Action by de Witt with Dunkirkers off Nieuport.	JACOB LOEFF.
1645	30th Aug. – 9th Sept. Action at Tamandare.	VAN DE VELDE THE ELDER.
1646	October. Blockade of Dunkirk by Lieut-Admr. Marten Tromp.	HENDRIK VAN ANTHONISSEN.
1650	Defeat of Royalist squadron under Prince Rupert by Parliamentary fleet under Robert Blake at Cartagena Bay, in the Mediterranean.	
1652-54	FIRST DUTCH WAR.	
1652	19th May. Battle of Dover. Marten Tromp attacked English under Blake.	
1653	4th March. Battle of Leghorn.	WILLIAM VAN DIEST REINIER NOONS (ZEEMAN) National Maritime Museum (both). PETER COOPSE.
1653		First dated work of VAN DE VELDE THE YOUNGER.
1653	18th February. Battle of Portland. Blake attacked Dutch merchant fleet of 200 ships heading home from the Mediterranean under the command of Marten Tromp.	
1652	28th September. Battle of the Kentish Knock. Dutch under de Witt beaten by English under Blake.	
1657	7th August. Blake died at sea as his squadron was entering Plymouth Sound.	
1658	29th Oct. – 8th Nov. Battle of the Sound. Dutch defeated the Swedish fleet.	VAN DE VELDE THE ELDER. Grisaille. Several versions in the Rijksmuseum, and at Alkmaar.
1660	RESTORATION OF CHARLES II. The King on the journey between Moerdijk and Delft. Embarkation of Charles II for England. Embarkation of Charles II from Scheveningen.	VAN DE VELDE THE YOUNGER. VAN DE VELDE THE YOUNGER. 5 versions. HENDRIK MEYER.
1665-67	SECOND DUTCH WAR.	
1665	3rd June. Battle of Lowestoft. Dutch under Obdan heavily defeated.	LUDOLPH BACKHUYZEN. HENDRICK VAN MINDERHOUT. National Maritime Museum.
	31st July – 10th Aug. Battle of Scheveningen. 3rd August. English prevented from attacking Dutch East India fleet seeking refuge in Bergen harbour by intervention of the Danish governor.	VAN DE VELDE THE YOUNGER. VAN DE VELDE THE YOUNGER. Grisaille. Rijksmuseum.
1666	1st – 4th June. Four Day Battle. English fleet under Monck, now Duke of Albemarle and Prince Rupert in inconclusive encounter with the Dutch fleet under De Ruyter. Burning of the *Royal Prince*.	VAN DE VELDE THE YOUNGER. PETER VAN SOEST. ABRAHAM STORCK. WILLIAM VAN DIEST. National Maritime Museum.
1666	25th – 26th July. Battle of St. James's Day. Albemarle and Prince Rupert defeat De Ruyter. 8th August. Destruction by Sir Robert Holmes of about 170 Dutch merchant ships in the Vlie.	

DATE	EVENT	ARTIST WHO PAINTED EVENT
1667	June. Dutch Fleet sails up the Medway. Attacked English fleet off Sheerness. *Royal Charles,* 80 taken and three others burnt.	JAN VAN LEYDEN. PETER VAN SOEST. WILLIAM SCHELLINKS. JAN PEETERS.
1672-73	THIRD DUTCH WAR.	
1672	28th May. Battle of Solebay. *Duke of York* caught at anchor by Dutch so went into battle in some disorder. As a result the flagship of Lord Sandwich, *Royal James,* 100 guns, was destroyed by a fireship and the Admiral drowned. Dutch lost two ships and the French failed to come into action.	VAN DE VELDE THE YOUNGER. 10 versions.
1673	28th May. Battle of Schoonevelde.	VAN DE VELDE THE ELDER. Oil and Grisaille in National Maritime Museum. Both of 1st battle.
	4th June. 2nd Battle of Schoonvelde. 11th August. Battle of Texel, *Royal Prince* almost lost.	VAN DE VELDE THE ELDER.
	Battle of Kijkdrin.	VAN DE VELDE THE YOUNGER.
1674	February. End of War. Charles II signifies his pleasure that WILLIAM VAN DE VELDE THE ELDER should be given £100 a year for taking and making draughts of sea fights, and a like sum to the YOUNGER for putting the said sea fights into colour.	
1677	William of Orange returned to Holland with Princess Mary. Royal Yacht *Mary* and others becalmed in the Thames.	VAN DE VELDE THE YOUNGER. National Maritime Museum.
1680	24th May. *Kingfisher* in action with the Barbary pirates. *Kingfisher* under command of Captain Sir John Kempthorne fought alone with 7 Barbary corsairs for 12 hours. The *Kingfisher* carried 46 guns. Captain Sir John Kempthorne was killed.	VAN DE VELDE THE YOUNGER.
1688	William III escorted to England from Hellevoetsluis.	PETER VOGELAER. VAN DE VELDE THE YOUNGER. Oil. National Gallery of Ireland.
1692	19th – 24th May. Battle of Barfleur. English under Admiral Edward Russell (afterwards Earl of Oxford) with 97 ships of-the-line destroyed French fleet sheltering in the harbour of La Hogue. Burning of Tourville's flagship the *Soleil Royal.*	ABRAHAM VAN DIEST. National Maritime Museum. PETER MONAMY (after W.V.V.)
1697	Visit of Peter the Great to Amsterdam.	ABRAHAM STORCK. Nederlandsch Historisch Scheepvaart Museum, Amsterdam.

Ships

The enormous expansion in overseas exploration and trade in the 17th century was responsible for the corresponding development in the size and design of ships to keep pace with this. These changes are well illustrated in the prolific marine paintings of the time and should be taken into account, together with other important factors such as the colouring, hand of the artist and the age of the panel or canvas when identifying and dating a painting.

The earliest mode of transport on water would have been a log paddled along by the hands and feet. The next step would obviously be to lash several logs together to make a raft, moved along by paddles or oars. Hollowing out a log would make a canoe which later would be enlarged to hold more people and cargo and the addition of a mast and sail would utilise the wind force. In Northern waters the Viking influence was the predominant one – their ships being driven by oars and a square sail. In the Mediterranean, however, a triangular sail developed and remained the most characteristic feature of vessels from these waters to the present day.

Increasing exploration and communication led to the exchange of trade and the carrying of merchandise required vessels with larger hulls and a corresponding increase in the size and number of masts to carry the larger sail area necessary to drive the ships.

In the Mediterranean the larger galleys were driven by one, two, three or even four rows of banked oars with two or three masts carrying the huge triangular sails. This type of sail was known to European sailors as a 'lateen sail' – which may have come from the exaggerated pronunciation of the word 'latin'.

Ships of course were not only used for trading but were important weapons of war, indeed in such perilous times every merchantship had to be capable of defending herself or run the risk of capture and destruction at the hands of a stronger force. The Mediterranean galley acquired a long, sharp beak, as their oars gave them great manoeuverability and speed especially over short distances at close quarters and ramming their opponent was the chief tactic. The development to meet the requirements for fighting in northern waters, however, led directly to the characteristic appearance of sailing ships which survived with only minor changes until the beginning of the 18th century.

For protection and to provide a high platform from which to fire, castellated structures were built up at each end of the vessel – the stern and forecastles – the higher the better for shooting down on the enemy at close range and to give greater advantage when boarding. Until armament became powerful enough to inflict damage at long range, an enemy ship was usually defeated by grappling, boarding and hand-to-hand fighting.

Gradually, as these structures became higher and larger, the hulls also increased in depth to offset the topheaviness and consequently were divided into decks. As guns also became heavier and larger, the piercing of the ships' sides with ports for the guns to be carried below was invented as early as 1501 by a Frenchman, Deschampes of Brest. Great care had to be taken that the ports were not so low that they could ship water in heavy weather and several tragedies are known to have occurred for just this reason. One of the earliest was the loss of the English *Mary Rose* in July 1545 and as late as the Battle of Quiberon Bay, fought in bad weather in 1759, the French ship *Thesee* foundered suddenly and was lost with all hands when caught by a particularly heavy sea, with her gun ports open for action.

The earliest marine painters of the Netherlands depict ships of a very characteristic appearance. In origin they were mostly Dutch, Spanish, Portuguese and English. They were of two main types, a short, wide and rather round-hulled ship known as a carrack and the longer, narrower, lofty ship described as a galleon.

The ships usually had three masts but occasionally four, with the forecastle projecting well over the bows and a high aftercastle at the stern. This build-up of height gave superiority at close quarters, but the ships were unwieldy and slow moving and could be defeated by smaller, handier ships such as those built by the

English, who, with longer-ranged guns, could keep them at bay and were quicker than either the Spanish or Dutch to see the advantage of this. Their harrying of the Spanish Armada of 1588 showed the superiority of their tactics. The Spanish galleons filled with troops equipped for land fighting simply could not close with and crush the smaller English forces in the face of their gunfire.

The masts of the ships were supported by shrouds attached by lanyards and deadeyes to the chainwales (channels) at the sides of the ship. Those supporting the mainmast were situated lower down the sides of the hull than the others but this was found to interfere with the firing of the guns on occasions, consequently about the middle of the century, they were moved up to the level of the foremast channels.

The appearance of the sails is very characteristic in the early works. They were painted very square, always full blown. The main and foremasts carried two large square sails with square topsails above them. Below the bowsprit, a square spritsail helped to keep the head off the wind and the aftermast (or mizzen) – and in the case of the fourmasted vessel, the bonaventure mizzen – carried lateen sails – again to help the ship to sail closer to the wind.

The rich style of painting of the hulls in the 16th century began in the 17th century to give way to elaborate gilding and decoration. Even the comparatively sober Dutch evinced their justifiable pride in their fine ships in this manner, as did the English. During the Commonwealth however, the decoration of ships was considered too frivolous for a Puritan republic, but with the Restoration there was a return to embellishing of ships as much as, if not more than before. The most elaborately decorated ships were undoubtedly the French. Under the expert hand of Louis XIV's brilliant administrator the Marquis de Colbert towards the end of the 17th century, French shipbuilding became the finest in the world, every capture a prize to be copied. Even though the finest artists of the age such as Pierre Puget, Charles Lebrun and Jean Berain were employed to design the decoration, this became elaborate almost to the point of absurdity, each great ship taking to the sea in the guise of a small palace.

With the development of two or more decks completely armed – though the Dutch did not build three-deckers i.e. ships with three gun decks until almost the end of the century – the overhanging forecastle was brought back into the main hull of the ship and the bow continued forward with a projecting head to form a beak. On Dutch ships, this was always decorated with a lion differentiating them from the English and French which bore lions or other figureheads.

In early ships the beak was long and narrow but through the century the design tended to shorten and widen and gradually became set at a much higher angle. The built-up aftercastles disappeared and instead, abaft the mainmast there rose a half-deck, a quarter-deck and a poop.

Not only did the sterns of the ship give great scope for artistic embellishment, but their shape gives an important indication of their nationality. Those of Spanish ships were extremely high and narrow, bearing a painting which identified the name of the ship – usually a saint. The sterns of Dutch ships were also rather upright and rectangular but appreciably smaller than the Spanish. English ships were readily distinguished by having a rounded tuck (the term used to describe the method of building by which the planking curves round to the stern-post) and the stern usually bearing the Royal Arms with supporters.

Spanish sea power was effectively smashed with the destruction of the Armada of 1639 by the Dutch fleet, and generally speaking after that time marine paintings show almost exclusively Dutch ships and their chief rivals and protagonists, the English. In the latter part of the century after the deposed English King, James II fled to France where Louis XIV promised support to press the claims of James, the splendidly decorated French ships with their low square sterns are to be seen in battle with the now allied Dutch and English fleets. Galleries ran along the sides of the stern which were later extended round the sterns in tiers, making a walk. Through the 17th century though they were gradually discontinued by all except the French.

Until about 1640, ships carried a single lantern at the poop, but as ships became larger, they acquired two or three lanterns. An interesting point here is that during Admiral Tromp's actions in the Channel against the Dunkirkers in the two years preceding the Battle of the Downs in 1639, he personally identified his ship to his squadrons by carrying two large lanterns at the poop and one at the maintop.

Early in the 17th century, the fourth mast or bonaventure mizzen disappeared and for the next two hundred years, increase in power came within the framework of the three-masted rig, larger hulls and a developing

sail plan. Larger ships acquired topsails on the mizzen mast and a spritsail topsail on the bowsprit. The methods of reducing sail to meet varying weather conditions also underwent several changes. At the beginning of the century the sail could be increased by the addition of a bonnet – a strip of canvas laced to the bottom of the mainsail, a further piece being called a drabbler. To reduce sail, the yard was partially lowered and the drabbler and bonnet detached. The topsails were taken in and furled and the ship worked under its course with the bonnet unlaced. At a later date, the use of bonnets and drabblers was discontinued and the much older method of reef-points was reintroduced in which the yard was lowered and a strip at the top of the sail was tied up to the yard with the reef-points, thus reducing the sail area. Or, the courses could be furled completely and the ship worked under reefed topsails.

In very heavy weather the ship usually struck her topmasts and worked under reefed courses or ran before the gale under the fore course only.

In 1637 when the greatest ship of her time, the *Sovereign of the Seas* was built, she also carried additional square sails at the main and foretops which because of their singular use in this ship were called 'royals' in addition to a mizzen top-gallant – the only ship to carry so great a sail area until the 18th century.

In the second quarter of the 17th century, with the establishment of the three-masted rig, there was some experimenting with the raking of the masts, which seemed to become less pronounced from the 1650's, until by the 1670's, as can be seen by the paintings of the Van de Veldes who are considered accurate in their technical details, masts have practically no rake at all.

During the time of the Commonwealth, the gilding and decoration of English ships was much reduced. With the Restoration however, there was a return to the richness of former times. Gunports, formerly square in shape, became rounded and ornamented with an elaborate wreathed surround - hence the name of 'wreath-port'. In the latter part of the century, ships generally were much larger, though the Dutch did not build their first three-decker until 1683, the English and French had been building them for some time.

Staysails, i.e. fore-and-aft sails between the masts came into general use on larger vessels, while the square sails had also increased in size and acquired a more rectangular shape.

Towards the end of the 17th century, under the influence of Louis XIV's Minister, the Marquis de Colbert, the supremacy in ship-building passed to the French. They also brought into use the bomb ketch for discharging bombs in mortars at sea for the first time at the bombardment of Algiers in 1682.

In 1705, there is the first evidence of the lengthening of the bowsprit with a jibboom and the introduction of fore-and-aft headsails; this one feature alone being sufficient to distinguish 18th century ships from those of the 17th.

While Charles II was in exile in Holland, he enjoyed the pleasurable Dutch sport of yachting. On his Restoration he was presented by the Dutch with what was to become the first of a line of English Royal yachts; richly decorated and luxuriously appointed, they were also armed with brass cannon. The yachts were not merely built for pleasure, being used normally for the conveyance of distinguished persons. A few yachts similar to the Royal yachts were owned by private individuals – particularly in Holland where there were many private yachts. They were usually smack-rigged with a standing gaff, but from 1682 English Royal yachts were more often ketch-rigged – they were also distinguished from Dutch yachts by not having lee boards.

The Dutch, who were supremely realistic painters, painted not only their most famous ships but also liked to show themselves at work, small boats fishing industriously off-shore and fisher folk landing their catches.

In general, the small fishing boats changed little in appearance, having one mast with a large fore-and-aft spritsail and a fore-staysail. The boats portrayed by the early masters such as Jan Porcellis would show the spritsail laced to the mast. Later painters indicate that the large spritsail was attached to the mast with iron hoops. Herring busses, distinguished by their rounded hulls and square sails varied enormously in size, the largest being up to 300 tons. A familiar scene in paintings is of whaling, the ships characterized by their workmanlike appearance, lack of decoration and bluff bows.

The painting of ships by succeeding generations of marine artists reflected to a large extent the spirit of the age. Vroom, Ertvelt and van Antum with other panoramist painters, depicted them vividly in colourful, dramatic scenes but very often, the later work of Jan Porcellis and other painters of the monochrome school;

Arnoldus Anthonissen, Jan van Beyeren and the early Simon de Vlieger is a reflection of the Dutch people at work at a time when they were consolidating their new-found freedom from Spanish oppression.

The final recognition of the United Provinces as an independent Republic in 1648, coupled with their increasing wealth and prosperity was reflected in a more colourful approach and an emphasis on ceremony and grandeur.

Something of realism was sacrificed to artistic licence. Ships were very often painted with their guns run out to emphasise their aggressive role, however unsuitable or dangerous the weather. There was not a great deal of difference between large merchant-men and men-of-war. Their roles were often interchangeable. Every merchant-man was armed, as once beyond territorial waters they were at the mercy of any stronger opponent and piracy was extremely profitable. A large permanent standing Navy sufficient to meet the requirements of war was too expensive to maintain in peacetime and the squadrons had to be supplemented by the addition of vessels from the trading fleets.

Unless they caught fire or blew up, these great wooden ships were almost unsinkable in battle. Casualties were often heavy, many caused by falling spars and rigging and of course only a small number of the wounded had the constitution to resist the effects of the brutal surgery of the day.

Towards the end of the 17th century, the Dutch Republic began to lose her position as a major power. In the Anglo-Dutch struggles against the French, the Dutch fleet played a subordinate role and generally Dutch shipbuilding and design fell behind that of France and England. Ship building acquired a more technical approach, more emphasis being laid on designing vessels for a specific purpose. Men-of-war acquired a different outline with flush decks and were divided into rates according to the amount of armament they were capable of carrying, the largest being first rates of 100 guns.

Gradually, however, heavy armament led to the need for armour plating and with the later development of steam propulsion in the 19th century, the use of sail, with all its grace and beauty, came to an end for most practical purposes.

Précis

1600 Ship would have a characteristic outline: rounded hull, prominent and overhanging fore- and stern-castles, three or possibly four masts. The fore- and main-masts would carry two large square sails with lateen sails on the mizzen and bonaventure mizzen masts and a spritsail under the bowsprit. Painting in Tudor colours giving way to gilding and decoration.

1610 Launching of the *Royal Prince,* without high poop and overhanging forecastle.

1613 Mast has developed out of the flagstaff to carry the spritsail topsail.

1615 Fourth mast disappearing.

1618 Addition of square mizzen topsail.

1620 Disappearance of prominent stern- and fore-castles.

1630 Rake of masts being experimented with.

1637 Building of the *Sovereign of the Seas.* First ship to carry 'royals' on main and fore tops and a mizzen topgallant.

1640 Larger ships acquired 2 or 3 lanterns at the poop. Addition of square mizzen topsails and spritsail topsails for all men-of-war.

1650 Main channels have moved up wales to level of fore channels. Fishing boats now have sails attached to masts with iron hoops instead of laces. Reef points reintroduced.

1652 During Protectorate, decorating and gilding of ships forbidden.

1660 Restoration of the Monarchy. Introduction of yachting into England. Staysails come into general use.

1661 Foot-ropes appear in rigging.

1670 Disappearance of raked mast. Wreath decoration around gun-ports.

1683 Dutch built first ships with three gun-decks.

1690 Galleries providing a walk around stern disused except in French ships.

1705 Most important identifying feature distinguishing 17th from 18th century ships, lengthening of jib-boom with bow-sprit and introduction of fore-and-aft head sails.

1719 Scales established for construction of ships of six 'rates'.

SOME TYPES OF 17TH CENTURY DUTCH SHIPS

BUSS (BUIS). A small three-masted flute-sterned vessel used for herring fishing.

FLUTE (FLUITSCHIP). A large three-masted full-sterned vessel with narrow decoration built up aft. The most important merchantmen in the 17th century. All Indiamen were armed, as also were many merchantmen.

FRIGATE (FREGAT). A three-masted man-o-war with only one complete tier of guns, though after 1660 many English frigates were given additional guns on an upper deck.

GALLEY (GALEI). A low flat-built vessel of the Mediterranean, using sails and oars.

YACHT (JACHTEN). Used as despatch vessel, also for carrying distinguished persons. They had large cabins aft.

SMALL DUTCH TRANSPORT, COASTING AND FISHING VESSELS

CALJOOT. Catsting vessel. Standing gaff at the mainmast with small lateen mizzen. The tiller passes over and not through the rail.

HOEKER. Fishing vessel. Square foresail and mainsail.

PINK. Fishing vessel. Square-rigged sometimes with a foremast.

SMALSCHIP. Transport vessel. Sprit-rigged, i.e. a spar reaching from the bottom of the mast to the outer top corner of a sail to extend it.

WIDJSCHIP. Transport vessel. A large version of a smalschip.

Flags

The use of emblems to denote a unity, whether of family or purpose or state has been recognised from time immemorial. From these has gradually developed the form of a national flag peculiar to a State or nation.

At the beginning of the 17th century, ships wore flags to identify themselves both to their own and foreign powers. Through that century there was established the use of the flag not merely to identify nationality, but to differentiate between merchant ships and men-of-war; in the case of the former to identify the ships of the various trading companies; and for the latter, to indicate the divisions of squadrons for naval combat, the rank and status of the officers aboard and signify the course of action they intend to pursue.

The paintings of the early Netherlands School depict ships which were mainly of Spanish, Portuguese, Dutch or English origin and the lateen-rigged galleys of the Mediterranean. The Spaniards were easily identified by the greater size of their ships which flew a white flag bearing the arms of Leon and Castille. The larger ships of Portugal carried the 'Cross of Christ' on the fore and main courses, the cross so called in recognition of the fact that the Order of Christ had largely contributed to the cost of the exploratory voyages which had laid the foundation of the overseas Portuguese Empire during the reign of Henry the Navigator. The Portuguese flag bore the arms of the King of Portugal with the easily recognisable emblems of five shields. Most English ships flew the red cross of St George, at this date, merchant and King's ships alike, while Scottish ships flew the white St Andrew's saltire on a blue ground.

After the accession of James VI of Scotland to the English throne as James I a Royal Ordinance of April 14th 1606 caused a new flag to be devised which would symbolise the union of the Scottish and English thrones in the person of the new King. This Union flag bore the St George's cross superimposed on the St Andrew's saltire (always a source of some disaffection to the Scots), though the name 'Union' actually did not appear until listed as such amongst the flags and banners at the funeral of James in 1620.

English warships also carried pendants which prior to 1653 were often flown at the yardarm and not the masthead.

These were the early days of the struggles for independence of the United Provinces from Spanish rule and with them came the emergence of a new National flag. Until this time the flag of the Spanish Netherlands seems to have been the red crossed staves of Burgundy. The dominions of the Dukes of Burgundy which encompassed much of the Low Countries, had finally been absorbed by marriage into those of the Hapsburgs, but merchant ships had continued to fly the old flag of Burgundy and even as late as 1669 there is a signed and dated painting by Hendrik van Minderhout showing a ship wearing this flag.

The origin of the Dutch flag seems to be obscure. In an early Captain's flag-book the present Dutch flag was described as a 'Spanish merchantman' but the connection between the two flags is difficult to trace. It may well have been adapted from the Zeeland flag which took its colours from the arms – a red lion rising from a blue and silver sea (motto : I struggle and rise again). This epitomized the struggle against Spanish tyranny by the Dutch people. The flag bore the colours red, white and blue – the red symbolising the lion – in horizontal stripes, ships flying the flag with nine or more stripes of colour which became simplified to a single broad band of red, white and blue. The 'water-beggars' adopted the flag to prevent themselves being described as pirates, but the red was changed to Orange to show their adherance to the House of Orange. The colour red finally superseded the orange as it was more distinctive at sea. In 1600 the English East India Company was founded and the merchant ships adopted a red and white striped ensign as a means of identification.

In 1602 the Dutch East India Company was founded and with it a multiplicity of flags came into being.

The company was formed to unite the trading expeditions setting out independently to exploit the new markets in the East Indies, many of which had been pioneered by Portugal and Spain. In practice, the in-

88

creasing success of the new company was achieved largely at the expense of Portugal, Spain being more resourceful in protecting her trading establishments than the Portuguese.

The company was divided into six 'Chambers'. Amsterdam, Middelburg, Delft, Rotterdam, Hoorn and Enkhuizen. The Company flag was the Dutch tricolour with the initials VOC on it, usually upright but sometimes upside down. Each of the six chambers however wore the flag of their town of origin with the cipher VOC (Vereenigte Oost Indische Companie) superimposed on it.

A description of the individual flags is as follows:

Amsterdam: Red, white and black with the VOC cipher in black.
Rotterdam: Seven or more stripes alternating green and white, with the VOC cipher in red.
Delft: Black, white and black with the VOC in black.
Hoorn: Red, white, red with the VOC in black.
Middelburg: Yellow, white, red with the VOC in black.
Enkhuizen: Blue, white, blue with the VOC in black.

Flags developed uses other than identification. They could be used in salute – the dipping of a flag according honour and respect – and the right to be saluted was jealously guarded. The English expected the 'Right of Flag' i.e. any ship of any foreign power should dip his flag first to any English ship. The refusal by the Dutch to accord the English the right of flag was one of the provocations which precipitated the first Anglo-Dutch war of 1652-4.

Flags were also used as a signal of intent, though the establishment and regularising of signal codes was a much later development, however, two flags could be mentioned here. The signal used by General Monck to engage the enemy when fighting the Dutch Admiral Marten Tromp, was to hoist a red flag at the fore-topmast head. Later in the second Anglo-Dutch War 1665-7 a red and white striped flag signalling a chase was introduced. It has been thought that the red flag flown at the stern of Dutch ships was a signal 'I am about to sail or get under way'. As early as 1625 on the second expedition to Cadiz, the English fleet was divided into three squadrons, distinguished in seniority by the colour of the flags, this being notable as the first time a fleet fought under red, blue and white flags. The idea had first been mooted at the first expedition to Cadiz in 1596, but abandoned without being put into practice. Each of the three squadrons had three Flag Officers. The senior squadron was the red and the Admiral of the red being the C. in C., usually flew the Union at the main; the Vice-Admiral flew his flag at the fore-top and the Rear-Admiral at the mizzen-top. The next in seniority until 1653 was the blue squadron, the Admiral flying the blue flag at the main and the same pattern being followed; the White squadron was the last in seniority. From 1653 the order of seniority was red, white, blue.

A 'Suit of Colours' for a ship would be a flag – worn only at the masthead; the ensign, worn at the poop; the jack at the jackstaff and a pendant.

The pendant was the oldest method of distinguishing ships, the early ones being twenty yards long and four and a half inches wide. On the first expedition to Cadiz in 1596 the pendants in the English fleet were all white and hung only from the mizzen yards. In 1620, on the expedition to Algiers, the fleet was divided into three squadrons, these being distinguished one from the other by pendants flying from the main, fore and mizzen tops. These were white with the St George's cross at the head.

In 1625, on the second expedition to Cadiz, pendants were also coloured as well as being flown at different masts to indicate the seniority of the squadrons and their commanders.

From 1661 onwards there was in addition to the pendants of squadronal colours a Union pendant with a fly striped red, white and blue to be worn by those of His Majesty's ships not attached to a squadron. This was assigned by proclamation to His Majesty's ships only and a further proclamation of 1674 forbade merchant-men to fly any pendants whatsoever. At this time too, the use of a specially large distinction-pendant came into use as a method of identifying the ship of the officer commanding a squadron who was not of flag rank (the Flag List being restricted at this time to the nine Flag officers of the three squadrons).

Towards the end of the 17th century to make a greater distinction from the Genoese ships which also flew the St George's cross, a 'Budgee Pendant' and ensign were instituted for ships in the Mediterranean which had the Union instead of St George at the head and in the canton, but this has not so far been found portrayed in any picture.

Ensigns were first introduced in the English Navy in 1574 and carried the green and white colours of the Tudors in horizontal stripes. In 1621 a large red ensign was manufactured and used to some degree and by 1633, white and blue ensigns had appeared. From 1635, they were no longer plain but carried a St George's cross in the upper canton.

In 1653, during the first Anglo-Dutch war, the practice of supplying ensigns of squadronal colours to aid naval tactics came into being. In February 1653, the order of precedence was changed from red, blue, white to red, white and blue and remained so until squadronal colours were abandoned in 1864.

The next change in the design of the English ensign was in 1707 and this must be mentioned because this is as firm a distinguishing feature of the 18th century from the 17th century as the elongated bowsprit with the addition of fore-and-aft sail which came into use some two years earlier.

In 1707 the political reunion of Scotland with England and Ireland was formally recognized and moves were made to incorporate the St Andrew's saltire with the English flag. It was finally decided it should only be introduced into the ensign and not the pendant, and so until 1801 when the Union flag was redesigned, only the ensign was changed, the St George's cross in the upper canton acquiring the blue ground and white saltire of St Andrew as well. The 'jack' is the name given to the small flag which flies at the jackstaff, hence the name – and follows the national flag in design. The term 'jack' was used for the first time in the English navy on 3rd July 1633 in orders from Sir John Penington to his captain.

Charles I issued a proclamation on May 5th 1634 forbidding any but Royal ships to carry the Union flag as it was now known, while all merchantmen were to fly either the St George's cross or, on Scottish ships, the St Andrew's saltire. The Union was furthermore only to be flown to indicate that an Admiral was aboard, a Vice or Rear Admiral continuing to fly the St George's cross. These rules were not strictly adhered to – merchantmen and men-of-war flying flags fairly indiscriminately, caused several proclamations to be made at intervals to regularise their usage. With the death of Charles I in 1649, the union between England and Scotland dissolved and the Union flag was not flown again until the Restoration of the monarchy in 1660.

During the years of the Commonwealth, the national flag underwent several changes. In the early days, the flag reverted to the simple St George's cross, ordered at a meeting of Council of State, February 22nd 1649. At a further Council meeting held on March 5th, it was ordered that a new Union flag should be formed symbolising the union between England and Ireland who, for the first time was to be recognised in the National flag. Consequently, the flag bore the arms of England and Ireland in two escutcheons on a red ground.

The re-union of Scotland with England and Ireland was first promulgated in 1654 and the flag so designed had the St George's cross in the first and fourth cantons, the Irish harp in the second and the Scottish saltire in the third. However, in naval flags the St Andrew's saltire was not introduced until May 1658. The harp, naturally, was out of place and so was replaced by a red saltire in the third canton. The whole flag design though was unsatisfactory from the point of view of visibility and the old Union of James I was reverted to with the Irish harp in the centre.

With the Restoration the harp was removed by order of a Council of State of May 5th 1660, and the Union in its original form was flown until January 1st 1801 when the Union flag as we know it today with the cross and saltires of England, Scotland and Ireland was formed.

In addition to the national flag, His Majesty's ships of the English Navy could also fly a Royal Standard or an Admiralty flag in certain circumstances. These too underwent several important changes through the century which are also of help in dating a painting.

The Royal Standard was the personal flag of the Sovereign, always flown at the maintop when he was aboard. It could, however, be flown by the Lord High Admiral, as it was by Lord Howard of Effingham at the Battle of the Armada.

With the accession of James VI of Scotland and I of England to the English throne, the Stuart standard combining the red lion of Scotland and the Irish harp were added to the arms of England and France in his standard. After the execution of his son Charles I in 1649, the Royal Standard was replaced by the Commonwealth Standard. This bore the cross of St George and the Irish harp on shields surrounded by a laurel

wreath and was flown at sea in the battles of the first Anglo-Dutch war 1652-4, by the Generals. During the Protectorate 1653-59, it was succeeded by the standard assigned to Cromwell which in fact never flew at any naval occasion and on his death and during the short term of office of his son Richard, the standard reverted to the original Commonwealth standard until the Restoration of 1660, when once more a Stuart – Charles II ascended to the English throne.

When General Montague travelled to Holland to bring back Charles I, Charles, who disliked the emblem of the harp, had it removed from all flags and standards, and the work not being finished on time, even on the journey, the 'tailors and painters were at work cutting out some pieces of yellow cloth in the fashion of a crown and CR'.

It would appear that the Royal Standard was flown at times other than when the Sovereign was aboard. During the Civil War, command of the Royalist Navy was given to Prince Rupert as Lord High Admiral with the right to fly the Royal Standard at the main at his own discretion. After the Restoration it was flown by the Stuarts until the revolution of 1688, when James II was deposed. On the journey to England, William III flew a standard which bore not only his own arms and those of his English wife, Mary, but also the legend 'For the Protestant Religion and the Liberties of England'. The use of the Standard as the flag of the Lord High Admiral had gradually been curtailed and in 1702 was finally superseded by the Admiralty flag.

The Admiralty flag is the emblem symbolising the office of the Lord High Admiral which originated in 1360. The use of the anchor device to denote that office was first seen in 1588 when it was held by Lord Howard of Effingham. The anchor fouled with a cable was designed in 1601 and this form was adopted by the Commissioners of the Navy in 1633, placing it on a red field which has remained unchanged to this day. In 1638, when the Commission was dissolved and the office given to the Earl of Northumberland, he adopted the present design with the cable draped in graceful folds around the anchor. The Office of Lord High Admiral was placed in Commission during the Commonwealth, but with the Restoration, James, Duke of York, became Lord High Admiral.

When he in turn succeeded to the throne on the death of Charles II he retained the office for himself, flying the Admiralty flag distinguished by an anchor. His three-year reign ended in 1688 and William III once more placed the Office and with it the right to fly the Admiralty flag, in commision until 1702. The Earl of Pembroke was then created Lord High Admiral in February of that year, but with the sudden death of William a month later, Queen Anne deprived Pembroke of the office and the honour was later given to her husband, Prince George of Denmark. There was little opportunity to fly the Admiralty flag in his lifetime – in fact it has scarcely been flown at sea since the revolution of 1688. Since 1850, it has flown over the Admiralty Office in London and is flown on men-of-war during the ceremony of launching. In the Royal Yacht, the anchor flag is flown at the fore, with the Royal Standard at the main and the Union at the mizzen.

When James II fled to France in 1688, he invoked the aid of Louis XIV in the attempts to regain his throne. In 1689 the battle of Bantry Bay was the first naval action of the long French wars and the plain white flags of the French men-of-war were a source of some confusion to the English – especially when a squadron of the White was involved.

Further afield, throughout the century, shipping in the Mediterranean was at the mercy of pirates from the Turkish and Barbary coasts and there are many paintings illustrating the actions between merchant ships defending themselves and men-of-war on punitive expeditions sent against them. Whatever the origin of these vessels, the one immediate distinguishing feature was the crescent – the symbolic emblem of Islam – on their flags, usually three crescents and on a green ground. However, the artists may not have portrayed these flags with any great accuracy – the Muslim marauders in the Mediterranean flew a crescent flag wherever they originated.

An interesting point here is that Muslims would grant safe passage to Christian pilgrims travelling to Jerusalem, their ships travelling under the protection of the 'Jerusalem flag', which bore a cross in the centre of the flag with a small cross in each canton.

In action a ship captured as a prize wears its national flag either beneath the victor's flag at the maintop or at the ensign staff. Surrender was indicated by hauling down the colours. A flag flying at half-mast is a sign of mourning, the lowered flag symbolising the passing away of authority.

Towards the end of the 17th century and onwards, the importance of the use of certain flags and combinations of flags for signalling, not only on intention or purpose, but specific messages, had begun to be recognised. Although many changes were made the development of signalling codes led to an extremely competent form of communication between vessels at sea which continued throughout the 18th and 19th centuries.

Précis

1574 First ensigns worn in the English Navy.

1588 Admiralty flag flown at the Battle of the Armada.

1600 English ships fly St George's Cross. Formation of the English East India Company.

1601 Anchor flag with fouled cable designed for Admiralty flag.

1602 Formation of Dutch East India Company.

1603 Accession of James VI of Scotland and I of England. Formation of new Stuart Standard.

1606 Union flag designed incorporating the Cross of St George and St Andrew's Saltire.

1620 Expedition to Algiers; for the first time an English fleet was divided into three squadrons, distinguished by flying pendants at the main- fore- and mizzen-tops in order of seniority.

1621 A red ensign appears in the English Navy.

1625 The name 'Union' is used for the first time to describe the flag. Second expedition to Cadiz, English fleet appeared for the first time under red, blue and white flags.

1633 White and blue ensigns appear for the first time. Term 'Jack' appears in orders as applied to the small flag at the jackstaff. Admiralty flag acquires a red ground which has remained unchanged.

1634 May 5th. Proclamation forbidding any but Royal ships to carry the Union flag.

1638 Earl of Northumberland designed Admiralty flag with cable draped in folds around anchor.

1649 Execution of Charles I. Union between England and Scotland dissolved. February 2nd – Union flag replaced by St George's cross. March 5th – New flag symbolising union between Ireland and England now devised. Royal Standard replaced by Commonwealth Standard on Parliamentary ships.

1653 Ensigns of squadronal colours used. March – Order of precedence changed to red, white and blue.

1654 Reunion of Scotland with England and Ireland. New Union flag designed.

1658 Introduction into naval flags of Irish saltire instead of harp. Old Union then reverted to as being of a more practical design with the harp in the centre.

1660 Restoration of the Monarchy. May 5th – Removal of the harp from all flags and standards. Union then remained unchanged until 1801.

1661 Union pendant to be worn by H.M. ships not attached to a squadron.

1674 Distinction pendant identifying ship or Officer in Command of the Downs. Proclamation forbidding merchantment to fly pendant.

1684 Senior Officers' pendant.

1685 Accession of James II. Admiralty flag now bears a crown.

1687 Budgee Jack worn abroad.

1688 James II deposed. William and Mary succeed. Their Standard now replaces the Stuart Standard.

1689 Battle of Bantry Bay and first battle of Anglo-French wars. Confusion of white flags.

1690 Distinction pendant extended to officers commanding small squadrons though not of flag rank.

1707 Ensign designed to denote union of England, Scotland and Ireland.

FLAGS SEEN IN 17TH CENTURY PAINTING OF THE NETHERLANDS

AMSTERDAM. Red, white, black with arms on the white; or red, black, red with three gold salteres on the black.

DELFT. Black, in white and black, or white, black, white.

DORDRECHT. Red, white, red.

DUTCH EAST INDIA COMPANY. Red and white repeated several times. (Early town of registration flag colours in the letters V.O.C.O.).

DUTCH WEST INDIA COMPANY. Red, white, blue with initials.

DUTCH NATIONAL. At first orange, white, blue, later red, white, blue.

ENKHUIZEN. Red and yellow repeated several times. Or blue, white, blue.

FLUSHING (VLISSINGEN). Plain red with white urn crest.

FRIESLAND (Province of). Dark blue with two gold lions. Blue, yellow, blue was sometimes used.

HOLLAND (Province of). Yellow with red lion rampant.

UNITED PROVINCES AND NETHERLAND STATES GENERAL. There are two types of lions rampant seen on Dutch flags. The lion of 1602 had 17 arrows, each representing a province, but afterwards reduced to 10 owing to 7 provinces being lost. The later lions rampant had no arrows.

HOORN. Red, white, red with crest, a bugle on the white.

MIDDLEBURG. Yellow, white, red, or dark red, with crest, a castle.

OSTEND. Red, yellow or red with a yellow hand and sword.

ROTTERDAM. Green, white, green repeated.

ADMIRALTY. Red, wide white and blue.

TEXEL. Red, white, blue repeated on a light green and dark blue background.

ZEELAND. Red, white, blue with crest, a red lion, with crown, rising from a blue and silver wave. Their Admiralty flag was green with the same crest.

Signatures

ARNOLDUS VAN ANTHONISSEN

HENDRICK VAN ANTHONISSEN

H. VANTHONISSEN

H. V. ANT

AA

AËRT VAN ANTUM

AERT ANTVM

AERT ANTUM

LUDOLF BACKHUIZEN

LB

1695
LBAK.

L. Bakhuizen
1682

L. Back H

GERARD VAN BATTEM

Battem

JAN VAN BEECQ

Jv. Beecq 1677

CORNELIS BEELT

K beelt

JAN ABRAHAMSZ BEERSTRATEN

J. Beerstraten.

J. BEER-STRATEN
1654

J. Beerstraaten fecit

AB. F.

J B

JACOB BELLEVOIS

J bellevois
1664

ABRAHAM VAN BEYEREN

AB

ABf

ABf.

JAN THEUNISZ BLANKERHOOF

BH: *Blanker* 62B
£ B

CORNELIS BOUMEESTER

CBM

BOVMEESTER

PIETER BOUT

P. bout

P. bout 1686

LEONARD BRAMER

LBramer
1642

JAN VAN CAPPELLE

J. V. CAPPELLE fe 1653

JVCapell

J. V. CAPPELLE

L.A. CASTRO

L..... Castro fecil

L.A. CASTRO

Castro

ANTHONY JANSZ VAN DER CROOS

A. CROOS F 1651

VC 1650

PIETER COOPSE

PC

JACOB VAN DER CROOS

T.V CRO

PIETER VAN DE CROOS

PC

AELBERT CUYP

A. Cryp

AC

AC

A. cuyp.

ADRIEN VAN DIEST

ADiest

JERONYMOUS VAN DIEST

I. V. D.

WILLEM VAN DIEST

WVDIEST 1632

95

HENDRICK JACOBSZ DUBBELS

DVBBELS Dubbels Dubbels. H.

ANDRIES VAN ERTVELT

AE AE

ALLART VAN EVERDINGEN

A:VAN:EVERDINGEN
1647

Av.Everdingen
1650.

A.V.E.

AV: Everdingen.

A.V.Everdingen 1674.

JOOST VAN GEEL	I GERST	HANS GODERIS
J V GEEL	{ GERST	Goderis 1625

JAN VAN GOYEN

VGOYEN 1649 I.V GOJEN
1632 I.V.GOJEN 1625 VG 1643

VG.1646. VG 1655

JACOB DE GRUYTER

J.Gryter 1656

JORIS VAN DER HAGEN

JH *Hagen* *verhaege fe 1652*

WILLEM VAN DER HAGEN

BV Hagen *BV* *BV Hagen*

Gibraltar
1722
BV BV Hagen

JAN VAN LEYDEN	CORNELIS MAHU	HENDRIK DE MEYER
JV LEYDEN	*CMHV·1648*	*H. de Meyer fecit*

HENDRICK VAN MINDERHOUT

H van Minderhout Jut Fc *MDh*

CORNELIS PIETER MOOY·

C P Mooy 1689

PETER MULLIER THE YOUNGER

P.f. *Cavaglio P Tempesta f 1700*

PETER MULIER the Elder

RM· *RL*

97

REINIER NOOMS called ZEEMAN

.R Zeeman A: ZeeMannn R: Zceman R: Zeeman
A° 1659

BONAVENTURA PEETERS
THE ELDER

·B·Peeters B.p

BONAVENTURA PEETERS
THE YOUNGER

BP.

GILLIS PEETERS

G. ·Peeters·

JAN PEETERS

J·P

GERRIT POMPE

G : Pompe

JAN PORCELLIS

Joanns porsellis

1629
Joanns porsellis

JULIUS PORCELLIS

J. Por ·P

JAN CLAESZ RIETSCHOOF

R. R R

ABRAHAM SALM

ASALM A Salm

PIETER SAVERY

SAVERY

WILLEM SCHELLINKS

W Schellinkl

C.W. SCHUT

EXPERIENS SILLEMANS

ADAM SILO

AERNOUT SMIT

LUCAS SMOUT THE YOUNGER

HENDRICK MARTENSZ SORGH

EGMONT STOOTER

ABRAHAM STORCK

JACOBUS STORCK

PIETER VAN DE VELDE

WILLEM VAN DE VELDE the Elder

WILLEM VAN DE VELDE the Younger

W. V. Veldt insord 1678 velde de jonge 1653 CWCVCF

W V V W. W. Beeldei 1686 WVV

CORNELIS VERBEECK

CVB

LIEVE VERSCHUIER

L. verschuier L. verschuier Lvs Lvs

ABRAHAM DE VERWER

A. D. verwer infat 1621

W. VITRINGA

W: ViRinga F....t.

SIMON DE VLIEGER

S DE. VLIEGER S DE VLIEGER 1633 S.VLJ

PIETER VOGELAER

P Vagelaer

JACOB DE VRIES

JDV

CORNELIS HENDRIK VROOM

ᴀRoomf
1630

HENDRIK CORNELIS VROOM

VROOM

CORNELIS CLAESZ VAN WIERINGEN

C.W. C.CWieringen CW

ABRAHAM WILLAERTS

BW. AbW. A.W. AW A W · Je 1653

ADAM WILLAERTS

A·W·F. A·WILLARTS AW 1628
1639 A·Willarts ·1635.

ISAAC WILLAERTS

J.willarts. JW.

PIETER ZEELANDER

PZ 1647.

Recommended Bibliography

Die Niederländischen Maler des 17 Jahrhundert Walther Bernt.
Dictionnaire des Peintres, etc E. Benezit.
Sea & River Painters of the Netherlands Admiral Sir Lionel Preston KCB.
Van de Velde Drawings (National Maritime Museum) M. S. Robinson.
Willem Van de Velde de Oude and
Willem Van de Velde de Jonge H. P. Baard.
Niederländische Marinemalerei Leipzig F. C. Willis.
Die Hollandische Marinemalerei des 17 Jahrhunderts Laurens J. Bol.
The Macpherson Collection M. S. Robinson.
Meer und Land im Lich des 17 Jahrhunderts Kurt J. Mullenmeister.

General

The Adventure of Sail Captain D. Macintyre DSO, DSC, RN.
Fighting Ships R. Hough.
Great Sea Battles Oliver Warner.
The Great Age of Sail ed. J. Jobé, Edita Lausanne.
Royal Yachts Commander C. M. Gavin, RN.
History of the Royal Navy ed. Peter Kemp.
Old Naval Prints Commander Charles N. Robinson.
Sailing Ships & their Story E. Keble Chatterton.
The Wooden Fighting Ship E. H. H. Archibald.
Concise Catalogue of Paintings National Maritime Museum, Greenwich.
Dutch Landscape Painting of the 17th Century (chapter IV) W. Stechow.

Illustrations

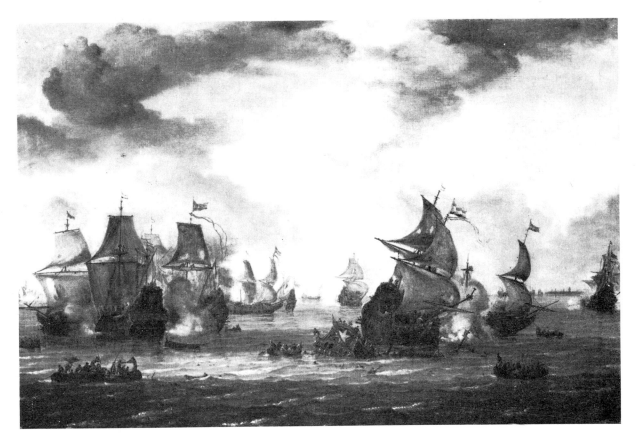

1. Canvas, signed 25½ x 37½ in. 67 x 95 cm

ARNOLDUS VAN ANTHONISSEN. *c* 1630–1703
Sea Battle in the Sound, Denmark 1658
In the Stedelijk Museum de Lakenhal, Leiden

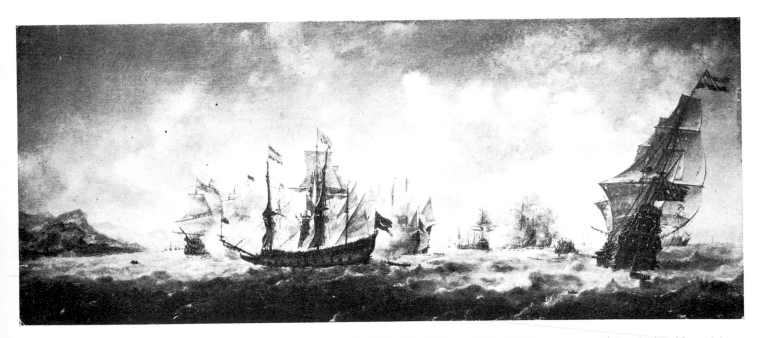

2. Panel, signed **HENDRIK VAN ANTHONISSEN.** 1605-1656 17½ x 41 in. 45 x 104cm
Episode in the Battle of the Downs 1639
In the Scheepvaart Museum, Amsterdam

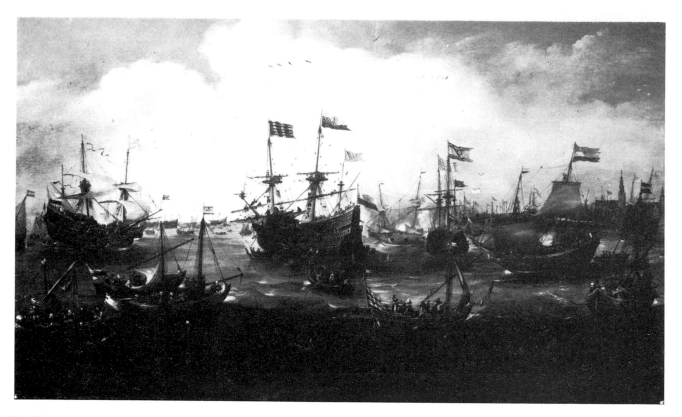

3. Canvas **AERT VAN ANTUM.** 1580-1620 22 x 35 in. 56 x 89cm
Shipping at Amsterdam
In the National Maritime Museum, Greenwich

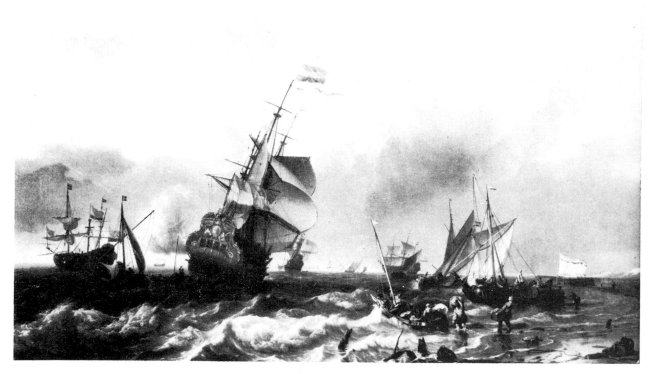

4. Canvas, S&D 1666-67 **LUDOLF BACKHUYZEN.** 1631-1708 44½ x 67 in. 113 x 171 cm
The Hollandia with Admiral De Ruyter. 1665
In the Scheepvaart Museum, Amsterdam

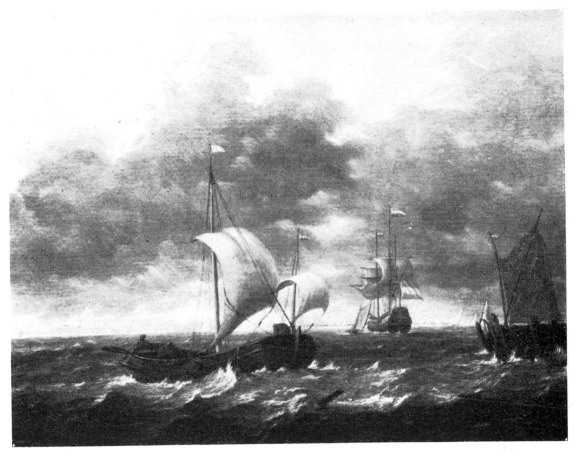

5. Panel, signed GERRIT VAN BATTEM. 1636-1684 10½ x 12 in. 27 x 31 cm
Shipping near a jetty
In the National Maritime Museum, Greenwich

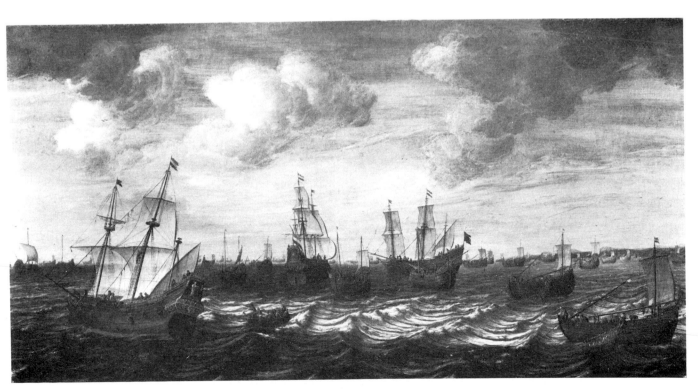

6. Canvas, signed CORNELIS BEELT. 1640-1702 44½ x 80½ in. 113.5 x 204 cm
The Herring Fleet
In the Rijksmuseum, Amsterdam

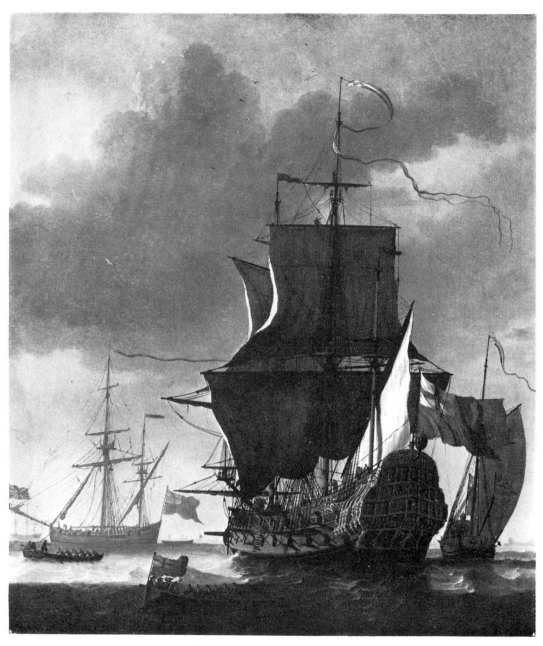

7. Canvas, S&D 1677 40 x 34 in. 101 x 86 cm

JAN KAREL DONATUS BEECQ. 1638-1722
Shipping in a calm
In the National Maritime Museum, Greenwich

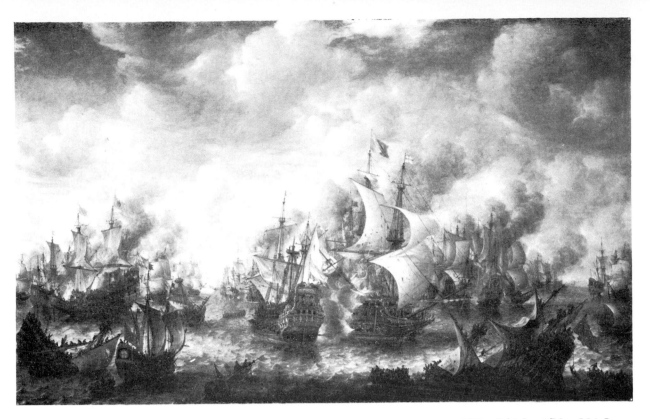

8. Canvas, S&D 1659 109 x 141 in. 176 x 281.5 cm

JAN ABRAHAM BEERSTRATEN. 1622-1666
The Battle of Ter Heyde
In the Rijksmuseum, Amsterdam

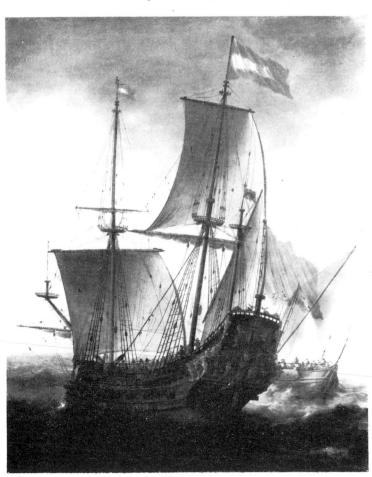

9. Panel, S&D 1653 JACOB BELLEVOIS. 1621-1671 32½ x 27½ in. 82 x 69 cm
Two ships passing in a choppy sea
Sometime in the author's collection

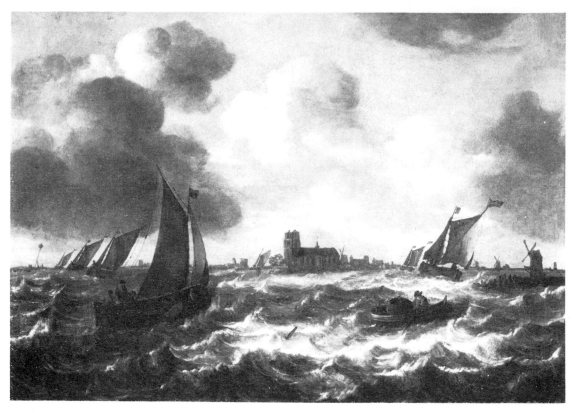

10. Canvas, signed 29 x 39 in. 73.5 x 99 cm
ABRAHAM VAN BEYEREN. 1620/1-1690
Ships in the Maas in a choppy sea
In the Boymans-Van Beuningen Museum, Rotterdam

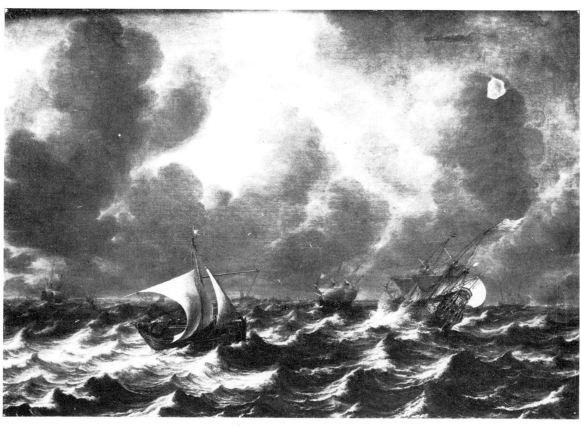

11. Canvas, signed 36 x 52 in. 91 x 132 cm
JAN THEUNISZ BLANKERHOOF. 1628-1669
Ships in a stormy sea
In the Musee des Beaux-Arts, Brussels

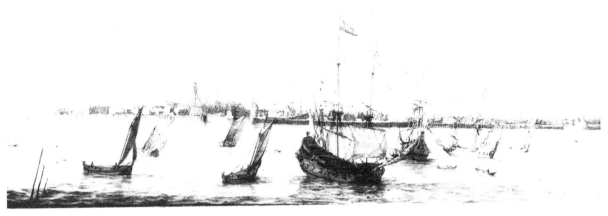

12. Panel, signed 12½ x 20 in. 32 x 50 cm
JASPAR (GASPAR) VAN DEN BOS. 1634 - after 1656
A view of the Hoorn 1654
In the Scheepvaart Museum, Amsterdam

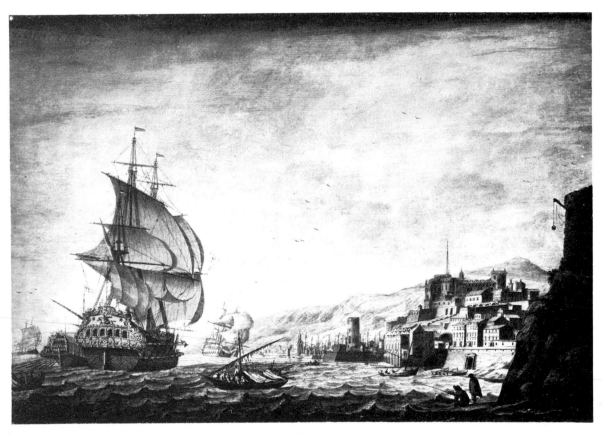

13. Panel, signed CORNELIS BOUMEESTER. 1670-1733 24 x 33 in. 61 x 84 cm
Dutch ships arriving at Naples
In the National Maritime Museum, Greenwich

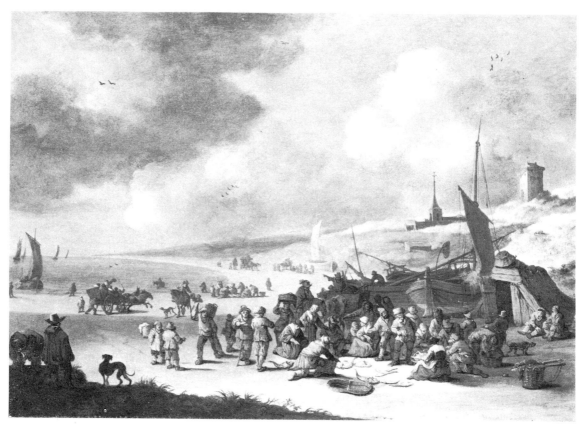

14. Panel, signed **PIETER BOUT.** 1658-1719 18¾ x 24⅜ in. 46 x 61 cm
Beach scene at Scheveningen with Fishermen
In the possession of Richard Green Fine Paintings Ltd (1965)

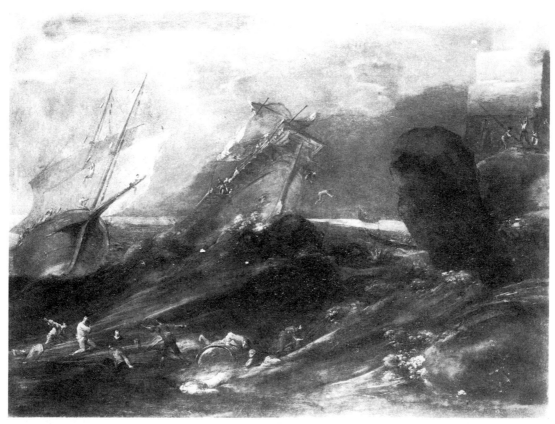

15. Canvas, signed 39½ x 53 in. 100 x 134.5 cm
LEONARD BRAMER. 1596-1674
Shipwreck on a rocky coast
In the Kunsthalle, Hamburg

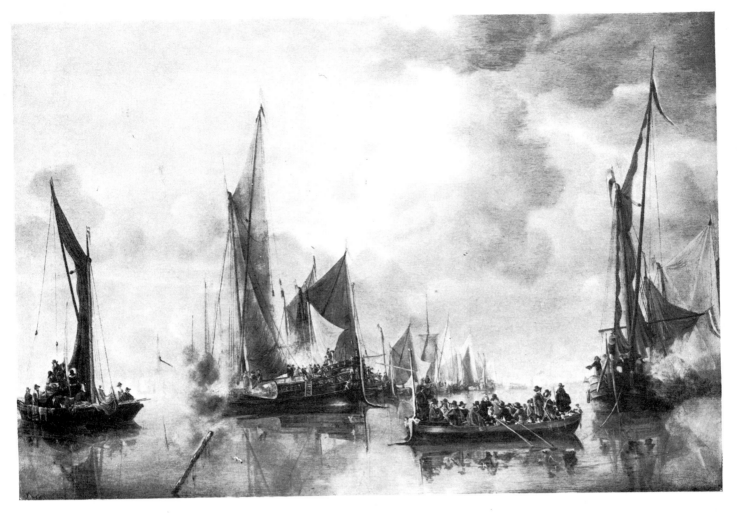

16. Panel, S&D 1650

JAN VAN DE CAPELLE. 1624-1679

25 x 36½ in. 63.5 x 93 cm

State barge saluted by the Home Fleet
In the Rijksmuseum, Amsterdam

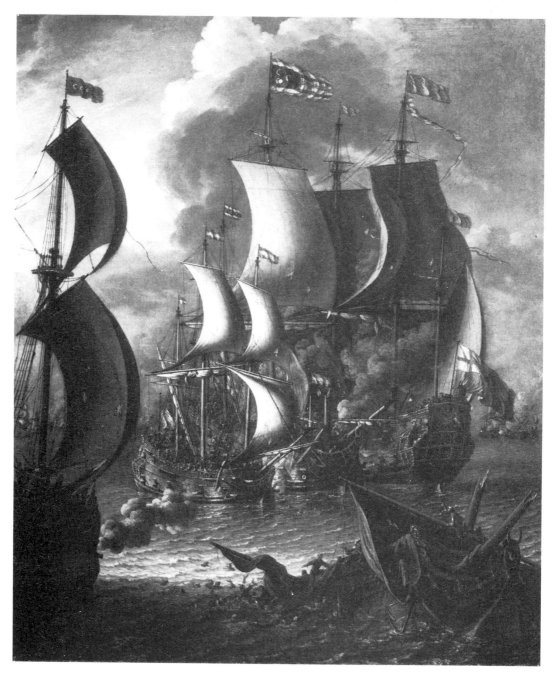

17. Canvas, signed 42 x 36½ in. 107 x 92 cm
LORENZO A. CASTRO. fl 1672-1675
Battle between Barbary coast ships and a British Ship
In the Dulwich College Picture Gallery

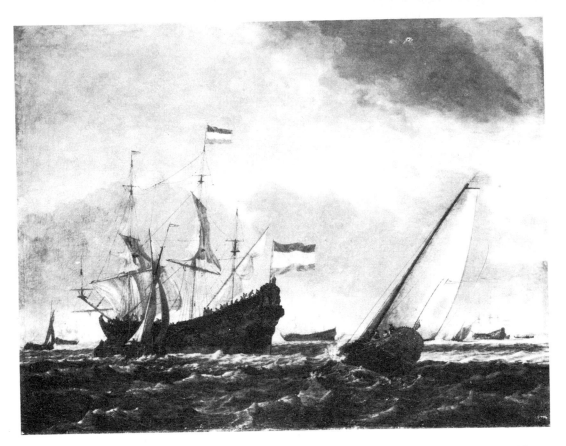

18. Canvas, signed 40½ x 52½ in. 103 x 133 cm

PIETER COOPSE. fl c 1675
Shipping at anchor, with smaller vessels under way
In the Alte Pinakothek, Munich

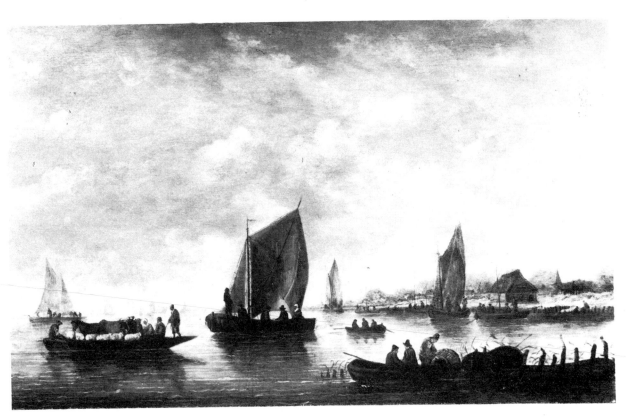

19. **ANTONIE JAN VAN DER CROOS.** 1606 - after 1662
River Scene
Sometime in the author's collection

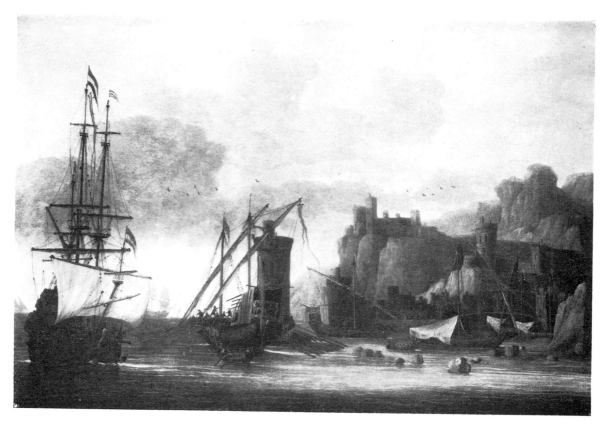

20. Canvas, signed **JACOB VAN DER CROOS.** fl 1600-1690 20½ x 26 in. 52 x 67cm
Shipping in the Bosphorus
In the National Maritime Museum, Greenwich

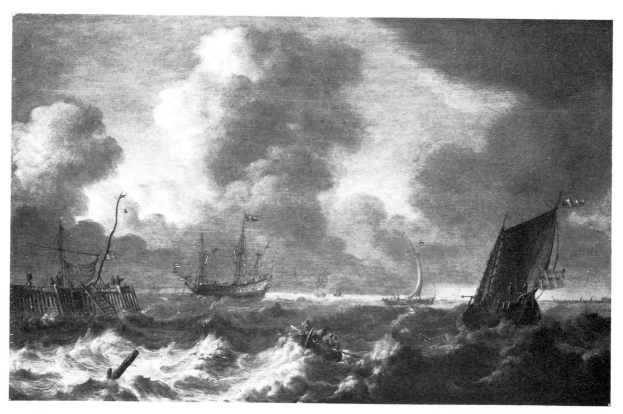

21. Panel, signed **PIETER VAN DER CROOS.** *c* 1620-1701 17 x 25½ in. 43 x 64 cm
Dutch ships in a rough sea off a pier
In the National Maritime Museum, Greenwich

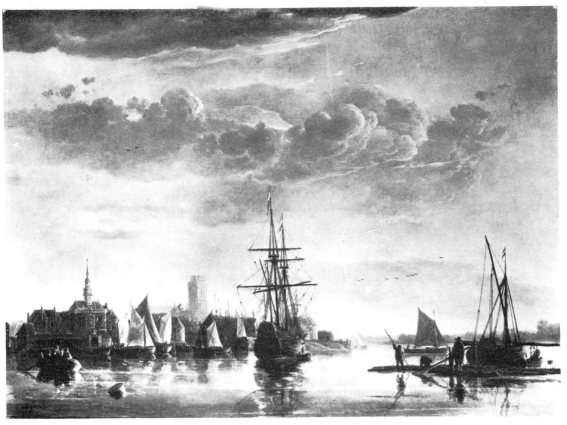

22. Canvas, signed ALBERT CUYP. 1620-1691 38½ x 54¼ in. 71 x 90 cm
View of Dordrecht
Courtesy, the Iveagh Bequest, Kenwood, London

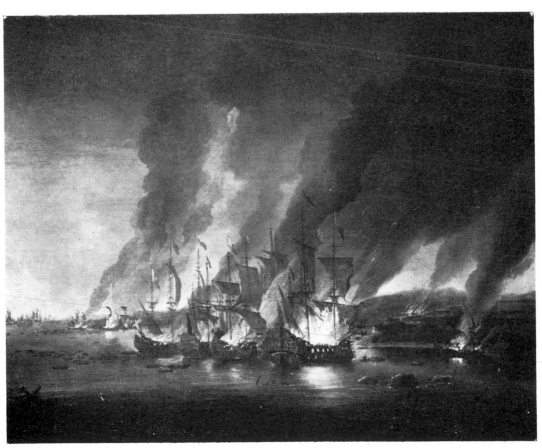

23. Canvas, signed 35½ x 44 in. 90 x 112 cm

ADRIAEN VAN DIEST. 1655-1704
Battle of La Hogue. 23 May 1692
In the National Maritime Museum, Greenwich

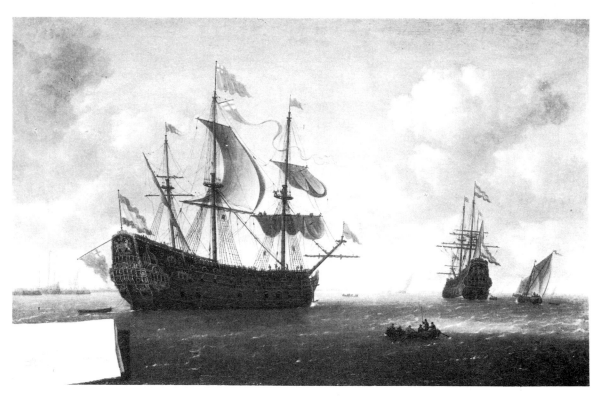

24. Canvas, signed $16\frac{3}{4}$ x $40\frac{1}{2}$ in. 68 x 103.5 cm

JERONYMUS VAN DIEST. 1631-1673
The captured 'Royal Charles' in the Maas estuary
In the Rijksmuseum, Amsterdam

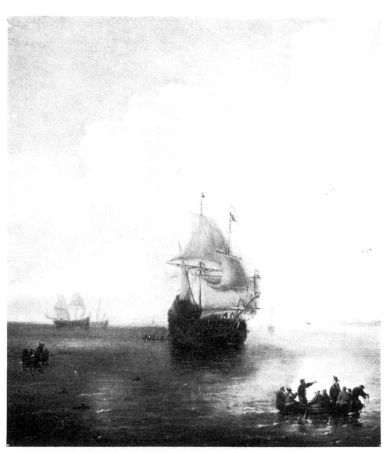

25. Panel, signed $12\frac{1}{2}$ x $10\frac{3}{4}$ in. 32 x 27 cm

WILLEM VAN DIEST. After 1610-1673
Ship's boats going ashore
In the National Maritime Museum, Greenwich

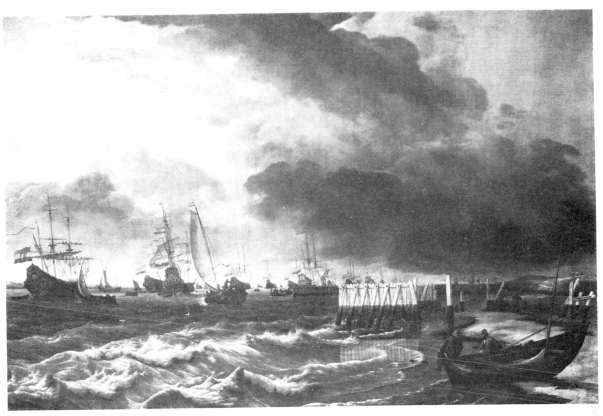

26. Canvas, signed 55 x 77 in. 140 x 196 cm

HENDRICK JACOBSZ DUBBELS. 1620-1676
The fleet of Admiral Wassenaar-Obdam leaving the Texel 1665
In the Rijksmuseum, Amsterdam

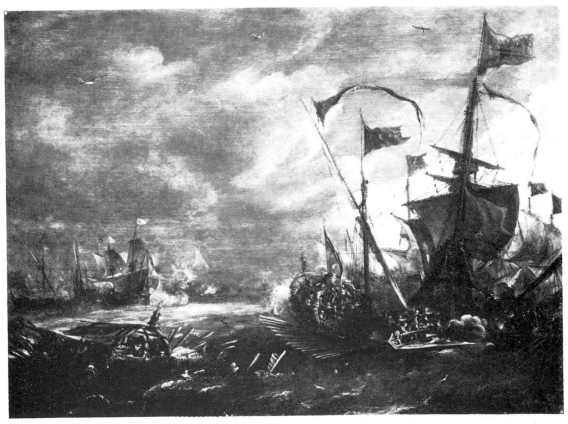

27. Panel, signed 21 x 28 in. 53.5 x 71 cm

ANDRIES VAN EERTVELT. 1590-1652
Spanish engagement with Barbary Pirates
In the National Maritime Museum, Greenwich

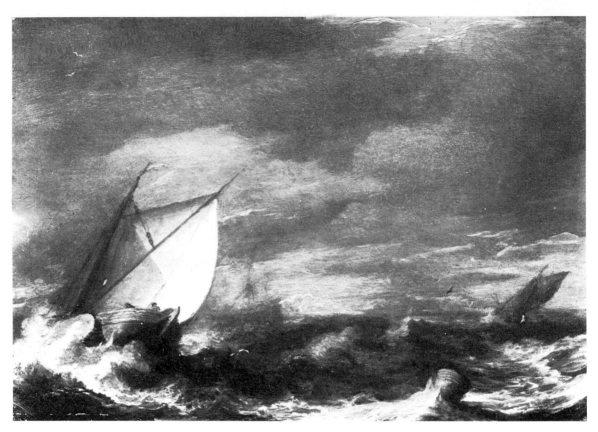

28. Panel, signed 10½ x 14½ in. 26.7 x 36.9 cm
ALLAERT VAN EVERDINGEN. 1621-1675
Small vessels in a very rough sea
In the Museum der Bildenden Kunste

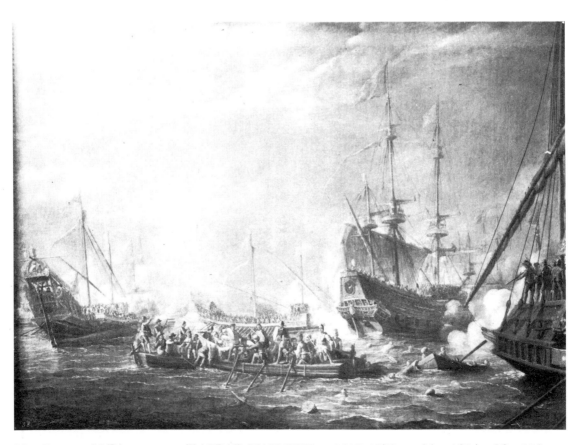

29. Canvas, S&D KASPAR VAN EYK. 1613-1673 34 x 46½ in. 86 x 118 cm
Battle between Christians and Turks
In the Prado Museum, Madrid

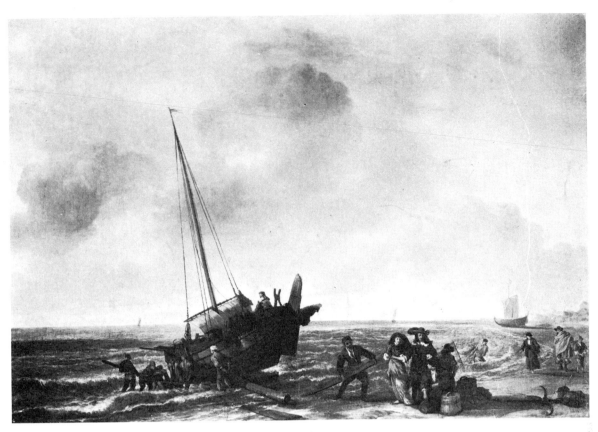

30. Canvas, signed JOOST VAN GEEL. 1631-1698 32¼ x 72½ in. 82 x 184 cm
Shipwreck
In the Museum, Lyon

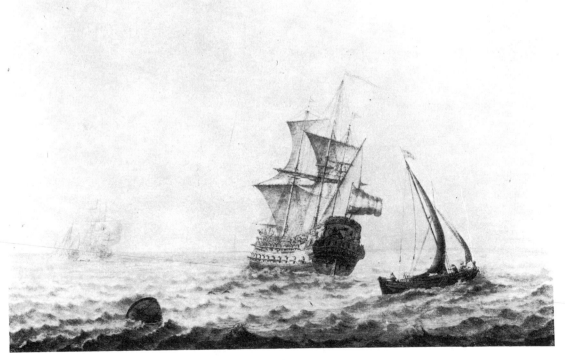

31. Panel, signed I. GERST. *c* 1690 18 x 25 in. 46 x 63.5 cm
The warship 'Utregt' (Utrecht)
Formerly in the author's collection

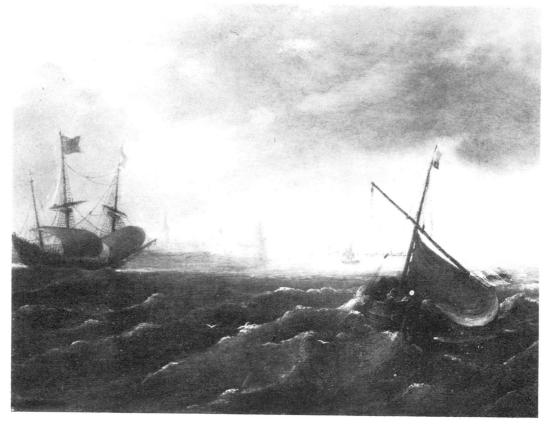

32. Panel HANS GODERIS. op 1625-1640 8 x 11 in. 20.5 x 28 cm
Vessels off Flushing
Formerly in the author's collection

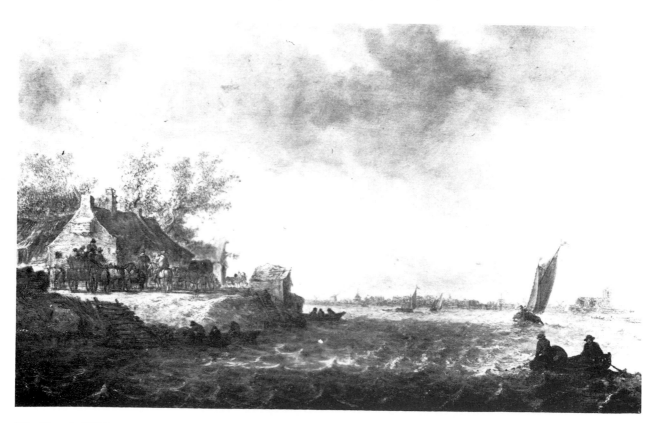

33. Panel, S&D JAN VAN GOYEN. 1596-1665 18¼ x 28¾ in. 46.5 x 72.7 cm
View of Dordrecht
In the Mauritshuis, The Hague

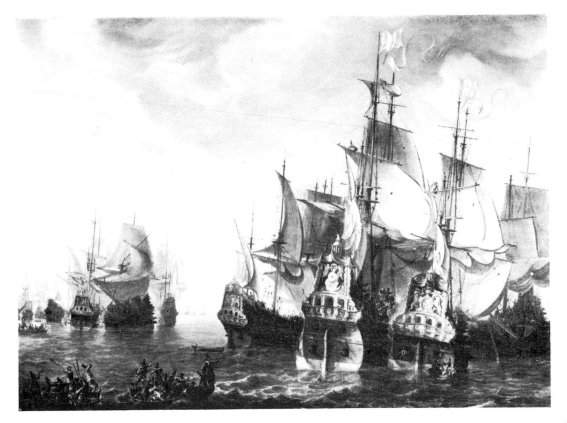

34. **JACOB DE GRUYTER.** op 1658-1689
In a private collection

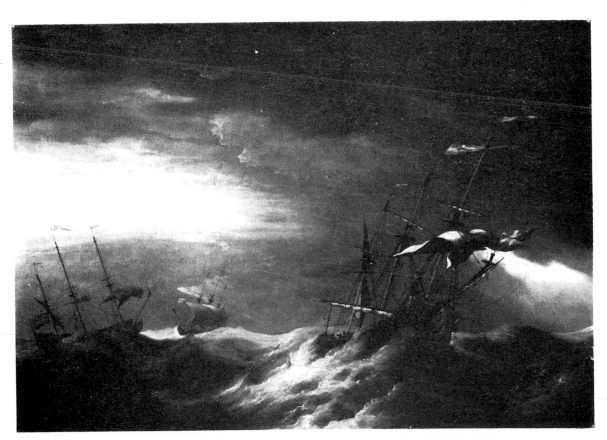

35. Signed

37½ x 50 in. 95.5 x 127 cm

J. C. VAN DER HAGEN. b c 1675 - d 1770
English Ships in a storm
In the National Maritime Museum, Greenwich

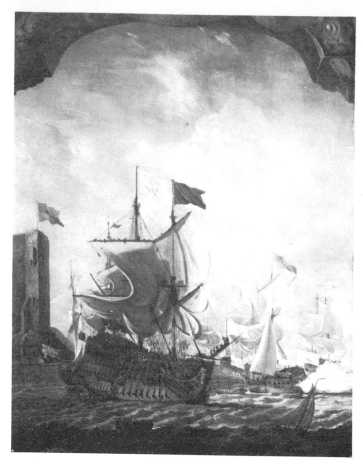

36. Canvas, signed 71 x 51 in. 180 x 130 cm
WILLEM VAN DER HAGEN. late 17th Century to *c* 1736
William II landing at Carrickfergus
In the Ulster Museum, Stranmillis

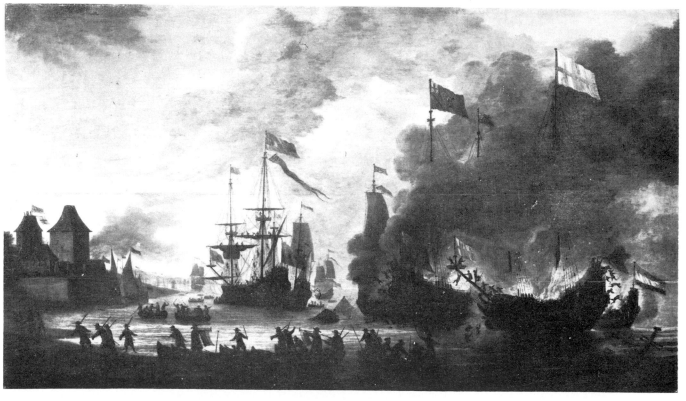

37. Panel, signed **JAN VAN LEYDEN.** op 1661-1675 $36\frac{1}{2}$ x $61\frac{1}{2}$ in. 92.7 x 156 cm
Dutch fleet attacking the English off the coast of Chatham, 20 June 1667
In the Rijksmuseum, Amsterdam

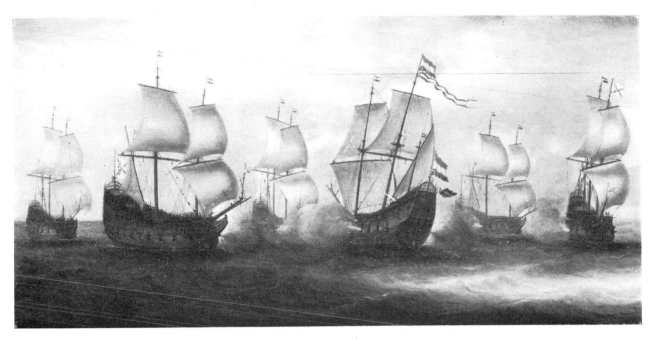

38. Panel, signed JACOB GERRITZ LOEFF. op 1646-1648 15 x 28½ in. 38.2 x 72.5 cm
De Witte in action against Dunkirkers off the coast of Nieuport in 1641
In the National Maritime Museum, Greenwich

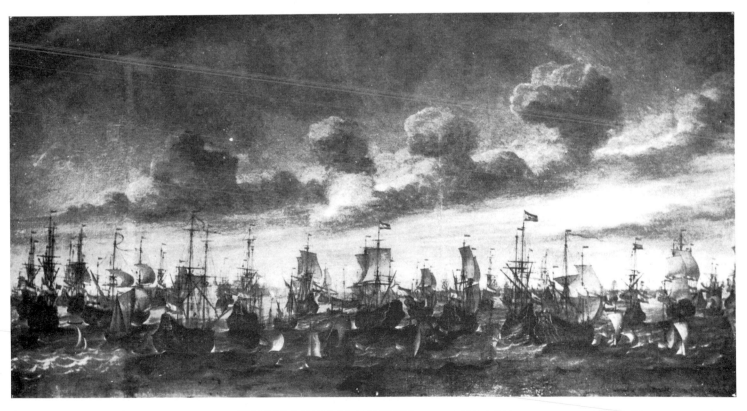

39. Canvas, signed PHILIP VAN MACKEREN. op 1650-1672 39 x 49½ in. 99 x 126 cm
Crowded scene in Veeve Harbour of Dutch Vessels
In the Stadthuis, Veeve

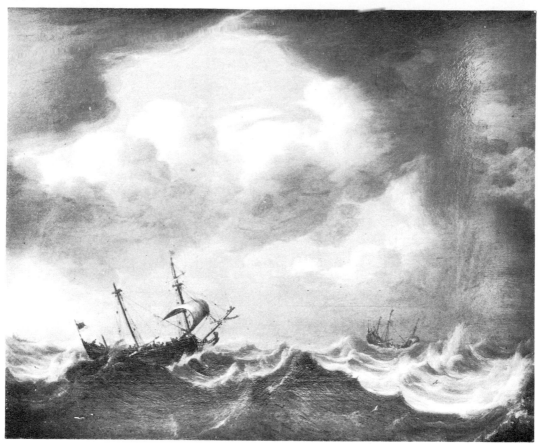

40. Panel $25\frac{3}{4}$ x $32\frac{1}{2}$ in. 65.5 x 82.5 cm

MICHIEL MADDERSTEG. 1659-1709
Sailing ships on the open sea
In the Museum der Stadt, Aachen

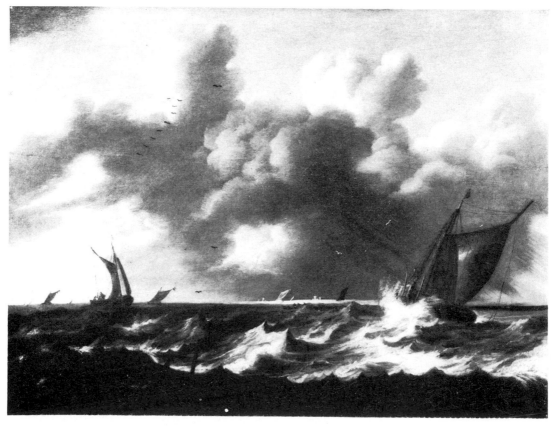

41. Panel, signed CORNELIS MAHU. *c* 1613 - d 1689 $16\frac{1}{2}$ x $22\frac{1}{2}$ in. 42 x 57 cm
Vessels in a high wind on an estuary
Exhibited Dordrecht Museum, 1964

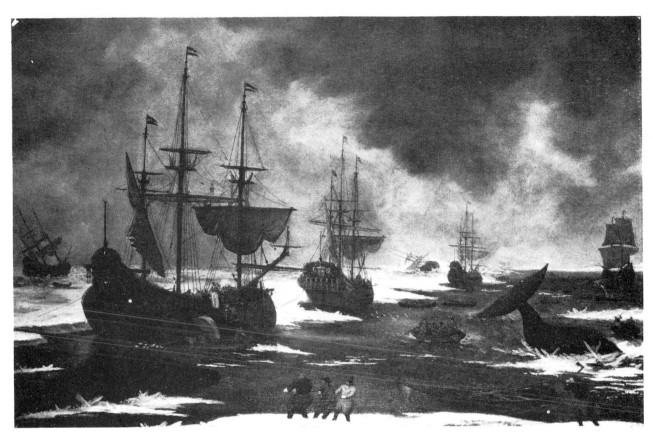

42. Canvas ABRAHAM MATTHUYS. 1581-1649 23½ x 39 in. 60 x 99 cm
Whaling fleet in action
In the National Maritime Museum, Greenwich

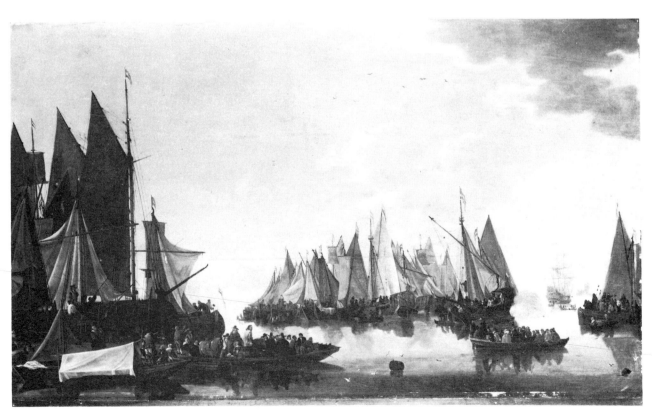

43. Panel, signed HENDRIK DE MEYER. 1620-1690 36 x 58½ in. 91.5 x 149 cm
Embarkation of troops on a Dutch river
In the Statens Museum for Kunst, Copenhagen

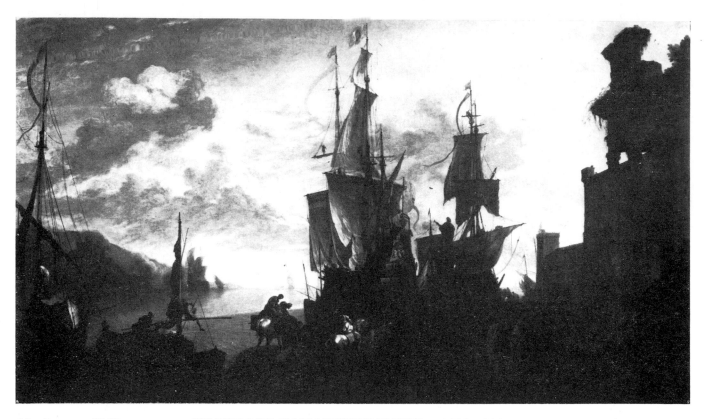

44. Canvas, S&D HENDRICK VAN MINDERHOUT. 1632-1696 58 x 103 in. 147.5 x 262 cm
Shipping at Leghorn
In the National Maritime Museum, Greenwich

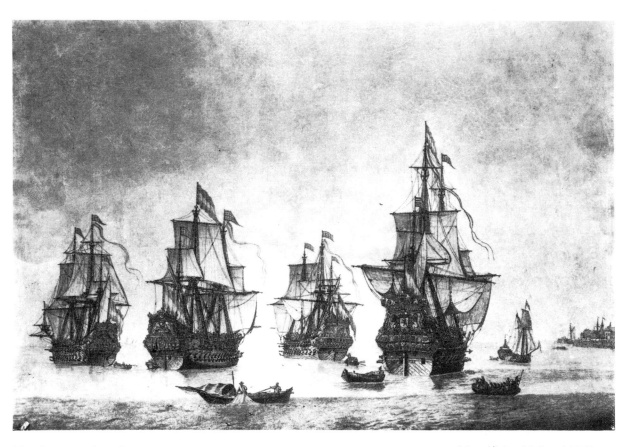

45. Canvas, signed 32 x 47 in. 81.5 x 119.5 cm

CORNELIS PIETERSZ DE MOOY. 1656-1701
The Eendracht and other men-of-war
In the National Maritime Museum, Greenwich

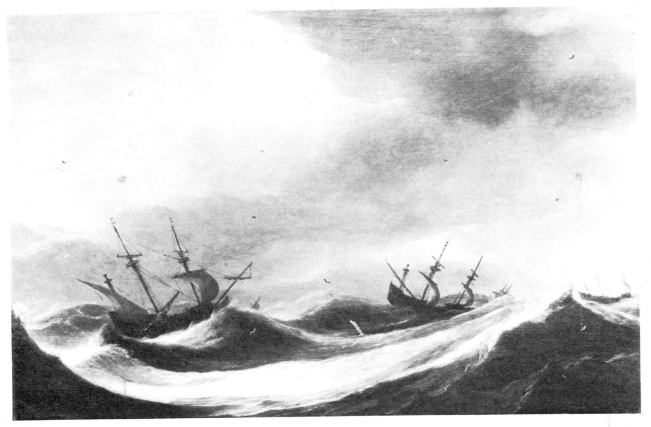

46. Panel, signed 15½ x 21 in. 39.5 x 53.5 cm

PIETER MULIER THE ELDER. 1615-1670
Ships in a heavy sea running before a storm
In the National Maritime Museum, Greenwich

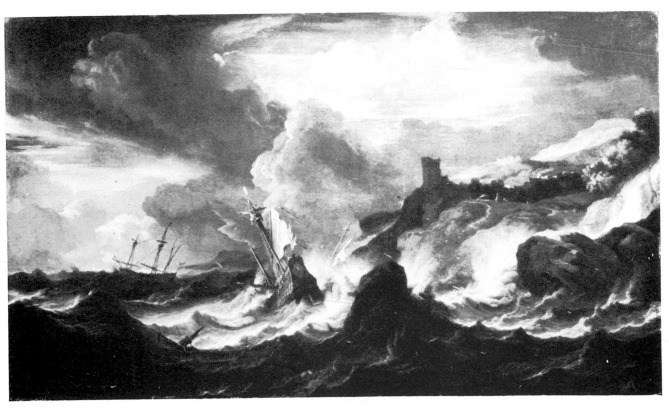

47. Canvas, signed **PIETER MULIER THE YOUNGER.** 1637-1701 16 x 28 in. 41 x 71 cm
Shipping in a storm off a rocky coast
In the National Maritime Museum, Greenwich

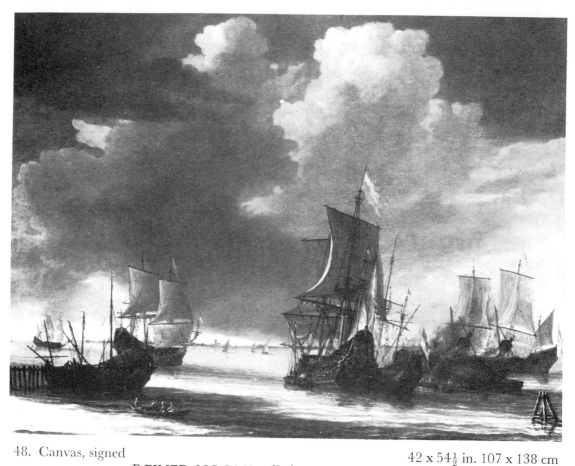

48. Canvas, signed 42 x 54½ in. 107 x 138 cm

REINER NOOMS called ZEEMAN. 1623-1667
Man-of-war at anchor and under repair
In the Royal Museum of Fine Arts, Copenhagen

49. Canvas, signed 23½ x 41½ in. 60 x 89 cm

BONAVENTURA PEETERS THE ELDER. 1614-1652
Estuary scene with cargo boat off a town
In the Alte Pinakothek, Munich

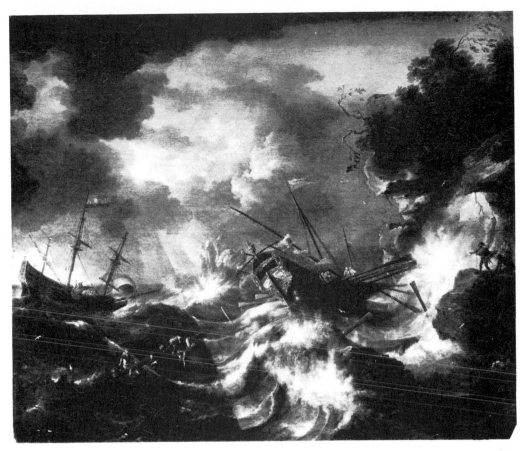

50. Canvas, signed JAN PEETERS. 1624-1680 34 x 40 in. 86 x 102 cm
Stormy sea with shipwreck
In the Kunsthistorisches Museum, Vienna

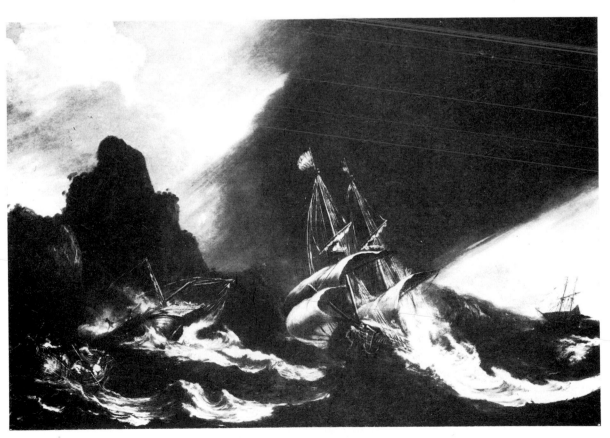

51. Canvas, signed MATHIEU VAN PLATTENBURG. 1608-1660 39 x 54 in. 99 x 137 cm
Ships wrecked on a Rocky Coast
In the National Maritime Museum, Greenwich

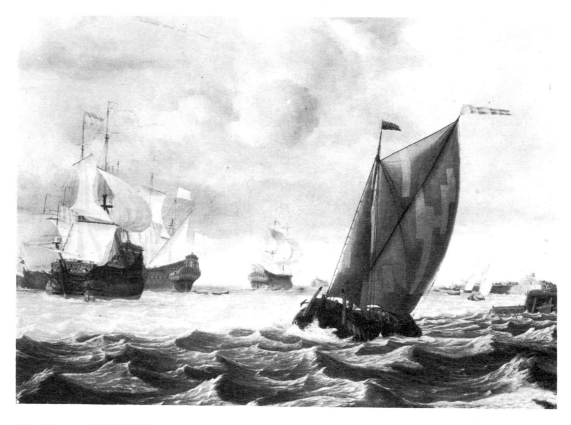

52. Canvas, S&D 1680 $33\frac{1}{2}$ x $44\frac{1}{2}$ in. 85 x 113 cm

GERRIT POMPE. *fl.* 1670–1690
Shipping off a Dutch harbour
In the National Maritime Museum, Greenwich

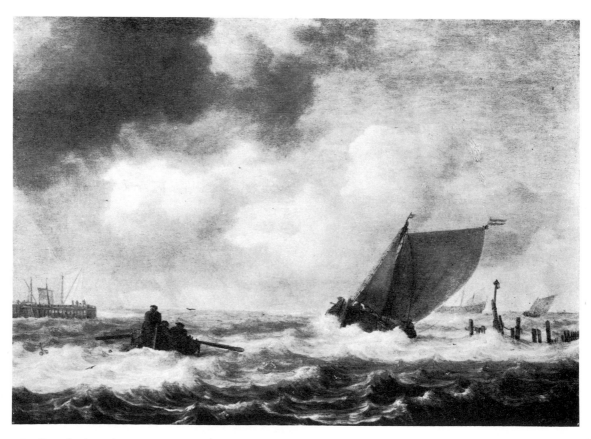

53. Panel, signed 23 x $31\frac{3}{4}$ in. 58.5 x 80.7 cm

JAN PORCELLIS. *c* 1584 - d 1632
Small vessels entering shallow choppy water
In the Museum Boymans-van Beuningen, Rotterdam

54. Panel, signed $14\frac{1}{4}$ x $23\frac{3}{4}$ in. 36.5 x 60.5 cm

JULIUS PORCELLIS. 1605-1645
Mussel Fishing
In the National Maritime Museum, Greenwich

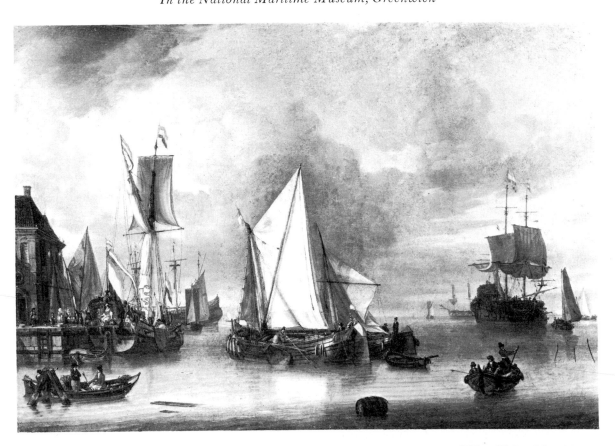

55. Canvas, signed $23\frac{1}{2}$ x 32 in. 60 x 81 cm

JAN CLAESZ RIETSCHOOF. 1652-1719
Calm Water
In the Rijksmuseum, Amsterdam

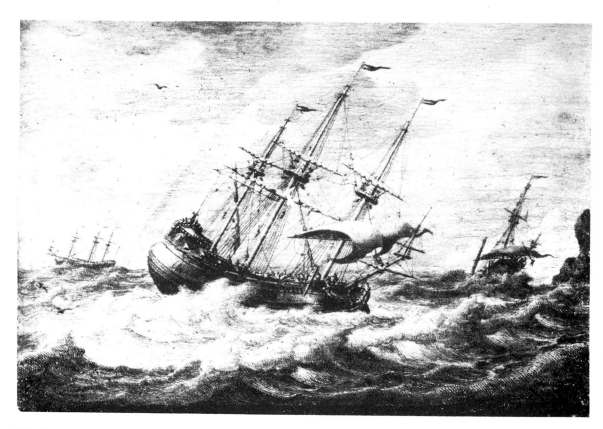

56. Panel, signed ADRIAN SALM. op Delfthaven *c* 1706-1719 $6\frac{1}{2}$ x 10 in. 17 x 25 cm
Fluteship off a Rocky Coast in rough weather
In the Prins Hendrik Maritiem Museum, Rotterdam

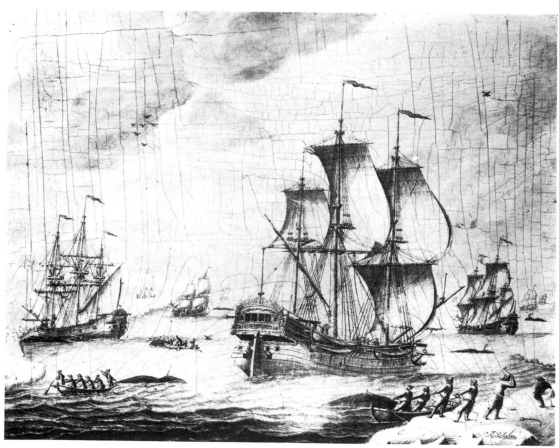

57. Panel, signed ROELOF SALM. 1688-1765 $9\frac{1}{4}$ x $11\frac{3}{4}$ in. 23.5 x 30 cm
Dutch Whalers
In the National Maritime Museum, Greenwich

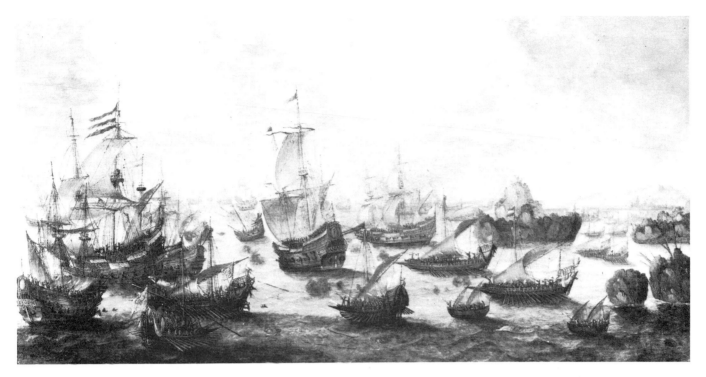

58. Panel, signed PIETER SAVERY. fl *c* 1593-1637 12½ x 20½ in. 32 x 52 cm
The Battle of Lepanto 1571
Sometime in the author's collection

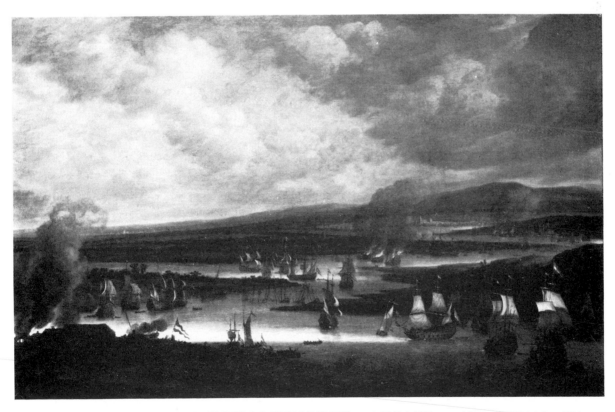

59. Canvas, unsigned WILLEM SCHELLINKS. 1627-1678 45 x 67 in. 114 x 171 cm
The Burning of the English Fleet by De Ruyter on the Medway off Rochester
In the Rijksmuseum, Amsterdam

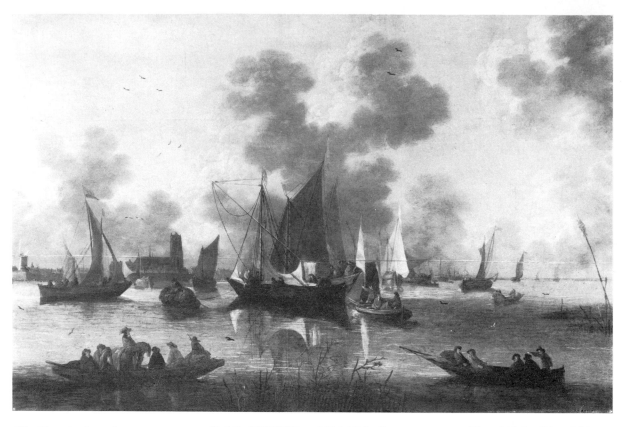

60. Panel, signed C. W. SCHUT. Mid 17th Century 28 x 41¾ in. 71 x 106 cm
Vessels in a calm with Dordrecht in background
In the Kunsthalle, Hamburg

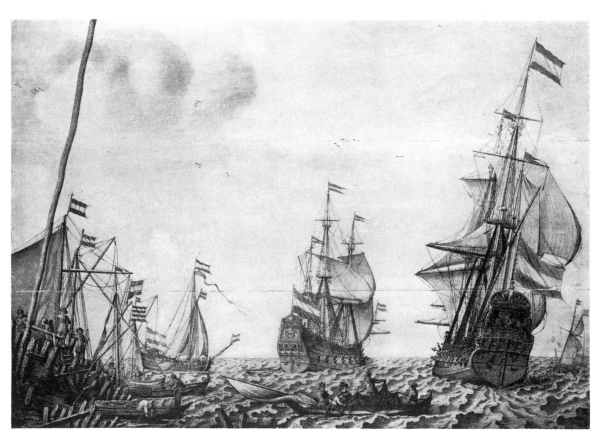

61. Panel, signed 30¼ x 41¾ in. 77 x 106 cm
EXPERIENS SILLEMANS. 1611-1653
Dutch Harbour with Ships
In the Rijksmuseum, Amsterdam

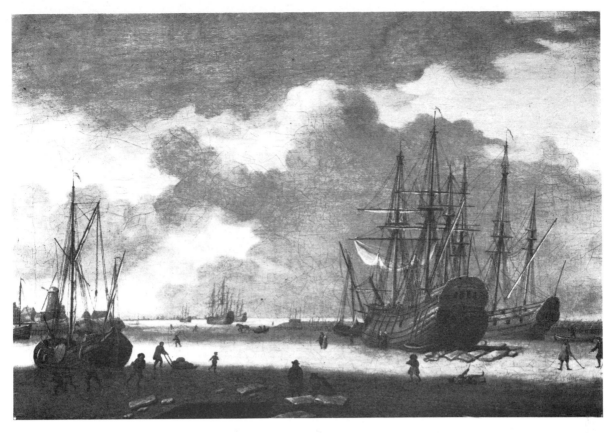

62. Canvas, signed ADAM SILO. 1674-1766 $17\frac{1}{4}$ x $24\frac{1}{4}$ in. 44 x 62 cm
Dutch Whaler in the ice
In the National Maritime Museum, Greenwich

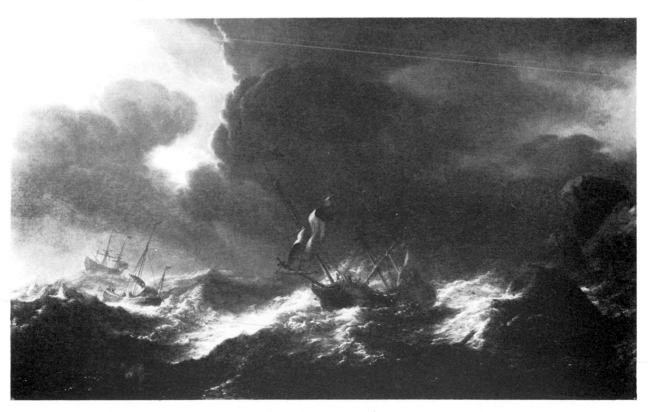

63. Canvas, signed AERNOUT SMIT. 1641-1710 $35\frac{1}{4}$ x 58 in. 89.5 x 147 cm
Storm at Sea
In the Kunsthalle, Karlsruhe

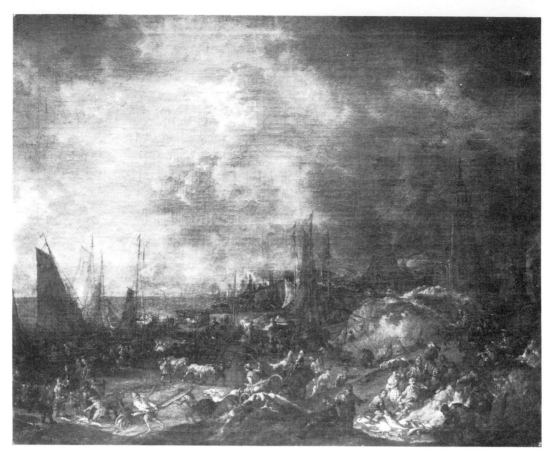

64. Canvas, signed 14 x 17¾ in. 36 x 45 cm

LUCAS SMOUT THE YOUNGER. 1671-1713
The Beach at Scheveningen
In the Keninklijk Museum voor Schone Kunsten, Antwerp

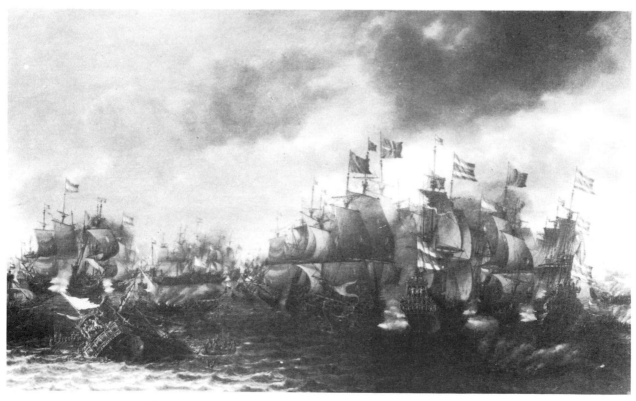

65. Panel, signed 26 x 42½ in. 66 x 108 cm

PIETER CORNELISZ VAN SOEST. fl mid 17th Century
The Four Days Battle 1666
In the Scheepvaart Museum, Amsterdam

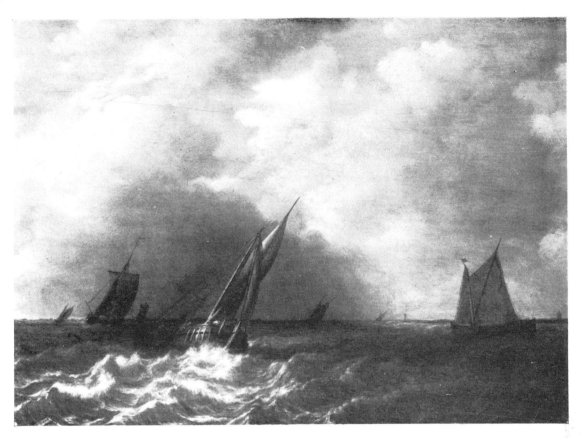

66. Panel, S&D 1668 18¾ x 25½ in. 47.5 x 64.5 cm
HENDRIK MARTENSZ SORGH. 1611-1670
Storm on the Maas with Fishing vessels
In the Rijksmuseum, Amsterdam

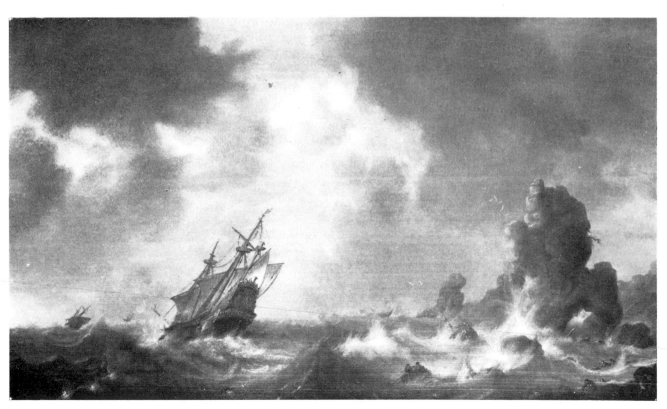

67. Panel, signed HENDRICK STAETS. fl c 1630-1660 21½ x 34½ in. 54.6 x 88 cm
Ships wrecked on a rocky coast
In the National Maritime Museum, Greenwich

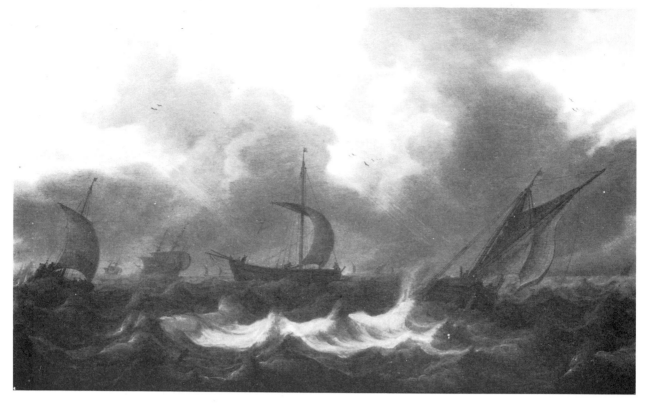

68. Panel, signed 16 x 22¼ in. 40 x 60.5 cm

EGMONT CORNELIS STOOTER. 1620-1655
Vessels in a choppy sea
In the National Maritime Museum, Greenwich

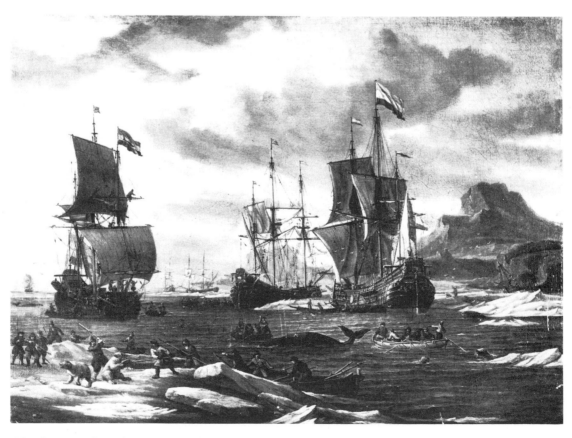

69. Canvas, signed 23½ x 30½ in. 60 x 77.5 cm

ABRAHAM JANSZ STORCK. 1644-1710
Dutch Whaling Fleet
In the Prins Hendrik Maritiem Museum, Rotterdam

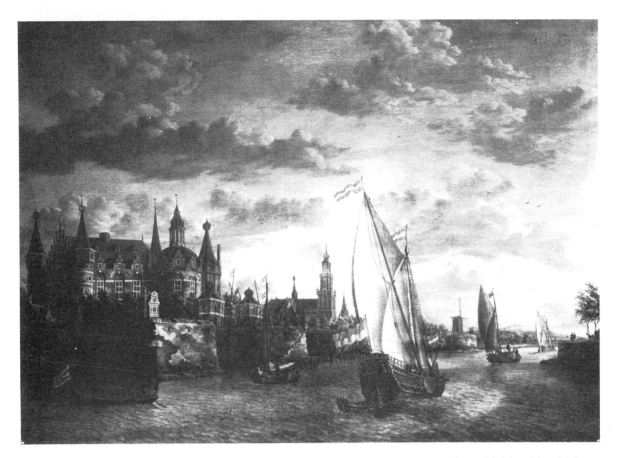

70. Canvas, signed JACOBUS STORCK. fl 1641-1693 $35\frac{1}{2}$ x $45\frac{1}{2}$ in. 90 x 114 cm
Castle on a river in Holland
In the Wallace Collection, London

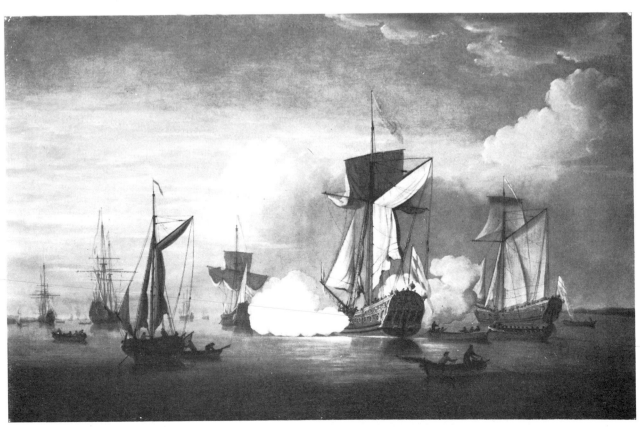

71. Canvas, signed CORNELIS VAN DE VELDE. *c* 1675-1729 36 x 55 in. 91.5 x 140 cm
Royal Yachts and other Yachts in a calm sea
In the author's collection

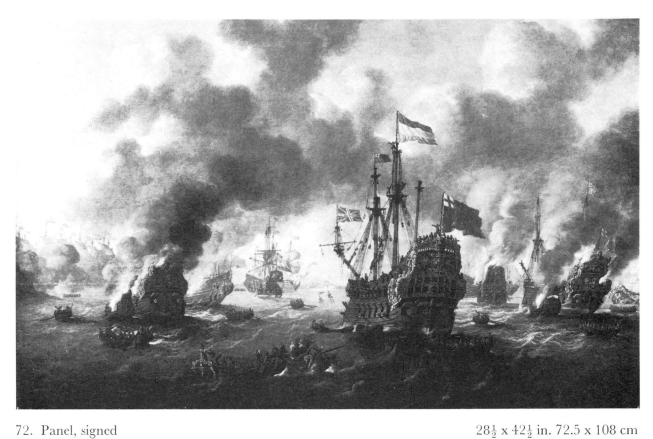

72. Panel, signed $28\frac{1}{2}$ x $42\frac{1}{2}$ in. 72.5 x 108 cm

PIETER VAN DE VELDE. 1634 - after 1687
The burning of the English fleet off Chatham, 20th June 1667
In the Rijksmuseum, Amsterdam

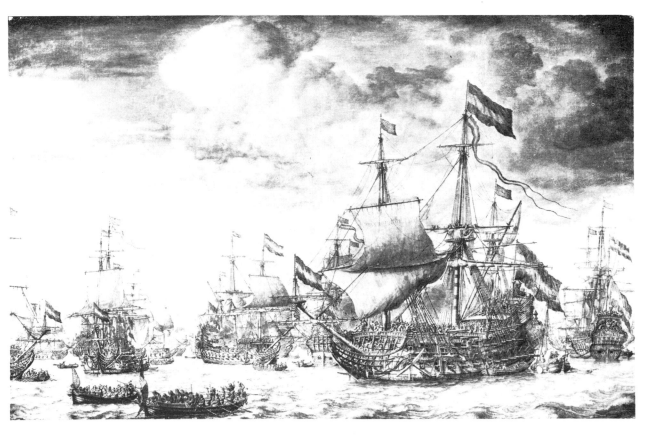

73. Canvas, S&D 1668 44 x 68 in. 112 x 174 cm

WILLEM VAN DE VELDE, THE ELDER. 1611-1693
Men-of-war at anchor with the 'Eendracht'
In the Prins Hendrik Maritiem Museum, Rotterdam

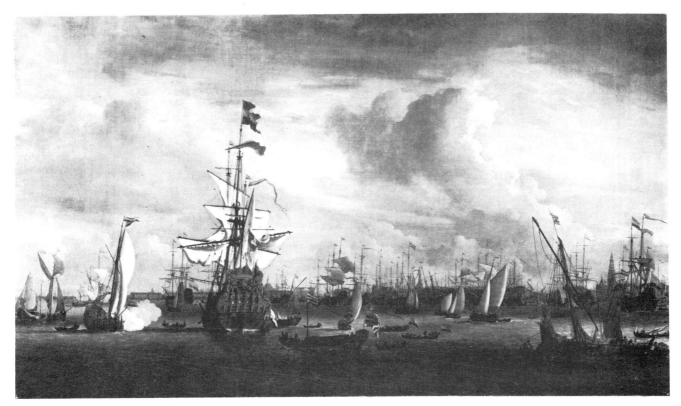

74. Canvas, S&D 1686 $35\frac{1}{4}$ x 124 in. 90 x 316 cm

WILLEM VAN DE VELDE, THE YOUNGER. 1633-1707
The Harbour at Amsterdam
In the Rijksmuseum, Amsterdam

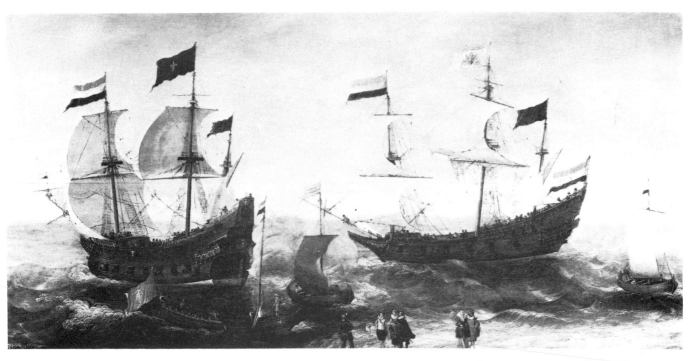

75. Canvas, signed **CORNELIS VERBEECK.** 1590-1631-5 19 x 38 in. 49 x 97 cm
Three masters off the shore
In the Frans Hals Museum, Haarlem

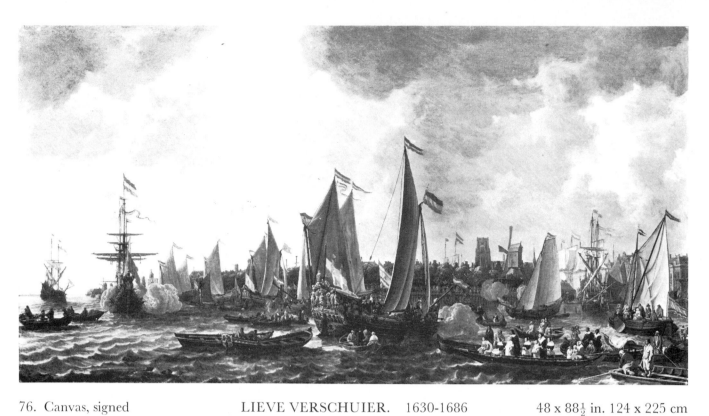

76. Canvas, signed LIEVE VERSCHUIER. 1630-1686 48 x 88½ in. 124 x 225 cm
King Charles arriving in Rotterdam on his way to England
In the Rijksmuseum, Amsterdam

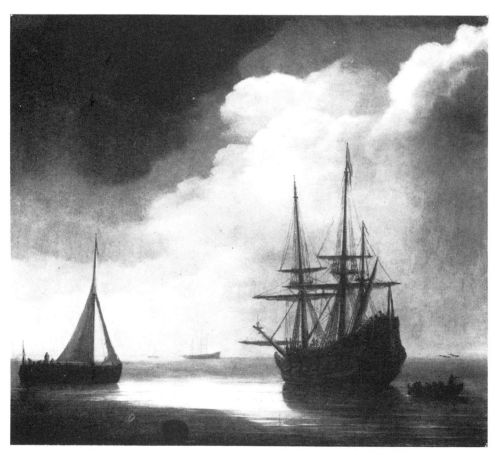

77. Panel, signed 18¼ x 20 in. 47 x 51 cm
ABRAHAM DE VERWER. *c* 1590-1650
A ship in a calm sea
In the National Maritime Museum, Greenwich

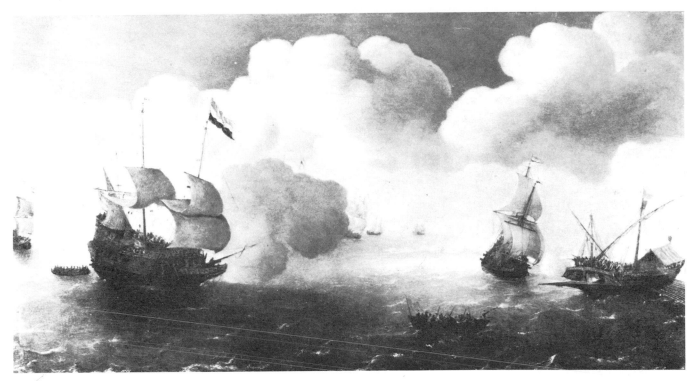

78. Panel, signed JUSTUS DE VERWER. *c* 1626 - *c* 1688 13¾ x 18⅞ in. 35 x 48 cm
Naval skirmish
In a private collection, London

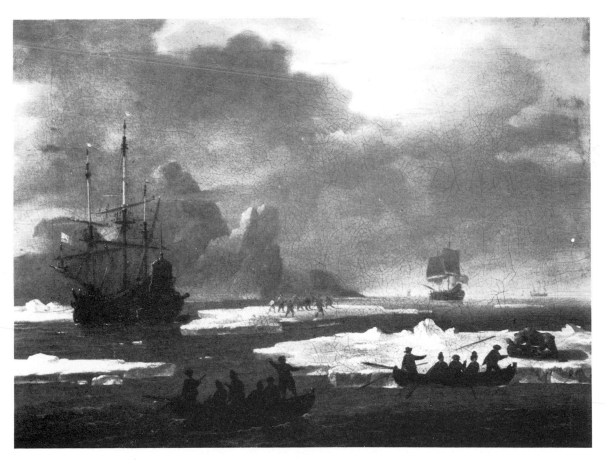

79. Canvas, S&D 1696 17½ x 22½ in. 44.5 x 57 cm
WIGERUS VITRINGA. 1657-1721
A Bear-hunt in the Arctic
In the National Maritime Museum, Greenwich

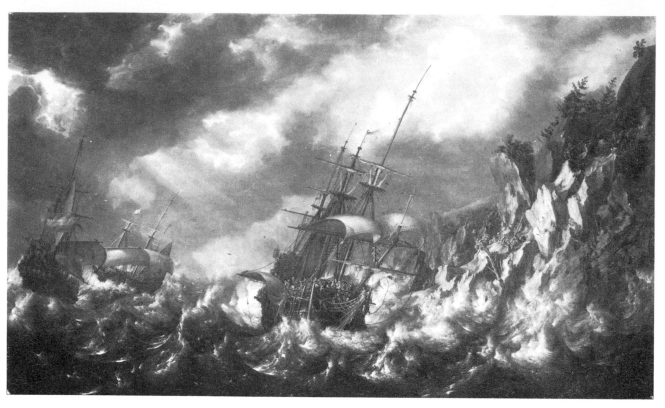

80. Canvas, S&D 1640 SIMON DE VLIEGER. 1600-1653 43½ x 72 in. 111 x 182 cm
A storm at sea
In the Rijksmuseum, Amsterdam

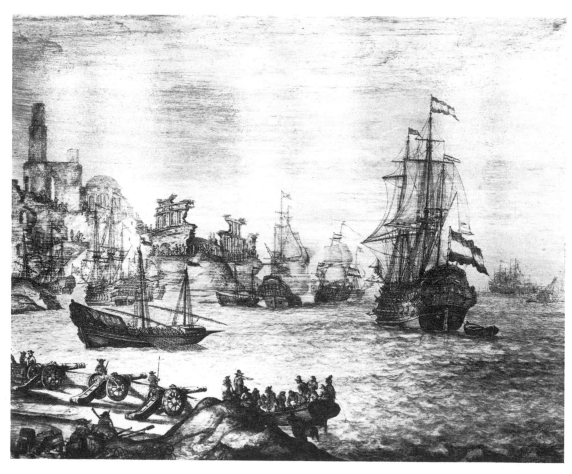

81. Panel, signed PIETER VOGELAER. 1641-1720 32 x 40 in. 81 x 101 cm
Dutch and Burgundian men-of-war and galleys in the Mediterranean
In the Prins Hendrik Maritiem Museum, Rotterdam

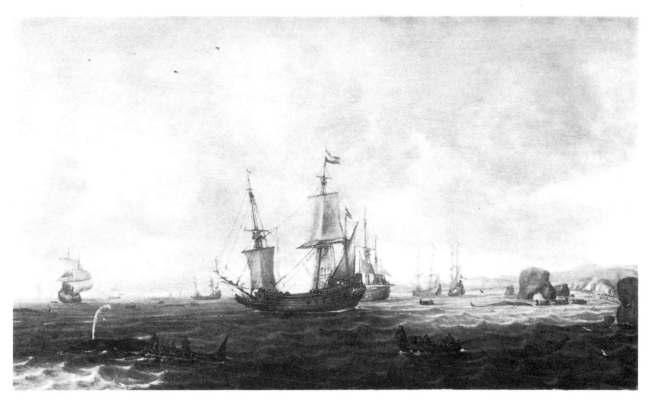

82. Panel JACOB FEYT DE VRIES. First half 17th Century $16\frac{1}{2}$ x $27\frac{1}{2}$ in. 42 x 70 cm
Dutch Whaling Fleet
In the National Maritime Museum, Greenwich

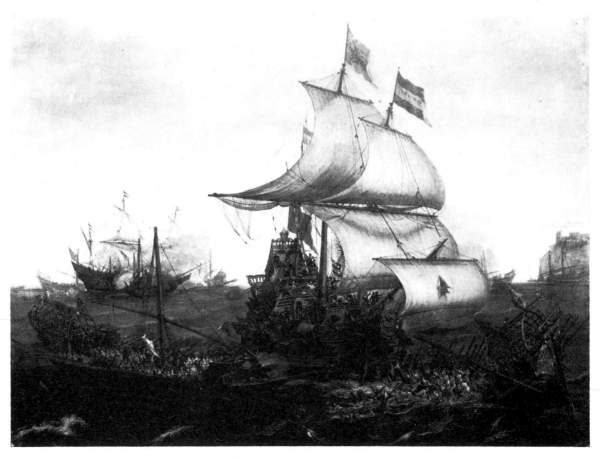

83. Canvas, S&D 1617 $46\frac{1}{4}$ x $57\frac{1}{2}$ in. 117 x 146 cm
CORNELIS HENDRIKSZ VROOM. 1591-1661
Dutch Ships running down Spanish Galleons off the Flemish coast
In the Rijksmuseum, Amsterdam

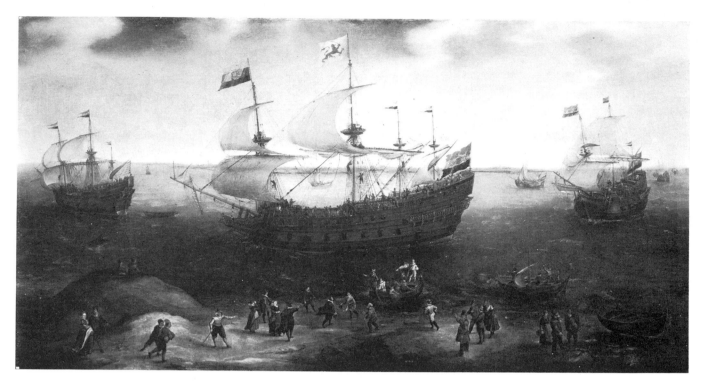

84. Canvas, signed $56\frac{1}{2}$ x 110 in. 144 x 279 cm

HENDRICK CORNELISZ VROOM. 1566-1640
The Hollandsche Tuyn and other ships entering the River Y, 1605
In the Rijksmuseum, Amsterdam

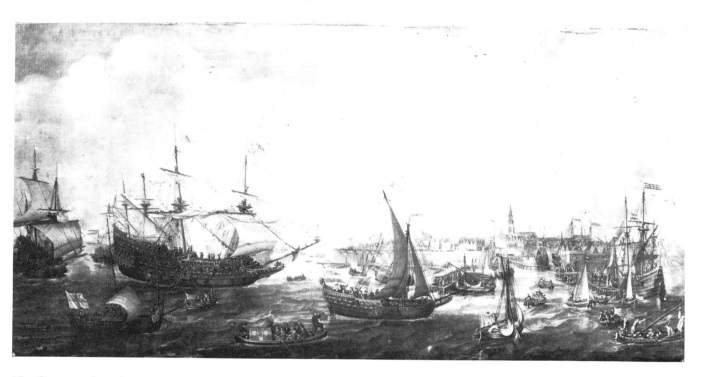

85. Canvas, signed $49\frac{1}{2}$ x 70 in. 126 x 176 cm

CORNELIS CLAESZ VAN WIERINGEN. 158--1633
Arrival of Frederick V., Elector Palatine, at Flushing, May 1613
In the Frans Hals Museum, Haarlem

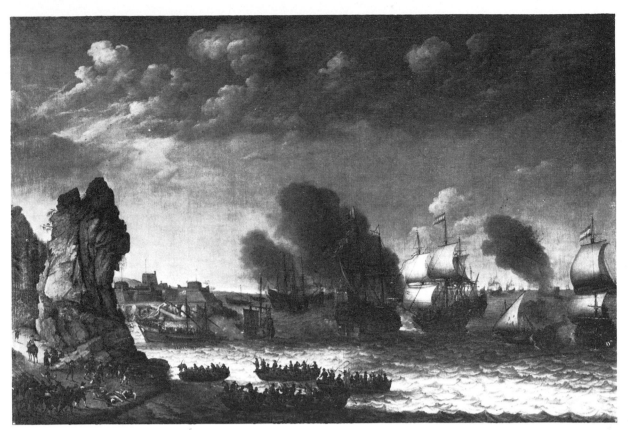

86. Canvas, S&D 1641 64 x 95½ in. 163.5 x 243 cm

ABRAHAM WILLAERTS. 1603-1669
Battle between Dutch & Spaniards, Dutch making a landing
In the Royal Museum of Fine Arts, Copenhagen

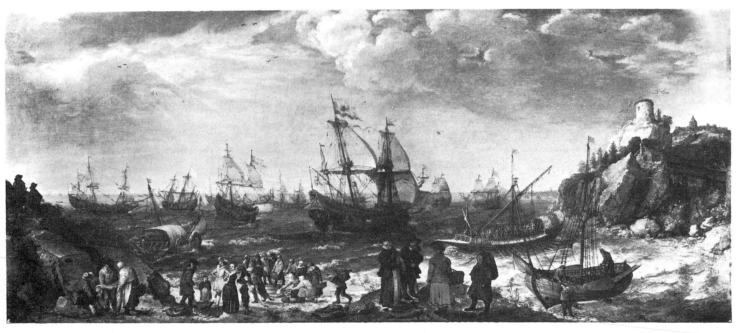

87. Panel, signed ADAM WILLAERTS. 1577-1664 19 x 42 in. 48 x 106 cm
Vessels at sea with fish market in the foreground
In the Ashmolean, Oxford

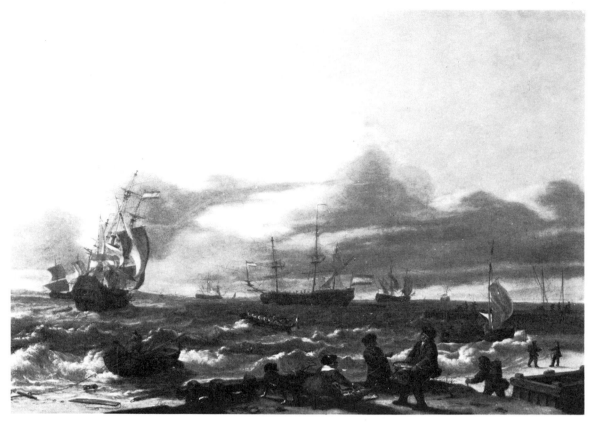

88. Canvas, signed ISSAC WILLAERTS. 1620-1693 $15\frac{1}{2}$ x 23 in. 39 x 58.5 cm
Dutch ships off shore with fishing folk on the beach
Sometime in the author's collection

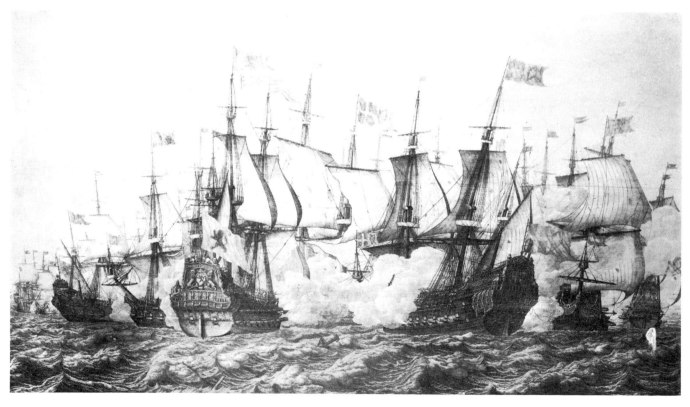

89. Panel, signed HERREMAN WITMONT. 1605 - d after 1683 44 x $70\frac{1}{2}$ in. 115 x 179 cm
The Battle of Gabbard, 2nd June 1653
In the National Maritime Museum, Greenwich

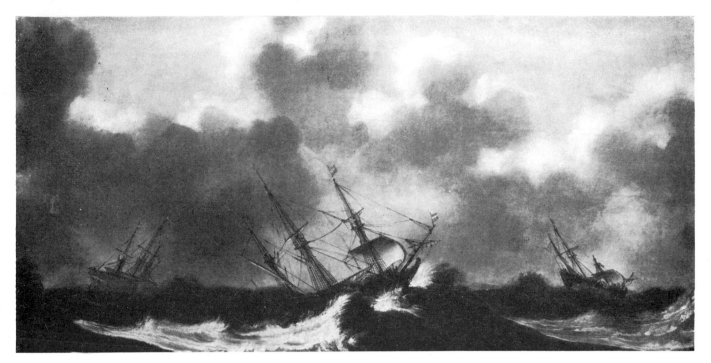

90. Panel, signed CLAES WOU. 1592-1665 20 x 38 in. 51 x 97 cm
Ships in a Gale
In the National Maritime Museum, Greenwich

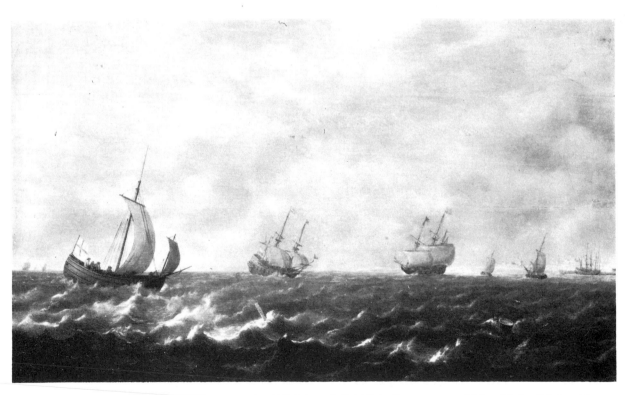

91. Panel, S&D 1644 PIETER ZEELANDER. Mid 17th Century 22¼ x 35 in. 56.5 x 89 cm
Channel Island light craft off the Dutch coast
Sometime in the author's collection